for the
BIRDS

for the
BIRDS

A Month-by-Month Guide to Attracting Birds to Your Backyard

Anne Schmauss,
Mary Schmauss,
and Geni Krolick

Stewart, Tabori & Chang
New York

Published in 2008 by Stewart, Tabori & Chang
An imprint of ABRAMS
Text copyright © 2008 Anne Schmauss, Mary Schmauss, and
Geni Krolick

Library of Congress Cataloging-in-Publication Data

Schmauss, Anne.
 For the birds : a month-by-month guide to attracting birds
to your backyard / Anne Schmauss, Mary Schmauss, and
Geni Krolick.
 p. cm.
 ISBN 978-1-58479-717-3
 1. Bird attracting—North America. 2. Birds—Food—North
America. 3. Birds—Nests—North America. 4. Birds—Habi-
tats—North America. I. Schmauss, Mary. II. Krolick, Geni. III.
Title.
 QL676.57.N7S42 2008
 598.072'347—dc22
 2008018853
Editor: Rahel Lerner
Designer: LeAnna Weller Smith
Production Manager: Tina Cameron
The text of this book was composed in Avenir, Century,
Glypha, and Rosewood.

Printed and Bound in the United States of America

10 9 8 7 6 5

Stewart, Tabori & Chang books are available at special
discounts when purchased in quantity for premiums and
promotions as well as fundraising or educational use. Special
editions can also be created to specification. For details, contact
specialsales@abramsbooks.com or the address below.

ABRAMS
THE ART OF BOOKS SINCE 1949
115 West 18th Street
New York, NY 10011
www.abramsbooks.com

for mom and dad

CONTENTS

78

111

116

ACKNOWLEDGMENTS 9

INTRODUCTION 13

BACKYARD BIRDING BASICS

Food 18
Birdseed 18
Types of Seed Feeders 25
Suet 27
Types of Suet Feeders 29
Nectar 30
Hummingbird Feeders 30
Oriole Feeders 32
Fruit 33
Mealworms 34

Water 35
Types of Birdbaths 37
Birdbath Tips 37
Types of Moving Water 38
Water in Winter 40

Nesting 41
Things to Look for in a Good Nesting Box 44
Hanging and Mounted Nest Boxes 44
Attracting Bluebirds 45

Habitat 46

JANUARY 48
Food 50
Water 55
Nesting 56
Habitat 56

FEBRUARY 60
Food 62
Water 66
Nesting 67
Habitat 69

MARCH 72
Food 74
Water 78
Nesting 80
Habitat 81

APRIL 84
Food 86
Water 92
Nesting 92
Habitat 95

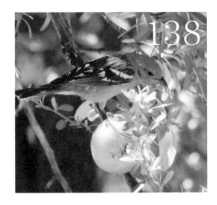

138

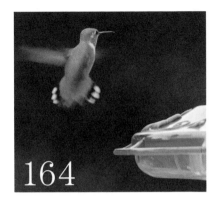

164

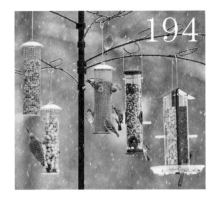

194

MAY 98
Food 100
Water 107
Nesting 108
Habitat 110

JUNE 114
Food 116
Water 124
Nesting 125
Habitat 126

JULY 130
Food 132
Water 139
Nesting 140
Habitat 141

AUGUST 144
Food 146
Water 152
Nesting 154
Habitat 155

SEPTEMBER 158
Food 160
Water 165
Nesting 166
Habitat 167

OCTOBER 170
Food 172
Water 178
Nesting 178
Habitat 179

NOVEMBER 182
Food 184
Water 189
Nesting 189
Habitat 191

DECEMBER 194
Food 196
Water 200
Nesting 201
Habitat 201

TROUBLESHOOTING 206
Unwanted Guests (Squirrels,
 House Sparrows, Etc....) 208
Oh, What a Mess! 213
It's Wet Out There! 215
Lions, Tigers, and Bears 215

REFERENCES 217

INDEX 218

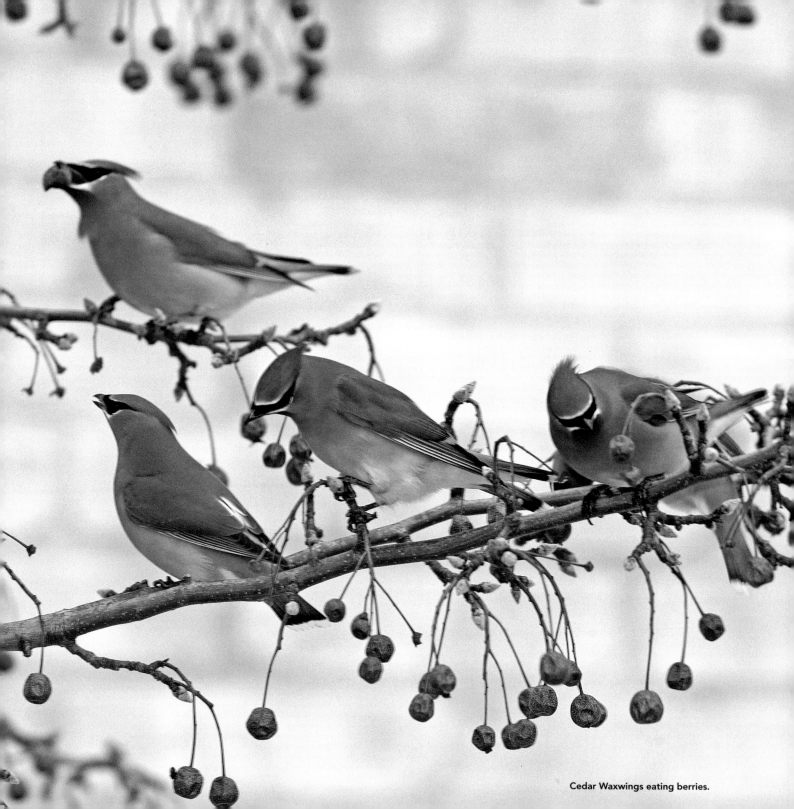

Cedar Waxwings eating berries.

WITHOUT A LOT OF HELP, this book would not have happened. We owe thanks to many people, some of whom are listed below.

- To our many customers in St. Paul, Minnesota, and Albuquerque and Santa Fe, New Mexico. We have learned so much from you and your backyard birding experiences. The hundreds of tips we provide in this guide have been informed by your questions and bird stories. It has been our pleasure, these many years, to talk with you about your birds. Thank you.
- To all of our co-workers in the bird business for the past fifteen years. Thank you for sharing your knowledge, humor, and hard work with us.
- To our friends and families, for their early, enthusiastic support of us and this project.
- To little Mary, for always saying "You can do it, Mommy!"
- To our sister-in-law Judy Schmauss, who so generously lent her professional eye to our book proposal and was helpful and encouraging at every step.
- To our seven-year-old friend Sophie, who came up with the Kids Project idea. Way to go, Sophie.
- To Debby and Elaine at WordCenter. Thank you, Debby, for making our handwritten manuscript presentable and clear.
- To our fabulous agent, Meredith Bernstein. The early bird did get the worm.
- To the folks at Stewart, Tabori & Chang—in particular Jennifer Levesque for her positive attitude and willingness to explain everything to these first-time authors. Also to our editor Rahel Lerner for shepherding this

for the **BIRDS** 9

ACKNOWLEDGMENTS

project with enthusiasm, competence, and patience. And we'd like to thank LeAnna Weller Smith for her wonderful design, and Ana Deboo for her extraordinary attention to detail.

- To all the folks at Wild Birds Unlimited, who have taught us so much about the business of birds without ever losing sight of the birds and the people who love them.
- To Jim Carpenter at Wild Birds Unlimited, Inc., who generously shared his photographs.
- To all the talented photographers whose love of birds contributed to this book. Thank you, Ruth, Pete, Gail, Jess, Jim, Steve, Dave, Reese, and Carolyn.
- To Jeanne, not only for her technical support, but for her "we'll get it done" attitude.
- To the folks at Sierra Grande Lodge in Truth or Consequences, New Mexico, for your hospitality when we locked ourselves away to finish the book. This peaceful spot was just what we needed and was where, on one hour-long walk along the Rio Grande in January, we saw a covey of Scaled Quail, a Belted Kingfisher, two Osprey, a Great Blue Heron, a Pyrrhuloxia, a Phainopepla, and a White-crowned Sparrow. Wow! Seems like a good omen of things to come.
- Mostly, we thank you, our readers, who share with us a love of nature and birds and the wonderful hobby that brings us all so much joy.

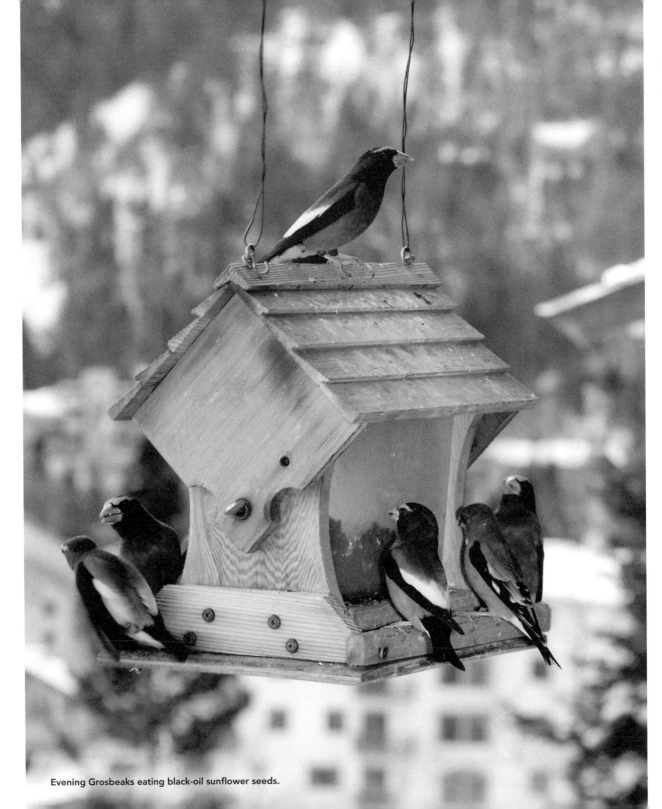

Evening Grosbeaks eating black-oil sunflower seeds.

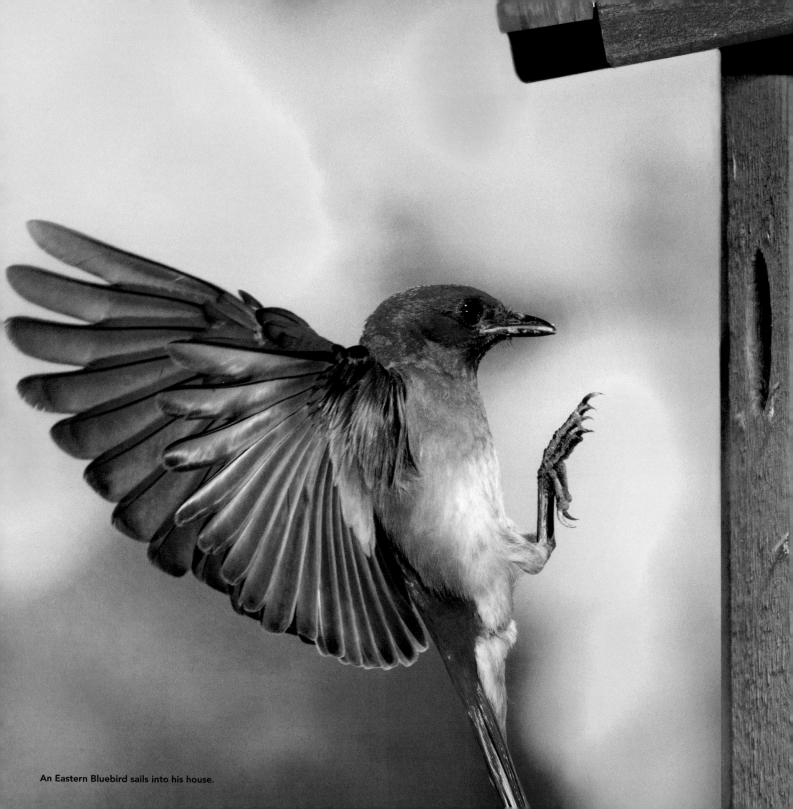

An Eastern Bluebird sails into his house.

IF YOU'RE READING THIS BOOK, it probably means you're one of fifty-four million backyard birders in North America, and whether you live in Maine or Mississippi, Albuquerque or St. Paul, this book will help you attract a wider variety of birds to your backyard. Just imagine

- cardinals eating safflower seeds from a tray at your kitchen window,
- Red-headed Woodpeckers hanging from your suet feeder,
- bluebirds gobbling up mealworms,
- robins splashing in your birdbath, and
- squirrels defeated by your squirrel baffle.

All of this and more can happen in your backyard—if you know how. For more than forty-five combined years, we have been in the business of helping folks attract more birds. We have talked to tens of thousands of you about the birds in your backyards, conversations like "What is working best to attract cardinals?" "When are you seeing the first orioles arrive?" "Which feeder is working best to attract goldfinches?" and more. Boy, have we learned a lot! This book is a reflection of our personal experiences and what we have learned from you.

The three of us are sisters. We grew up in northern Illinois and have lived and watched birds in Illinois, Minnesota, Missouri, and New Mexico. We have attracted birds in the mountains and on the plains, in the desert, and on a frozen lakeside. Anne owned the Wild Birds Unlimited store in St. Paul, Minnesota, for almost nine years and currently owns the same type of store in Santa Fe, New Mexico. Since 1991, Geni and Mary have owned and operated the Wild Birds Unlimited store in Albuquerque, New Mexico. We grew up hiking, fishing, camping, and developing a love of the out-

doors. As adults we all fell in love with backyard birding and have greatly enjoyed sharing the hobby with each other. We are thrilled to share it with you, too. We are confident that *For the Birds: A Month-by-Month Guide to Attracting Birds to Your Backyard* will help you do just that!

Most backyard birders don't realize that they can attract more than fifty different birds to their yard. Timing is everything. Different birds arrive at different times of year, and knowing what to do each month makes all the difference.

Our book starts with an overview of backyard birding basics. We review types of feeders, seed, and birdbaths and touch on the overall importance of habitat. Once you know the basics and the foundation is laid, the real guts of the book—the month-by-month guide of what to do—follows.

Each month of the year has its own chapter and follows the same easy-to-use format. When you flip to a particular month, you'll find a list of birds to look for and details on how to attract them. All birds require four things: food, water, a place to nest, and appropriate habitat. So each month we tell you how to attract the widest variety of birds by using those four things as guides. The food sections of the April and May chapters are full of hummingbird tips because that is when hummingbirds return. December's water section contains details of heated birdbaths, and July's nesting section tells you how to identify a baby bird who is as big as his parent.

Each month includes everything you need to know at that time to attract the widest variety of birds. Within each chapter, we highlight a kids' project—a fun and easy project for you to do with your kids or grandkids to help attract more birds. In a world where we are constantly plugged in to a TV, computer, cell phone, or iPod, these projects can help your family unplug and begin to enjoy the excitement of nature in your own backyard.

At the end of the book you'll find a section called Troubleshooting. There we detail how to best resolve common challenges faced by backyard birders. Dealing with too many squirrels, cats, House Sparrows, starlings, and more is covered. Some of you may need to refer to this section often.

For the Birds is easy to use and will work for you no matter where you live in North America. To identify birds, we suggest you use a good bird field guide as a companion to our book. Often we will refer to a general family of birds—for example, "woodpeckers like suet"—but a field guide

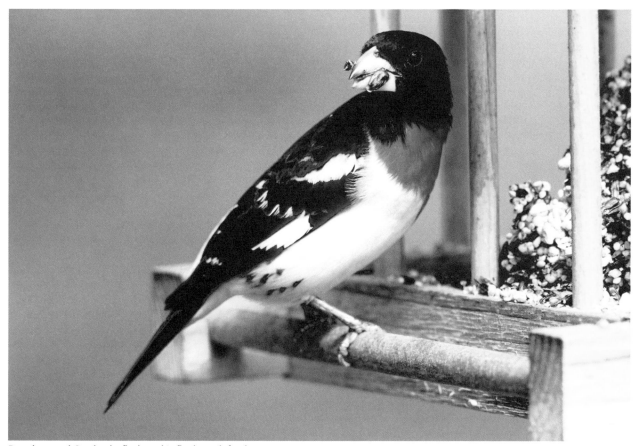

Rose-breasted Grosbeaks flock to this fly-through feeder.

will enable you to identify the specific species found in your area, say, the Ladder-backed Woodpecker. Our favorite field guide is *Sibley's Guide to North American Birds*. Sibley also has smaller field guides available in Western and Eastern versions. Many other good field guides exist on the market today. Spend some time looking at each one to see which you like the best. Ask the experts at your local bird store for their favorites, too.

We love watching birds in our backyards and are continually thrilled by this hobby. We hope that *For the Birds* helps you to enjoy your birds even more and brings you and your family closer to nature.

Happy birding!

Anne, Mary, Geni

for the
BIRDS

BACKYARD BIRDING BASICS

Attracting backyard birds is a great hobby enjoyed by millions. There are four things to pay attention to when considering how to bring more birds to your backyard: a nice variety of food, a steady source of open water, appropriate nesting boxes, and a dense native landscape. Backyard Birding Basics and each subsequent chapter of this book is broken down into these categories.

Most people try to attract birds with birdseed, but remember, not all birds eat seed. By providing other food sources, water, nesting spots, and an appealing backyard habitat, you can attract elusive, non-seed-eaters as well.

The importance of habitat to birds is often overlooked. As urban sprawl and other types of habitat destruction continue, the oasis you provide in your backyard becomes more important. Each month we urge you to copy nature by creating a native, bird-friendly habitat in your backyard. We suggest bird-friendly flowers, shrubs, and trees that provide birds' natural food, cover, and nesting opportunities.

By supplying a wide variety of food, water, nesting spots, and bird-friendly habitat, you will welcome a greater number and diversity of birds than ever.

An ever-changing variety of birds can be yours for the watching. Enjoy the show!

FOOD: BIRDSEED

COMMON BIRDS AT SEED

cardinals	chickadees	juncos
finches	thrashers	titmice
nuthatches	sparrows	Pine Siskins
towhees	jays	grosbeaks

All birdseed is not created equal. Walk into any grocery store or home improvement store and you will find birdseed of uneven quality. We are going to teach you what types of birdseed are available, what your backyard birds want—and, as importantly, what they don't want. Not everyone would be interested in eating at a restaurant that serves only one dish. We like choices and so do your birds.

Some birds prefer black-oil sunflower, while others want nyjer or millet. For that reason a good birdseed mix that includes several different seeds will lure a wider array of seed-eating birds to your yard. So we will review mixes before discussing individual seed types.

Birdseed Mixes
Good and Bad Mixes
Feeding a high-quality birdseed mix is the best way to attract the widest variety of birds to your backyard. Most of the birds that come to your feeder

Quick Seed Tips

- Black-oil sunflower is the seed preferred by the majority of birds.

- White millet is preferred by ground-feeding juncos, sparrow species, and towhees.

- Feeding a good-quality birdseed mix will attract the widest variety of birds.

- Avoid mixes that contain milo, rape seed, canary seed, and wheat. Birds don't like these seeds.

- Safflower seed is best used as a problem solver. Squirrels, House Sparrows, and blackbirds don't like it very much.

- Use different styles of seed feeders to attract a wider variety of birds—a nyjer feeder for goldfinches, a shelled peanut feeder for woodpeckers, and so on.

- Keep birdseed in a cool, dry place and don't buy more than a six- or seven-week supply at one time. Seed is perishable.

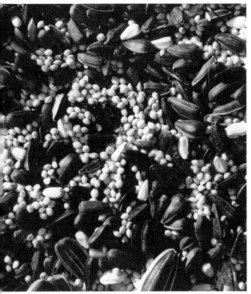
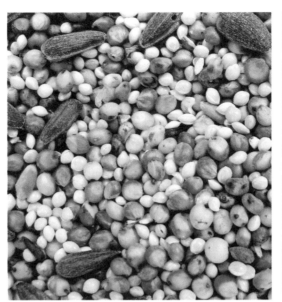

A good birdseed mix. A bad birdseed mix. A "no-mess" birdseed mix.

want black-oil sunflower, so black-oil should comprise at least half of your seed blend. The other half should be mostly (or maybe even all) white millet. Millet will be kicked to the ground, which is good because it is the favorite of ground-feeding birds. If your yard is heavily wooded, increase the percentage of sunflower and lower the percentage of millet. **More trees = more sunflower-eating birds.**

Not all birdseed mixes are formulated with the birds in mind. Some low-cost mixes are made purely for profit, without consideration of what birds want. Many contain seeds that the birds don't like, which are commonly called "fillers." The birds will just knock these seeds out of your feeder onto the ground. This causes a buildup of uneaten seed *and* unwanted sprouting because not even ground-feeding birds want the filler seeds. And some commercial mixes are as much as 70 percent filler seed. So a bag of birdseed that's cheap might not be a good value—it might just be mostly filler.

Common filler seeds include milo, wheat, red millet, rape seed, oats, and canary seed. Beware of the generic ingredient "grains," which is likely to be one or more of these. Always check the label on your birdseed blend for fillers before you purchase it. We recommend purchasing your mixes at a backyard-bird-feeding specialty store, where you are more likely to find high-quality mixes and where the seed is also usually fresh. Seed is perishable and can lose oil content if it sits on the shelf too long, making it unattractive to your birds.

If you are seeing mostly House Sparrows at your feeder, it's likely you are using a commercial mix. Improving your food offerings can increase bird variety. Be careful, however, about calling everything a House Sparrow. Often you may see an LBJ (little brown job) and assume it's the very common, non-native House Sparrow. Look closely, though, and it may be a different type of sparrow or another species altogether.

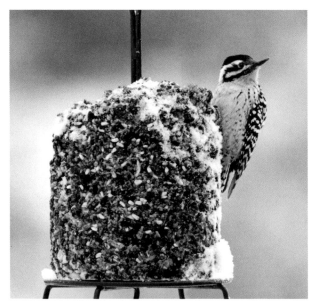

A Ladder-backed Woodpecker with a quality seed block.

No-Mess Birdseed Blends

No shells, no sprouting, no sweeping—a no-mess blend is the boneless, skinless, chicken breast of birdseed. It costs more, but it is pure food and easy to use. A good no-mess blend contains at least 50 percent sunflower chips (sunflower seeds without shells). Since most birds prefer sunflower, this is the most important ingredient. Most seed-eaters, including cardinals, siskins, grosbeaks, chickadees, and House Finches, will be happy eating chips.

This mix should also have at least 30 percent hullless white millet for ground-feeding juncos, doves, towhees, and sparrow species, and it can contain a little cracked corn for birds like quail. A small percentage of shelled peanuts may attract jays, nuthatches, and others.

If you don't want ground feeding but like the idea of a no-mess seed, then use only sunflower chips.

In our stores, no-mess is very popular in the spring and summer months, when many customers are willing to pay more to avoid the sprouting and mess that can come with regular birdseed.

When first feeding a no-mess blend or straight sunflower chips, mix in a little black-oil sunflower seed. Birds find food by sight and may not recognize shelled seeds as food, so by adding something they do recognize (black-oil sunflower), you can jump-start bird activity.

One caution about no-mess seeds: Without the protection of a shell, seeds can spoil more quickly, so don't put them in a large-capacity feeder unless your birds go through it quickly, especially if you live in a rainy climate.

Birdseed Blocks

We love these!

Seed blocks—often referred to as "vacation blocks" because they last so long—are our favorite way to feed seed to birds.

They last forever . . . at least one or two weeks feels like forever when you're used to filling your feeders every day.

One easy-to-remember rule of thumb: Your block should be mostly black, not yellow. Good-quality seed blocks are loaded with black-oil sunflower, peanuts, and sometimes dried fruit. If your seed block has a lot of millet or filler seed like milo, it won't last as long or satisfy your birds. Bell-shaped seed blocks often contain filler. These bells, typically found at hardware and discount stores, have tended to be low-cost and low-quality. We are just beginning to see higher-quality bells, containing more sunflower, emerge in the marketplace.

A good-quality block can attract cardinals, chickadees, nuthatches, woodpeckers, grosbeaks, House Finches, and others. We've even seen robins eat from our seed block containing cranberries. Good seed blocks are held together with gelatin and last well in

all climates. They can be placed on a tray or stump, or wedged in a tree, but they work best hung. Check your wild bird specialty store for seed-block hangers and high-quality blocks of various shapes and sizes.

Individual Seeds

Black-oil Sunflower

Preferred by cardinals, grosbeaks, chickadees, House Finches, nuthatches, thrashers, and titmice.

This seed is preferred by the majority of seed-eating birds. Contrary to popular belief, small birds love it despite its rather large size. (It's not necessarily true that big birds like big seed and small birds like small seed.) Black-oil sunflower seed packs a punch. It is high in fat to help the birds stay warm in winter and gives them the energy needed to raise their young in the spring and summer.

Watch small birds like chickadees and nuthatches grab a sunflower seed, hold it between their toes, and hammer at it with their beaks. Larger birds like cardinals and grosbeaks simply crack the shell with ease and dig in for more—and they do it with lightning speed.

Black-oil sunflower should be put in feeders above the ground because many birds who prefer it don't typically feed on the ground. Black-oil can be fed by itself or in a mix but should comprise at least 50 percent of any blend used in elevated feeders.

White Proso Millet

Preferred by sparrow species, juncos, towhees, doves, and buntings.

Ever notice how messy birds can be? Most of the birds that come to your elevated feeder want black-oil sunflower, and they kick everything else to the ground. White proso millet is one of these seeds that ends up getting kicked around. Don't get upset, though, because birds such as juncos, doves, sparrow species, and towhees will readily clean it up for you. In fact, these birds prefer to eat on the ground.

White millet is commonly found in birdseed mixes, or it can be fed by itself, sprinkled on or near the ground.

Safflower

Preferred by cardinals, grosbeaks, House Finches, titmice, chickadees, and nuthatches.

Are squirrels taking over your birdfeeders? Are House Sparrows or blackbirds monopolizing your bird food? Safflower to the rescue! Safflower is enjoyed by many of the same birds that prefer black-oil sunflower seed, and why not? Both are high in fat and provide a huge energy boost—especially helpful in the winter and during nesting season when your birds need more calories.

For some lucky reason, though, squirrels, House Sparrows, and blackbirds don't like it very much. If you have any of these challenges, try putting safflower seed all by itself in your above-the-ground feeders. Don't mix it with other seed—squirrels and blackbirds will just pick around it.

Reducing the number of squirrels, House Sparrows, and blackbirds at your feeders gives the birds you want a fighting chance. As a result, you may end up with a wider variety of birds. Safflower costs more than black-oil sunflower, but it usually lasts longer since the greediest animals leave it alone. One fabulous side benefit of feeding safflower? Cardinals love it!

Cracked Corn

Preferred by quail, pheasant, meadowlarks, and jays.

The birds that feed on cracked corn are limited, mainly ground-feeding birds such as quail, pheasant, and meadowlarks. We only recommend feeding cracked corn in a ground-feeding tray or scattered directly on the ground. Avoid birdseed mixes with a lot of cracked corn unless you are scattering the mix on

the ground or ground-feeding tray. White proso millet tends to be a better ground-feeding seed and is less vulnerable to spoilage than cracked corn.

Corncobs on a prong feeder are a fun way to attract jays and squirrels, for those of you who enjoy watching their antics. Occasionally woodpeckers will grab a kernel, too.

Striped Sunflower

Preferred by Northern Flickers, jays, and grosbeaks.

Striped sunflower used to be a favorite of birders many years ago before we knew that birds themselves prefer *black-oil* sunflower. Only a few species can crack the larger shell, and striped sunflower does not contain as much fat. Any birdseed blend should have no more than 10 percent striped sunflower content.

Sunflower Chips

Preferred by cardinals, chickadees, Pine Siskins, grosbeaks, House Finches, titmice, nuthatches, and thrashers.

Sunflower chips are simply sunflower seeds without the shell. They are the cleanest seeds to feed. The majority of birds that feed above the ground will eat them. And don't assume the birds will eat sunflower chips faster because there is no shell—in fact, you actually get more bang for your buck. Without the weight of the shell, you are paying for pure, edible seed.

Remember, birds find food by sight and may not recognize sunflower chips as a food source. By initially adding the more recognizable black-oil sunflower seeds (with shells) to your sunflower chips, you may help the birds discover the seed. Once the birds have found your feeder, it is no longer necessary to add the black-oil sunflower.

Nyjer Seed (commonly called Thistle)

Preferred by goldfinches and Pine Siskins.

Nyjer seed is grown in Southeast Asia. It can attract goldfinches and Pine Siskins that won't always come to your other seed feeders. We recommend feeding nyjer in a specialized finch or nyjer feeder, which is designed with very small holes or mesh that only accommodates this seed.

Because goldfinches and Pine Siskins tend to be a bit shy, we suggest hanging your nyjer feeder separate from other feeders. Choose a location that's out in the open, where finches can spot it; don't hide it under an awning or large tree. Placing your nyjer feeder near your birdbath may jump-start activity, too.

Because nyjer seed is imported and more vulnerable to spoilage, always buy it fresh and store it in a cool, dry place. In warm months, you may want to keep it in the refrigerator. The shelf life for nyjer is about eight weeks at room temperature, but much longer in the fridge. In your feeder expect nyjer to stay fresh for a month or so, less in rainy or very warm conditions. Typically, birds will eat the seed before it spoils, but if your nyjer goes uneaten for more than a month, throw the old seed away and refill the feeder. Nyjer will usually not sprout, but it does have a small shell that may accumulate under your feeder.

In-Shell Peanuts

Preferred by jays, Northern Flickers, and thrashers.

In-shell peanuts are fun to feed. We recommend raw, unsalted peanuts displayed in an open, freestanding tray or specialized in-shell peanut feeder. You can also sprinkle them on an outside shelf or stump. The jays, Northern Flickers, and thrashers that prefer the peanuts are larger, bold birds that are easy to see and provide lots of backyard entertainment. Watch for the jays to spend time picking just the right peanut and then bury it under a leaf. It's also fun to see the thrasher tear the shell apart with its large beak.

Black-oil sunflower

White proso millet

Safflower

Cracked corn

Striped sunflower

Sunflower chips

Nyjer Seed/Thistle

In-shell peanuts

Shelled peanuts

Once your jays begin to visit your in-shell peanut feeder regularly, try feeding them by hand. We've had many patient customers bring photos documenting the boldness of these jay birds.

Shelled Peanuts

Preferred by chickadees, nuthatches, woodpeckers, titmice, Bushtits, jays, and Brown Creepers.

Feeding shelled peanuts is a great way to attract nuthatches and chickadees, as well as birds like woodpeckers and Bushtits that may not usually come to a seed feeder. We recommend using a stainless-steel cage-type peanut feeder. Birds that eat shelled peanuts are mostly tree-clinging birds, so hang this feeder where the birds are . . . in a tree. You can also feed nuts in a tray feeder.

When first hanging your peanut feeder, mix some black-oil sunflower with the nuts. Birds might not recognize peanuts as a food source, but they will come for the sunflower and will soon figure it out.

Nuts are high in fat and provide the energy birds are looking for, especially in winter; they are also prone to spoilage, so store them in a cool, dry place away from squirrels—a metal storage can works well.

A Word about the Price of Birdseed

Seed is a commodity, so price is controlled by supply and demand. In recent years, all grain prices have increased significantly. Why? Petroleum and cooking oil.

Petroleum. We all know what has happened to oil and gas prices. The shipping cost for birdseed, which has always been steep, has followed the price of gasoline.

Also, as gas prices increase, so does the demand for ethanol made from corn. As more farmers switch from raising black-oil sunflower to raising corn in response to the high ethanol demand, fewer sunflower and other birdseed grains are grown. Less sunflower results in higher prices. Other birdseed grains are affected in the same way.

Cooking Oil. As more and more food manufacturers move away from partially hydrogenated oils toward natural oils like sunflower and safflower, a larger share of available sunflower is being bought up for the "crush market" to make cooking oil. Again, less sunflower for birdseed means higher prices. Also, the developing world is using more of its nyjer for cooking oil, which puts upward pressure on its price.

Since the market is heading mostly in one direction—up!—merchants who sell birdseed have several options. Some mass marketers have lowered the weight of their birdseed bags or have added more lower-cost filler seeds like milo and wheat to their blends. These tactics help to hide the cost increase but may not be good for you or your birds. As we say throughout our book, use a high-quality seed blend to get the widest variety of birds.

Here are a few seed-conservation ideas if the increased cost is hitting you hard.

- Although putting out some birdseed every day is important in attracting consistent bird activity, every feeder does not need to be filled every day. Once a feeder is empty, birds usually clean up any leftover seed on the ground.
- Feeding suet in multiple places offers another relatively inexpensive food source for birds.
- Add one or more good-quality seed blocks loaded with sunflower and nuts to your feeding station. They can be a bit pricey, but they last a long time, allowing you to cut way back on loose seed feeding.
- Plant native seed-producing flowers and put in trees and shrubs that produce berries. Providing more natural, fresh food allows you to cut back on seed and suet and not lose consistent bird activity.

Types of Seed Feeders

Place feeders where you can easily fill them, but most importantly, position them where you can easily see the birds!

Hopper Feeders

Pros:
- Can have large seed capacity
- Attract both large and small songbirds
- Can hang or pole mount
- Can be used to feed mixes or individual seed types

Cons:
- May have limited viewing of birds

Hopper feeders are generally made from wood and, more recently, occasionally from recycled plastic. They are sometimes referred to as house-type feeders. All hopper feeders have a hopper, which usually holds a large amount of seed. The quality and durability of hopper feeders can vary significantly. Avoid those that are held together with staples or wood glue. Feeders built with screws will last much longer. Make sure the feeder is designed so that when it is hung or mounted you can easily see the birds feeding.

Hopper feeders can attract large and small birds and can accommodate just about any seed or seed mix. Cardinals love hopper feeders because they usually have enough head room and a comfortable standing platform. Cardinals like elbow room.

Tray Feeders

Pros:
- Accommodate both large and small birds
- Easy viewing of birds

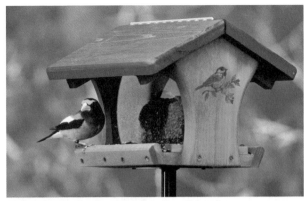

An Evening Grosbeak eating black-oil sunflower from a hopper feeder.

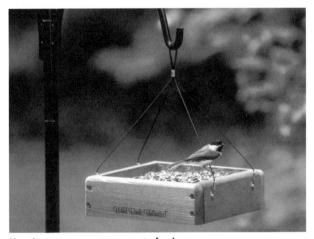

Hanging trays are an easy way to feed.

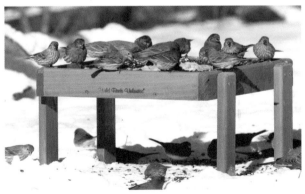

Ground trays welcome everybody.

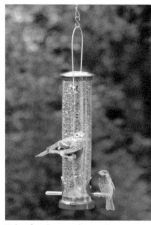

Tube feeders make seeing your birds easy.

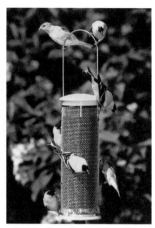

Goldfinches cling to wire mesh nyjer feeder.

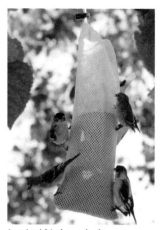

A nyjer/thistle sock also works well.

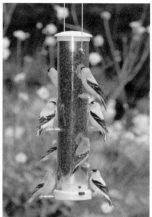

American Goldfinches at a tube-style thistle feeder.

- Less seed knocked out
- Often less expensive than other feeders
- Can be used to feed seed, in-shell peanuts, or fruit

Cons:
- Easy access for squirrels
- No weather protection
- Small seed capacity

A tray feeder, a four-sided tray with no roof, is probably the easiest way to feed birds. Because the seed is so visible, birds find tray feeders quickly, too. Trays vary in size, are usually made from wood or recycled plastic, and are designed for hanging or pole mounting. You can also add legs to create a ground feeder. An open tray can attract the widest variety of birds and can accommodate any seed or mix. Cardinals love a tray—again, lots of elbow room. A small hanging tray is a great starter feeder, low-cost and easy to fill.

Another type of tray feeder is a fly-through feeder. Essentially a tray with a roof, a fly-through is easy to use, welcomes a wide variety of seed eaters, and makes for easy bird viewing. The roof helps protect

the seed from the elements. Usually a fly-through is mounted on a pole or fitted with legs to become a ground feeder.

Tube Feeders

Pros:
- Large, protected seed capacity
- Easy viewing of birds
- Can attract larger birds by adding a tray
- Easy to hang
- Holds most seeds or seed mixes
- Durable

Cons:
- Without tray will usually only accommodate small birds

These feeders are usually made from plastic, PVC, or Lexan. They are fairly lightweight and easy to hang. Most tube feeders have perches where smaller birds stand to feed. Adding a tray to the bottom allows larger birds to use the feeder as well but has

a drawback because it provides a comfortable seat for squirrels. If the tray is very large, it may help catch seed knocked out of the tube.

Tube feeders are designed to make it easy for you to see the birds. And because birds find seed by sight, the clear tube often helps them find the feeders quickly.

We suggest feeding black-oil sunflower or a sunflower-heavy mix in a tube feeder. Don't feed nyjer in a general tube, as the large holes will allow sparrows and others to eat this expensive seed.

Nyjer Feeders

Pros:

• Attracts goldfinches and Pine Siskins
• Mesh style is discouraging to other birds

Cons:

• Seed is expensive (but eaten more slowly if used properly)

There are two types of nyjer seed feeders, the tube style with perches and the mesh style. Both are popular with the birds, but we highly recommend the mesh style. Mesh feeders are more effective at discouraging other birds like House Finches, who tend to monopolize finch feeders. Nyjer socks and stainless-steel mesh feeders both fall into this category, and both are easy to hang. Goldfinches are shy, so hang the feeder by itself, a bit out in the open, and near a birdbath to encourage these beautiful birds.

Goldfinches and Pine Siskins are also famously disloyal. If they disappear, keep trying—and keep your seed fresh. Don't be hesitant to dump out old seed after a month of inactivity and try again with fresh seed.

FOOD: SUET

COMMON SUET-EATING BIRDS

woodpeckers	wrens	nuthatches
Bushtits	jays	kinglets
chickadees	grosbeaks	

If you are not feeding suet, you are missing out on the easiest way to attract a wider variety of birds to your yard. Again, not all birds eat seed. By feeding suet, you can attract non-seed-eating birds like woodpeckers, Bushtits, nuthatches, wrens, and kinglets.

Suet is rendered beef kidney fat and is loaded with the calories birds need in colder weather and during the spring and summer nesting season. There are two general categories of suet: "fatty" (usually mixed with seed or nuts) and "no-melt" dough (usually mixed with grain products to prevent melting in warm weather).

Dozens of different suet varieties exist. Some have calcium added to help strengthen eggshells during nesting season. Others have added bugs to better entice woodpeckers. Fruit mixed in suet can sometimes encourage orioles. Plain suet with nothing added is often least attractive to squirrels, so it may be a

Quick Suet Tips

• Feed suet year-round.

• Use no-melt dough suet in warm weather.

• Mount suet cage to tree trunk or branches for stability.

• Store suet in freezer or refrigerator for freshness.

• When first feeding suet, teach birds to come by smearing the cage with a combination of peanut butter and birdseed. Sometimes birds don't recognize suet as food but do recognize seed. This should jump-start activity at your suet feeder.

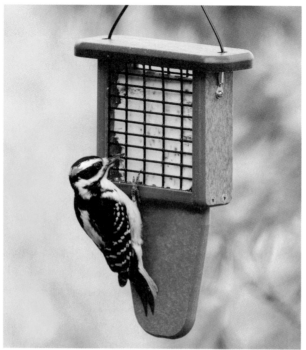

Suet feeding leads to a wider variety of birds, like this Hairy Woodpecker.

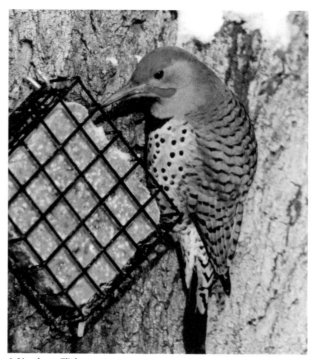

A Northern Flicker at a suet cage.

good problem solver if squirrels have discovered your feeder.

Suet ingredients will always be listed on the package. A good rule of thumb is to buy suet with only natural ingredients and no dyes or chemical additives. We usually use a fatty suet with nuts, but any high-quality suet will succeed in attracting most suet-eating birds.

Suet is most often sold in cakes—small bricks, usually under a pound, rendered to remove impurities. Most "flavors" of both no-melt suet dough and fatty suet come in cake size, packaged in easy-to-handle plastic. Non-rendered suet can be purchased in slabs from most meat markets and it works well, too, though it melts especially easily in warm weather.

Suet-eating birds are looking for insects in trees and bushes, so mount your feeder in a tree or bush. Instead of leaving it to hang free, nestle it in so it doesn't move when birds land on it.

Birds don't find suet in nature, so to help them recognize the suet as food, we recommend smearing peanut butter on the feeder and pressing birdseed onto the peanut butter. (The peanut butter is just the glue for the seed.) Seed eaters will come for the seed, and that activity will encourage suet eaters to investigate. Once the birds find the suet it is no longer necessary to use peanut butter and seed. Although suet can be quite odorous, birds can't smell, so they often need a visual prompt to find your suet feeder.

Be patient—it may take time for the birds to find the suet. If after two weeks there is no activity, replace the suet and move the feeder to a new location. You can store excess suet in your refrigerator or freezer to

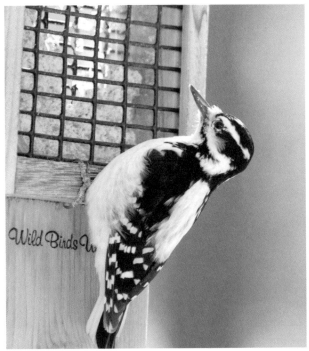

Tail-prop suet feeders are a favorite of woodpeckers.

A Ruby-crowned Kinglet at a log-style suet feeder.

maintain its freshness. Cold suet is also easier to get out of the package.

Types of Suet Feeders

Suet Cage

A suet cage is the easiest and least expensive type of suet feeder. For best results, we recommend mounting the cage up against a tree with a nail or mug hook. Woodpeckers prefer to feed on the suet up against the trunk, using the trunk as a tail-prop while they eat.

Tail-Prop Suet Feeder

These are wooden or recycled plastic suet cages with a lower extension specially designed to be used by woodpeckers as a place to prop their tails. These are intended to hang freely from a tree branch.

Upside-Down Suet Feeder

Suet feeders that allow birds to access suet only from the bottom discourage birds like House Sparrows and starlings, who don't cling very well. Woodpeckers, chickadees, and nuthatches have no difficulty hanging at odd angles for food. They do this naturally.

Suet Log Feeder

This is our favorite suet feeder and the most natural looking. It's a log with holes drilled in it to hold the suet. Suet "plugs" are available at wild bird specialty stores and are easiest to use in this feeder type. You can also break off chunks from a suet cake to fill the feeder. Suet logs are designed to hang from a tree branch. If your suet log offers no perching spots, it may help discourage starlings from monopolizing your suet.

FOOD: NECTAR

COMMON NECTAR-EATING BIRDS
hummingbirds
orioles

Hummingbirds and orioles love nectar! Proper placement of your feeder and providing fresh nectar are the keys to hummingbird and oriole activity. Change your nectar twice a week, whether the birds are coming or not. When they do arrive, you want them to find fresh food. This will entice them to become regular visitors.

Making your own nectar is less expensive and usually better for the birds. Often commercial mixes contain coloring, vitamins, or preservatives that the birds neither like nor need.

Hummingbirds and orioles begin arriving in early spring, so get your nectar feeders out in late March or April in the South and early May in the North. Feed hummingbirds late into the fall, until you haven't seen a hummingbird for two weeks. This is often as late as the end of October or early November. You may have heard that hummingbirds won't migrate south if you feed them too late. This is a common myth. Hummingbirds instinctively know to migrate by the length of the days, but they must reach a certain body weight to make the trip. Feeding hummingbirds late into the fall helps smaller birds get the energy boost they need for the long journey to Central or South America.

If you don't have luck attracting orioles by mid-June, you probably won't see them again until they are done nesting—typically August. Timing is important with orioles. Get your feeder out early, April in the South and May in the North.

Always hang nectar feeders separate from seed feeders. Nectar-eating birds shy away from the hubbub of activity often found at seed feeders.

Hummingbird Feeders

All hummingbird feeders will work. Providing fresh nectar every three or four days and placement of the feeder are the keys to lots of activity. Fill the feeder with a mixture of four parts water to one part sugar. Always bring the water to a boil to remove impurities and to help fully dissolve the sugar. Do not add food coloring. Also, don't get fancy with the sugar. No brown sugar, honey, or molasses—just use white table sugar, which most closely matches the nectar from flowers that hummingbirds eat naturally.

It is true that hummingbirds are attracted to red, so always choose a feeder with red on it. If your feeder has no red, tie a red ribbon to it. Hang your hummingbird feeder where you and the birds can see it. A tree with too many branches can obstruct visibility. Position it at least twelve inches down from a tree branch, porch edge, or overhang. Hummingbirds like room to maneuver.

Bottle Style
The bottle-style hummingbird feeder is the most common. It is a glass or plastic bottle with a red screw-on base with holes from which the hummingbirds feed. Bottle feeders hold six to seventy-two ounces of nectar. Don't buy one that holds more than your hummingbirds can drink in three or four days or you will be dumping out unused nectar. Hummingbirds love to perch, so choose a feeder with perches. Sometimes

Quick Nectar Tips

- Hang nectar feeders separate from seed feeders.

- Nectar recipe is 4 parts water to 1 part sugar.
 No food coloring. Bring to a boil, cool, and serve.

- Change nectar twice a week to maintain freshness
 and increase bird activity.

- Store unused nectar in the refrigerator for up to
 two weeks.

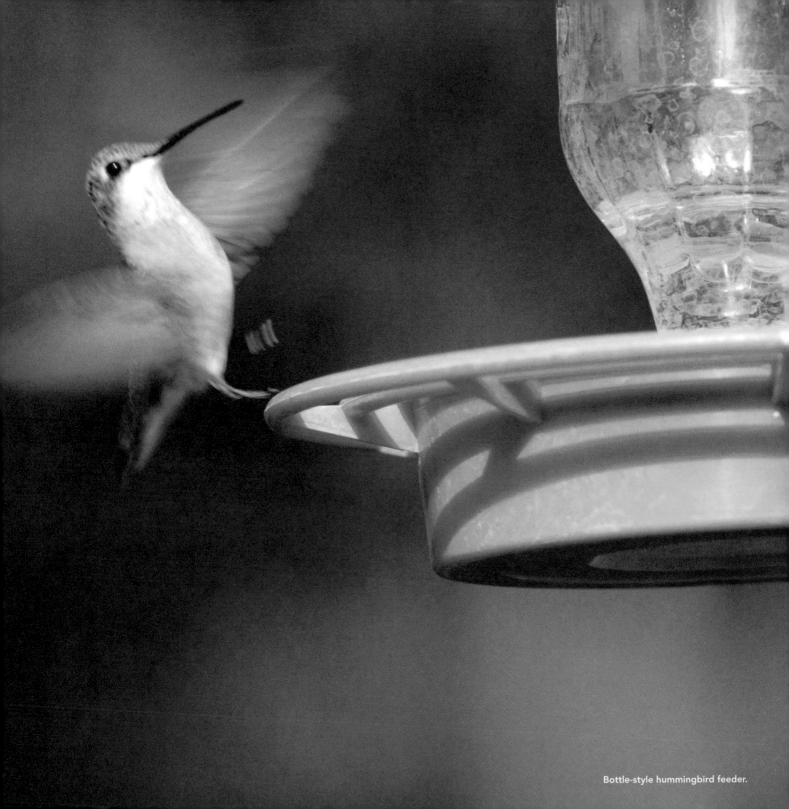

Bottle-style hummingbird feeder.

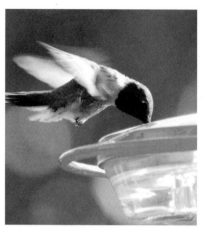

A Black-chinned Hummingbird enjoying nectar from a saucer-style feeder.

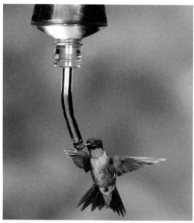

A Ruby-throated Hummingbird drinks from a decorative, but sometimes drippy, feeder.

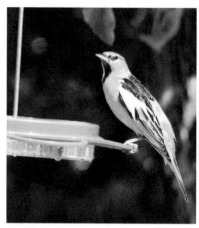

A Bullock's Oriole using a saucer-style oriole feeder.

pesky House Finches and sparrows will sit on the perches and steal the sugar water. If this becomes a problem and keeps hummingbirds away, try to find a hummingbird feeder with removable perches.

Saucer Style

Our favorite hummingbird feeders, saucer-style feeders are easy to clean, drip-proof, and bee-proof.

Hummingbirds' tongues are as long as their beaks, so they can easily reach to the bottom of saucer-style feeders to lap up the nectar. House Finches and sparrows cannot usually drink from saucer-style feeders because of their large beaks.

Decorative Hummingbird Feeders

Although hummingbirds will use decorative feeders, many of these feeders are not very functional. They often drip and are very fragile. So, consider both form and function before you buy one.

Oriole Feeders

Orioles drink the same four parts water to one part sugar solution that hummingbirds do. Some experts recommend a five-to-one ratio for orioles—that's okay, too.

Oriole feeders are usually orange because that's the color that attracts these birds. Because orioles are large birds with large beaks, oriole feeders need larger holes and perches than hummingbird feeders have. Hummingbirds can often use oriole feeders, but orioles cannot use most hummingbird feeders.

In addition to fresh nectar, placement of the feeder is important. Orioles perch high in the tree tops. Give them a reason to come into your yard by hanging your feeder in the open where they can see it from above.

Because birds need water every day, they are always looking and listening for a fresh source, especially during migration when they are on the move. The sound of moving water can help the orioles find your yard. Hang your feeder near your moving water or birdbath.

Timing is also important. Orioles arrive in early spring and migrate south by late fall. Get your oriole feeder out in April in the South and in May in the North to encourage early migrants and enjoy these beautiful birds all summer long.

FOOD: FRUIT

COMMON FRUIT-EATING BIRDS

robins	grosbeaks	tanagers
cardinals	orioles	waxwings
mockingbirds	House Finches	woodpeckers

Providing fruit can attract species like robins, tanagers, orioles, and mockingbirds that would not normally come to your seed feeders. Proper placement of your fruit is the key to attracting these birds to your yard.

Always display fruit separate from your seed feeders and near your moving water or birdbath. All birds need water and will be more likely to find the fruit while at your water. Always keep fruit fresh.

Types of Fruit

Grape Jelly

Preferred by orioles, robins, and grosbeaks. Orioles love grape jelly, which can be displayed in a dish near the oriole nectar feeder. One fun, easy way to feed grape jelly is to cut an orange in half, scoop out the fruit, and use the orange "cup" to serve jelly to your orioles. Skewer the orange halves to tree branches near your nectar oriole feeder. If you'd rather feed another flavor of jelly, go ahead—your orioles won't mind. Most people use grape because it's often less expensive.

Quick Fruit Tips

- Fill orange halves with grape jelly and stake on dead tree branches.
- Display dried rather than fresh fruit in extreme temperatures.
- Place fruit feeders near moving water or a birdbath.
- Keep fruit fresh.

Orioles eating a smorgasbord of jelly, oranges, and nectar.

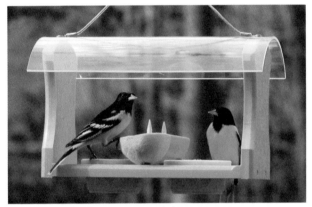

Baltimore Orioles dining on orange halves.

Dried Fruits

Raisins, cherries, cranberries, and blueberries are preferred by robins and waxwings. Display them in a dish on or near the ground near moving water or a birdbath. Dried fruit can easily be fed year-round. This can be a pricey but rewarding addition to your bird buffet. Try to find dried fruit without added sugar; it's better for the birds.

Orange and Apple Halves

Preferred by orioles, woodpeckers, tanagers, and cardinals. Display the fresh fruit on a prong fruit feeder or secure the fruit halves (cut side up) to branches near moving water or a birdbath.

FOOD: MEALWORMS

COMMON MEALWORM-EATING BIRDS

bluebirds	wrens	Gray Catbirds
thrashers	House Finches	American Robins

Okay, feeding mealworms may not be for everyone. Some people are a bit squeamish about touching the live worms and keeping them in the refrigerator. We shake the live mealworms directly into the feeder to avoid touching them. There are two types of mealworms, though, live and roasted or dried. So if the former makes you uncomfortable, you could choose the latter.

Live Mealworms

Feeding live mealworms is the best way to attract bluebirds. Keep your stock of worms in the refrigerator for up to two weeks. Since the worms can crawl away when you put them out, place them in a slippery-sided mealworm feeder or a plastic or glass dish from which they cannot escape.

Birds are attracted to the movement of the live worms, so put them where your birds will see them. Try a spot near your moving water or birdbath, because all birds need water and they may discover the mealworms when coming to drink or bathe. Don't expose live mealworms to intense, direct sun or freezing temperatures, which can kill them. The best time to

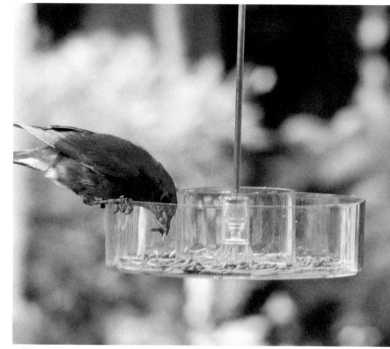

A bluebird at a mealworm feeder.

feed live mealworms is in spring and summer. Nesting birds love to bring them back to the nest to feed their young. A high-protein, slimy treat!

Roasted/Dried Mealworms

Because roasted/dried mealworms are already dead, they are not affected by exposure to direct sun or freezing temperatures and can easily be fed year-round.

These worms won't provide a visual cue by wiggling around, so it often helps to mix them with dried fruit and place them near moving water or a birdbath to help the birds find them. Robins, mockingbirds, and waxwings will discover the mealworms while eating the fruit or bathing.

Watch your adult birds bring their young to your mealworm feeder all summer long.

Quick Mealworm Tips

- Use dried or roasted mealworms in freezing or extremely hot temperatures.
- Place mealworm feeders near moving water.
- Place live mealworms in a slick-sided open dish.
- Store live mealworms in the refrigerator.

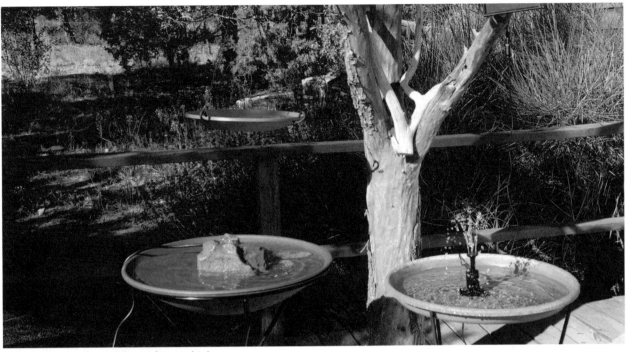

Provide a variety of water choices for your birds.

WATER

COMMON BIRDS AT WATER

Everybody! Including:

robins	tanagers	hummingbirds
orioles	warblers	
waxwings	mockingbirds	

Ever notice how birds just magically show up when you turn on your sprinklers? The robins hop around your yard waiting for worms to come up to the surface. Hummingbirds fly through your hose spray; sparrows and finches dance through the rain you've created.

Not all birds eat seed, but all birds love water. After all, they need it every day. Adding water is the single most important thing you can do to increase your bird variety. Add a birdbath and double the variety of birds in your yard. Make that water move and double it again. If possible, provide water in many areas of your yard using different styles of birdbaths at different heights.

Quick Water Tips

- Shallow is better. Use a birdbath no more than 2 inches deep.
- Change water daily.
- Provide water year-round with a deicer in winter.
- Add a dripper or bubbler to get your water moving.
- Place your birdbath where you can see it!
- Look especially for non-seed-eating birds at your birdbath.

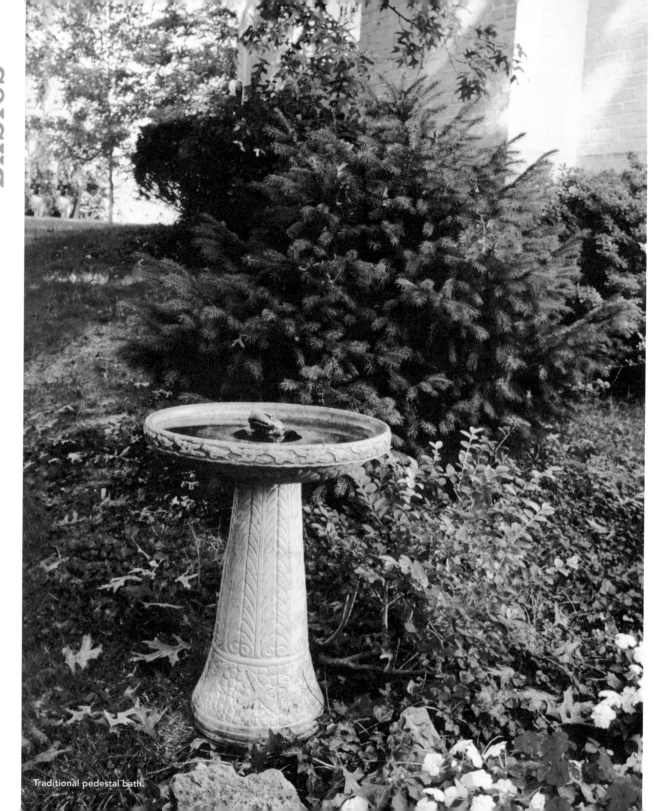

Traditional pedestal bath.

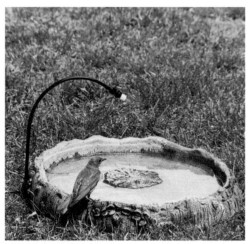

Ground bath with dripper.

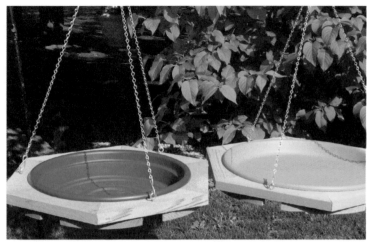

Hanging bird baths.

Types of Birdbaths

Pedestal Birdbath

The most traditional looking bath. Usually a two-piece birdbath, with a top and pedestal. These can range in height but usually stand about thirty-six inches tall. They can be made out of concrete, granite, plastic, resin, fiberglass, or metal. If your birdbath is made from ceramic or concrete, bring it in during the winter if you live in an area where freezing occurs.

Ground Birdbath

These are baths that sit on or very near the ground. Ground baths are popular with the birds because birds get their water on the ground in nature (think puddles and creeks). However, if your yard is visited by cats, this type of bath may not be as safe.

Hanging Birdbath

These baths are designed to hang from a tree, overhang, or pole and are the safest from cat attacks. They are also the least bird friendly. Birds just aren't used to finding their water hanging in midair. Sometimes putting a rock sprinkled with seed in the bath will teach your birds that the hanging bath is a good place to visit. If the bath has an outside flat rim, sprinkle seed on it, too.

Not all birdbaths are designed with the birds in mind. Sometimes a customer will complain about a bath from which birds drink but in which they won't bathe. Often we discover the bath in question is five or six inches across, with steep sides—way too narrow for birds to bathe in. If a bath is at least twelve inches across, birds can both drink and bathe. Some of our customers have used upside down-garbage can lids for a birdbath. This can work, but don't be surprised if the birds are spooked by the shiny metal surface on a sunny day.

Birdbath Tips

Always use a shallow bath that is no deeper than two inches. Young or small birds can drown in deeper water. If your existing bath is deeper than two inches, place some rocks in the dish to create a better bathing area for your birds.

When bathing, birds prefer to move gradually into the water to check for depth. A birdbath with sloped sides will be more bird friendly than a steeper drop-

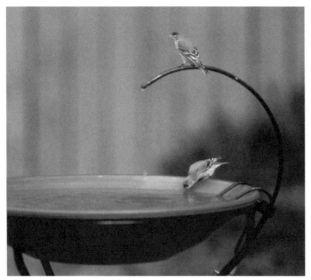

Birdbath with an attached dripper.

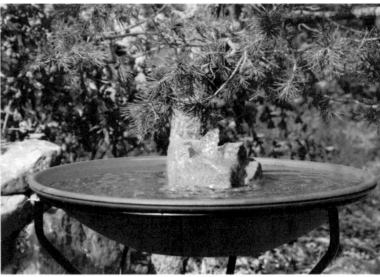

Birdbath with a rock bubbler.

off into the water. Think about the gentle incline of a natural stream.

A birdbath with a rough surface also helps the birds get a secure foothold. Consider the surfaces nature provides. For instance, a shallow creek with a sandy, rocky bottom is very bird friendly. Copy nature by duplicating rough and shallow with your choice of baths.

Watching your birds splash in the water is fun, and watching them groom after their bath can be a real treat. The best way to encourage your birds to stick around is to stick dead tree branches into the ground next to your bath. Again, this is a way to copy nature. Birds will often perch on a nearby branch to groom, rather than fly into a tree where they are hidden from you. Hummingbirds love to sit and groom on smaller twigs positioned against the bath. Sometimes laying a branch across your bath helps attract more birds, too.

Birds find water by sight and sound. If the birds are not using your bath, it may help to put a rock in your bath sprinkled with birdseed. Birds will see the birdseed and more quickly discover the bath.

Always put your birdbaths in visible places where you can enjoy them most. Birds need fresh water daily, so make sure your bath is located where you can fill it easily.

Types of Moving Water

Why are birds so attracted to a babbling brook? Moving water can make all the difference in attracting a wider variety of birds to your yard. Birds not only see the water but they hear it, too. Moving water is a bird magnet and will pay off most during the spring and fall migrations, when the greatest variety of birds is coming through your backyard.

In addition to all the seed eaters you'll see during migration, watch for robins, warblers, orioles, tanagers, and hummingbirds drawn by your moving water. These are birds you won't attract with seed; water and habitat are the keys.

Adding a source of moving water to your bath will

Recirculating Pumps

We love these—they are by far the most attractive to birds. They create water movement and the sound that birds find irresistible.

Most submersible pump units can sit in any birdbath, even the under-two-inch-deep baths we recommend. The bubbling sound and splashing they create is what attracts the birds. These pumps do require electricity, so use a good outdoor-quality extension cord. Keep the pump fully submerged so it does not become dry and burn out. When refilling your bath every day or two with your hose, give your pump a quick rinse.

Watch goldfinches and hummingbirds dive into the top of the bubbler while the water washes over them.

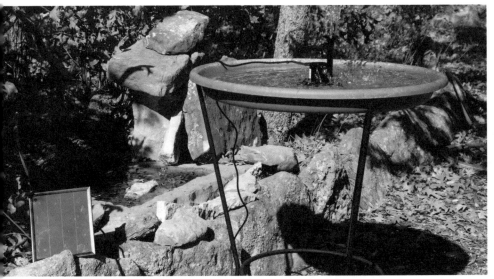

Birdbath with a solar pump.

take a little extra time and expense, but the payoff is well worth it. It is the single best way to attract a wide variety of birds.

Misters and Drippers

These devices are designed to work with any birdbath. They connect to your outside water spigot and a valve allows you to create a drip or mist of water into your birdbath. A dripper attaches to the edge or sits in the middle of the bath. You can adjust the flow so it keeps your bath full and fresh without overflowing. Drippers usually use about one gallon of water every four hours.

Misters spray a fine mist of water into your birdbath. They work best if positioned above the bath in tree branches, allowing the leaves to get wet and drip into your bath. Hummingbirds, Verdins, warblers, Bushtits, and other small birds will often fly through the mist or "leaf bathe" on the wet leaves. Hummingbirds *love* misters! Misters use about one gallon of water every hour.

Solar Pumps

Solar pumps are perfect if you do not have electrical access in your yard. Like electric pumps, they recirculate the water, but they have a solar panel to provide power. They are fairly low maintenance, but they will only work in full sun. They can burn out if they are not submerged in water.

Birdbaths with built-in solar pumps are also available. The technology of solar bath products has come a long way and still isn't perfect, but it is a nice option.

Ponds

Some ponds are bird friendly, others are not. Birds are looking for shallow water. Deep ponds may allow the birds to drink, but are too deep for bathing. Again, copy nature. A natural pond is very shallow at the edges and deeper in the middle.

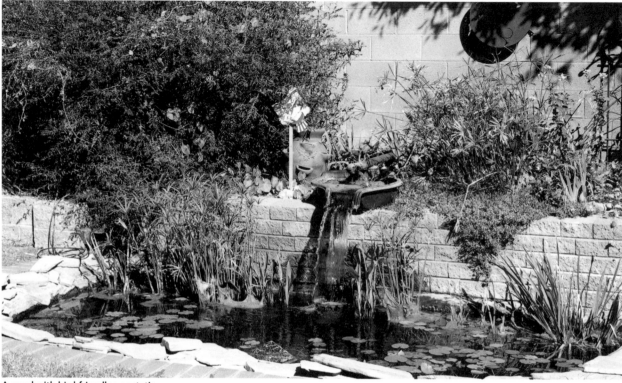

A pond with bird-friendly vegetation.

If you install a pond, make sure there are plenty of shallow areas no more than two inches deep to encourage the birds to bathe.

Ponds require much more maintenance than a simple pump unit or dripper but can be a real haven for wildlife. Depending on where you live, watch for everything from robins and ducks to deer and fox to visit your pond.

Water in Winter

Birds need water year-round and winter is the toughest time to find it. Eating snow is not a viable, long-term option for birds. They need fresh water for bathing as well as drinking. The cleaner the bird, the warmer the bird, so birds bathe often in cold weather.

Every time birds bathe, they reinsulate their feathers from the cold. Clean feathers more easily puff up and hold in warm air.

It may send shivers up your spine watching flocks of robins, bluebirds, starlings, and cardinals splash in icy cold water, but it is essential to their survival.

The easiest way to keep your birdbath ice-free is to use a birdbath deicer. These are electrical units that sit in any birdbath or pond. Some deicers are powerful enough to keep water open in ponds of up to six hundred gallons. Water and electricity usually don't mix, but these are very safe. Deicers have long been used to keep water open for cattle and other farm animals and have a reliable track record. Always read and follow the manufacturer's guidelines.

Birdbath with a deicer.

Birdbath with a built-in deicer.

Deicers keep water above freezing, but don't worry. The water won't get warm. Some have built-in thermostats that automatically turn the units on and off so they are only on when they need to be.

You can also buy birdbaths with built-in deicers. Whether built in or placed in the bath, deicers use very little electricity, even in bitter cold climates.

If you enjoy watching the birds at your bath in the summer, why not enjoy them year-round?

Cleaning Your Birdbath

Bird droppings can spread disease among birds, so it is important to change the water in your birdbath daily. During summer months you will see more algae growing in the water, but don't worry. It won't hurt the birds. The best way to clean the bath is with a solution of one part bleach to ten parts water every two weeks. Scrubbing with this mild bleach solution will kill harmful bacteria and algae. Rinse thoroughly afterward, though, as bleach can be deadly. A vinegar-and-water solution (two capfuls of vinegar to one cup water) is also a good option. Again, rinse well. There are also natural enzymes available that can be put in your bath or pond to control algae and lime buildup. You can usually find these products at your local wild bird specialty shop.

NESTING

COMMON CAVITY-NESTING BIRDS

chickadees	wrens	bluebirds
owls	swallows	starlings
nuthatches	flycatchers	finches
kestrels	sparrows	woodpeckers

Whether using a nesting box or building a nest out in the open, birds raise their young in spring and summer. Birds can nest in peculiar places. Customers have brought us photographs of hummingbirds nesting on top of wind chimes and barn swallows and phoebes nesting on porch light fixtures. House Finches love to nest in decorative wreaths.

Birds also use interesting nesting materials. Finches, flycatchers, and sparrows love to use animal fur to line their nests. Hummingbirds will sometimes use wool, and orioles will steal knitting yarn to weave their nests with.

It is not necessary to put nesting material in a box. Birds prefer to do their own decorating. Watch your backyard birds grab twigs, leaves, pine needles, fur, and grasses and carry them off to build their nest. Place pet fur, hair, and yarn in a netting bag hung from a tree or just leave it on the ground to give easy access to nesting birds.

Two No-Nos:

• Don't use dryer lint—it can disintegrate in the rain, causing the nest to collapse.
• Never use long pieces of yarn. Cut yarn in short three-inch pieces to avoid the birds' babies becoming entangled.

Watching birds nest and raise their young can be fun . . . and, at times, heartbreaking. Remember, birds have a high mortality rate. Birds may abandon a nest, or you may witness predators such as, jays, crows, or snakes attacking the nesting birds. This is nature at its best and worst. Many birds have several broods in the spring and summer nesting season to ensure that some of their young survive.

Not all birds are willing to nest in birdhouses. Many prefer to build their nests in trees, shrubs, and even on the ground. Of those who will, some want a house that hangs, and some want a house securely mounted.

Quick Nesting Tips

• Display your nesting box separate from seed feeders in a protected area.
• Clean out the nesting box at the end of nesting season.
• Keep the box out all year.
• Some birds will roost in the box in winter, but not all birds use nesting boxes.

When purchasing a nesting box, make sure it is appropriate for the birds in your area and properly constructed. Don't assume that your local hardware store will sell you the right nesting box for your area. Check with your local backyard-bird-feeding specialty store for the most accurate information and products that will work for your area birds.

A few specifics: Small birds like chickadees, nuthatches, titmice, and wrens live throughout North America. These smaller birds prefer a box with a four-inch-square interior (floor and ceiling), with an entrance hole about an inch and a quarter in diameter, approximately six to eight inches above the floor of the box. The boxes can be hung or mounted securely in a tree or on a pole from five to six feet above the ground.

Larger flickers, kestrels, and screech-owls require much larger accommodations. These birds also live across North America. The interior of their box (the floor and ceiling) should be eight inches square, with an entrance hole two and a half to three inches in diameter about nine to twelve inches above the floor of the box. Because of their size, these boxes should be firmly mounted on a tree trunk or pole between ten and thirty feet above the ground.

You'll find bluebirds of different varieties throughout North America. They like a house with a five-inch-square interior (floor and ceiling), and eight inches deep from top to bottom. A bluebird entrance hole should be an inch and a half in diameter and six inches from the floor. The box should be mounted five to ten feet above the ground. More in-depth bluebird house information follows shortly.

If you don't have the right habitat for bluebirds, though, don't waste your time and money with a bluebird box. Similarly, if you do not have Purple Martins in your area, installing a large, expensive, multiholed apartment house will only encourage non-native House Sparrows.

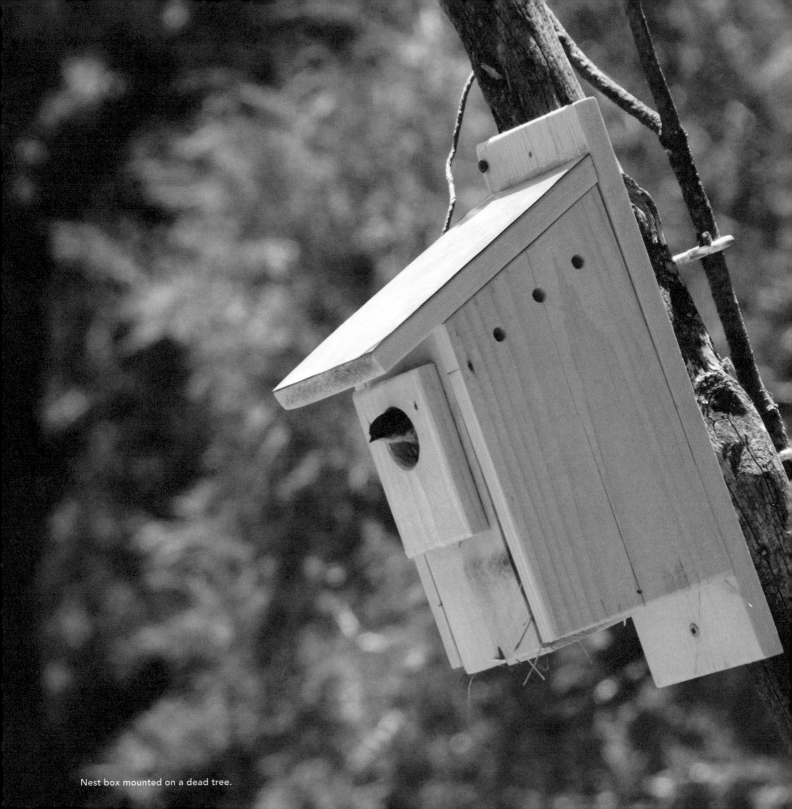

Nest box mounted on a dead tree.

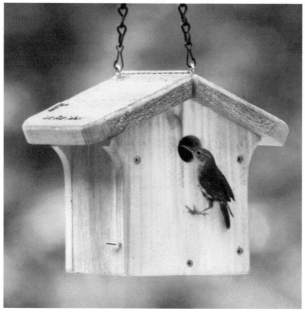

The wren comes home to his nesting box.

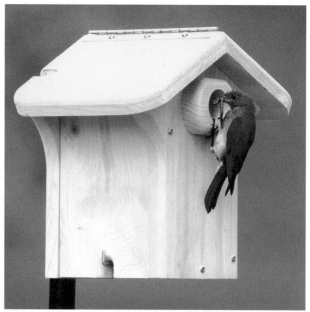

An occupied pole-mounted bluebird box.

Things to Look for in a Good Nesting Box

- The box should be constructed with correct dimensions and entrance hole size for the birds you hope to attract.
- Never use a nesting box with a perch. Birds do not need the perch and it allows easier access for predators.
- Natural, renewable, unpainted wood or recycled plastic is the best material for your birds' house.
- Correct thickness of wood is important to insulate the box against both cold and extreme heat.
- Boxes should have drainage and ventilation holes.
- An overhanging roof can help keep babies dry in a rainstorm.
- Birds do not clean up after themselves, so the box should have a panel that opens for easy cleaning after the nesting season. Most birds want to move into a clean house.

- Always place your nesting box in a private location away from your feeding area. Birds want a safe place to nest.

Hanging Nest Boxes

Hanging boxes are usually small in size, and the entrance hole is no larger than one-and-a-half inches. These boxes most commonly accommodate chickadees, nuthatches, sparrows, finches, titmice, and wrens. When hanging the box, make sure it is protected from the wind (and that the opening faces away from the wind). If possible, try to wedge it between branches so it will not swing too much. Remember, eggs are fragile, so choose a safe spot and use a strong hanger.

Mounted Nest Boxes

Mounted boxes vary greatly in size and entrance-hole diameter. Make sure you buy the right box for

the birds in your area and that you install it properly. Woodpeckers, kestrels, owls, and Wood Ducks prefer a nesting box mounted at least ten feet high on a tree trunk. Bluebirds, swallows, and flycatchers prefer boxes mounted about five feet high in a more open area.

If after two spring nesting seasons birds have not used your nesting box, move it to a new location. Always make sure you have the right box for your local birds. It is also important not to disturb your nesting birds, whether in a nesting box or a nest built in a tree or shrub. Enjoy them from a distance.

Most nest box activity will be in spring and summer; however, birds will roost in nesting boxes in winter to stay warm. All birds need shelter from the cold. In winter months it may be helpful to put out a roosting box. These are often larger boxes with one or more entrance holes at least one and a half inches in diameter, big enough to allow smaller birds such as chickadees, finches, and sparrows easy access. Built-in perches inside the box allow many birds a place to roost. Roosting birds will often huddle together for warmth—you have probably noticed birds perching close to each other on power lines in winter.

Larger nest boxes, such as flicker boxes, with entrance holes of two-and-a-half inches can also be used as roosting boxes and will accommodate larger birds such as flickers, kestrels, and screech-owls. Watch your boxes at dusk and dawn to see if there are any overnight guests.

Attracting Bluebirds

Bluebirds need manmade nesting boxes, and habitat is the key to a successful bluebird box. They usually have two or three broods per season and build a nest made mostly of grass. Bluebirds want open, rural countryside with a few trees and sparse ground cover. If you live in this type of country, you can attract them. You might also find successful bluebird boxes on golf courses, cemeteries, or the open meadow section of a park.

Bluebirds saw a dramatic decline in population during the mid-twentieth century, and their comeback is a real success story. Habitat destruction due to farming and urban sprawl destroyed the dead trees in which bluebirds liked to nest. Concerned birders figured out what type of houses might work for bluebirds and spread the word. Before long, birders all over rural North America began putting out bluebird boxes and the birds' slow, steady resurgence began. Today, in large part because of these efforts, bluebird populations are strong, but they remain fairly dependent upon manmade housing.

• Mount your bluebird box on a pole with the entrance hole about five feet high and facing away from prevailing winds. Face the entrance hole toward possible perching spots, like a wire or a tree branch, so your bluebirds and their babies can easily perch to search for food.

• If you put out more than one bluebird box, Eastern Bluebird boxes should be 100 to 150 yards apart. Western Bluebirds have a larger territory, so their boxes should be at least 300 yards apart. The exception to these distance rules is if you have an abundance of Tree Swallows, which can take over single bluebird boxes spaced far apart. To avoid this, boxes can be placed in pairs five to twenty-five feet apart to lessen competition. If a Tree Swallow nests in one such box, the other nearby box will be left open for bluebirds, as Tree Swallows typically don't nest within twenty-five feet of one another.

• Monitor your bluebird box closely. If you see House Sparrows making a nest, remove and discard it.

- Don't place bluebird boxes where pesticides are heavily used.
- After setting up your bluebird box, be patient. It might take several years for bluebirds to find your house. Once they do, they usually return year after year.
- Bluebird eggs and babies are vulnerable to predators. If raccoons or snakes are possible predators in your area, place a raccoon baffle on your pole and a snake guard over the entrance hole. Most snakes love eggs and can easily crawl up a pole or post.
- Bluebirds and their babies love to eat mealworms. Feeding live mealworms might attract them to your yard and help them find your box.
- In many rural areas of the South and Southwest, bluebirds will overwinter. Customers commonly report seeing flocks of them at birdbaths and mealworm feeders. Check your field guide to see if bluebirds overwinter in your area.

HABITAT

COMMON BIRDS IN A NATURAL YARD

cardinals	finches	mockingbirds
tanagers	towhees	waxwings
robins	grosbeaks	and many more
orioles	juncos	

If you were a bird, would you want to hang out in your yard? Are natural food, water, shelter, and nesting sites available? These are the things birds are looking for. You will see more birds in overgrown woods than on a manicured lawn. Some neighbors who like a well-manicured backyard may not appreciate your overgrown, native, bird-friendly yard; keeping trees and shrubs that hang over into a neighbor's yard well trimmed may go a long way toward keeping the peace. Sometimes, on the other hand, new customers in our stores are jealous of all the birds their neighbors get in an overgrown yard and "want good birds, too!"

We tell them to follow their neighbor's example and copy nature.

Birds enjoy feeding from your seed and nectar feeders, but for survival they rely on natural food sources. When planting, choose a variety of native, bird-friendly plants—like coneflowers, sunflowers, hollyhocks, and native grasses—that will provide cover and a natural food supply all year. In summer and fall, watch as acrobatic, beautiful goldfinches, grosbeaks, and cardinals cling to these plants eating the seeds.

In summer, you can lure nectar-eating hummingbirds and orioles to your yard with penstemon, red-hot pokers, trumpet vine, and honeysuckle. In the fall and winter months, look for flocks of hungry waxwings, robins, and solitaires gobbling up the berries from your mountain ash, mulberry, pyracantha, holly, hawthorns, and Virginia creeper.

Don't be too quick to cut back the seedheads in your garden. Wait until the birds have eaten all the dried seeds. Consider leaving the plants through the fall and waiting until spring instead. Birds will use the dried plants as cover from predators and protection from cold weather. Remember, nobody rakes, prunes, or sweeps the forest.

A variety of flowers, shrubs, and trees is best. Evergreens provide dense cover for birds all year long.

Uncle Charlie's Cabin

Early on in Anne's store in St. Paul, Minnesota, a customer requested a particular brand and size of tube feeder. She didn't carry the *exact* feeder, because she knew it was poorly made, but she did carry an almost identical one made of stronger materials. Despite the fact that the birds would not know the difference, this customer insisted upon that particular feeder because he had seen a huge variety of birds eating from it while visiting his Uncle Charlie's cabin. This feeder hung in the woods outside the window of a cabin surrounded

by wilderness. Anne is not sure she ever convinced this bird lover that it's the habitat—not the feeder!

Using an appropriate variety of feeders is great, but a manicured, city backyard will never attract the variety of birds found in the woods and wilderness. When we take away natural habitat, we reduce bird species. Habitat destruction due to sprawl or the draining of wetlands is a key contributor to declining bird populations. Creating an overgrown, native habitat in your backyard not only helps you to attract a wider variety of birds, it makes a little progress toward keeping our world green.

Remember, copy nature. Check with your local nursery and backyard-bird-feeding specialty shop for information or services offered to help you naturally attract the widest variety of birds to your yard. Our stores will send a master gardener who is also a certified birdfeeding specialist to your home to advise you on bird-friendly native plants and feeder placement to help you attract the widest variety of birds all year long. Check your local wild bird specialty store to see if they offer the same service.

It doesn't get any better than this.

Quick Habitat Tips

- Natural is better.
- Native flowers and berry-producing plants and shrubs are bird-friendly.
- Plant for year-round food sources for your birds.

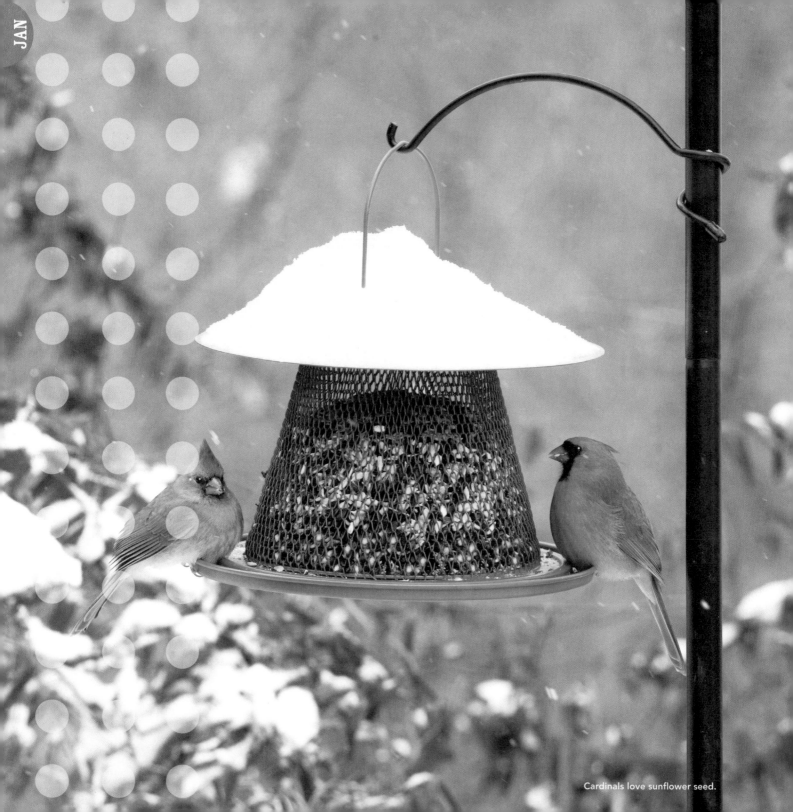

Cardinals love sunflower seed.

Birds to Look For

JANUARY is the perfect time for you to relax and enjoy your backyard birds after the busy holiday season. While you are slowing down, you may notice your birds are not. In fact, they are quite busy. Winter has settled in, and most of your birds' natural food sources have been depleted. Even if you don't have snow and cold, food can be scarce for birds, so provide them with plenty of food options.

Whether your winter is bitter cold and snowy or mild and sunny, your birds will appreciate a high-calorie seed mix loaded with black-oil sunflower. They'll also love high-fat foods such as suet and peanuts.

Not all birds migrate to warmer climates. Sunflower-eaters like chickadees and nuthatches are permanent residents, even in bitter cold regions. For those of you in the Midwest, East, and South, sunflower-loving cardinals will stick around, too. Woodpeckers stay put and will appreciate a steady source of suet. Jays are also permanent residents and love peanuts.

Two birds that are seen throughout the country *mostly* in winter are juncos and Pine Siskins. Juncos spend warmer months in Canada and Alaska and winters throughout the United States. (Imagine flying south to Minnesota for the winter!) Watch for juncos eating millet on the ground. Pine Siskins are likely to be seen at your nyjer feeder.

(found in most regions unless otherwise noted)

Evening Grosbeak (North and West)
Yellow-rumped Warbler (West Coast, Southwest, and East)
Dark-eyed Junco
Brown Thrasher (Southeast)
Purple Finch (Eastern half of U.S.)
Red-breasted Nuthatch
White-crowned Sparrow (Southern half of U.S.)
Black-capped Chickadee (Northern two-thirds of North America)
Carolina Chickadee (Southeast)
Mountain Chickadee (West)
White-breasted Nuthatch
American Goldfinch
Lesser Goldfinch (Southwest)
Northern Cardinal (Midwestern and Eastern U.S.)
Ladder-backed Woodpecker (Southwest)
Downy Woodpecker
Hairy Woodpecker
House Finch
European Starling
Tufted Titmouse (Eastern half of U.S.)
Juniper Titmouse (Southwest)
House Sparrow
Common Grackle (East)
Great-tailed Grackle (West)
Blue Jay (Midwest and East)
Scrub Jay (West and Southwest)
Spotted Towhee (West)
Eastern Towhee (Southeast and lower Midwest)
Pine Siskin

FOOD

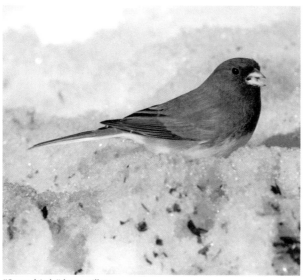

"Snow birds" love millet.

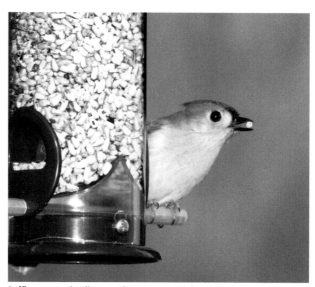

Safflower seed will warm this titmouse right up!

Heavy snow or colder-than-usual temperatures can force some birds to expand their winter territories in search of food, so you may see a few unusual visitors in January. In the northeast and western regions watch for large flocks of beautiful Evening Grosbeaks gorging themselves on black-oil sunflower seeds. Enjoy them while you can. Evening Grosbeaks are vagrants and can leave just as suddenly as they arrive. Rosy Finches in the west and Redpolls in the north central and northeastern regions can also make a brief winter appearance.

In winter months use several large-capacity feeders to minimize your trips out in the cold, and when you are out, brush snow off tray feeders to better welcome large birds like cardinals.

Roosting boxes and dense evergreens protect your birds from the elements, and berry-producing trees and shrubs like hawthorn and juniper can provide natural food all season long.

Watching birds splash away in your birdbath may give you shivers on cold January days, but it helps your birds stay warm. A clean bird is a warm bird. Your birds also need open water to drink.

January is one time of the year that providing food and open water may really make a difference to the birds in your backyard. It is also the time to find a cozy chair and enjoy the show.

Birdseed in January

COMMON BIRDS AT SEED

cardinals	nuthatches
jays	thrashers
chickadees	sparrows
grosbeaks	juncos

Best January Mix
50% black-oil sunflower, 40% white millet, 10% shelled peanut

MORE TREES = MORE SUNFLOWER

If you live in a heavily wooded area, increase black-oil sunflower to 75%, decrease millet to 20%, and use 5% nuts.

For general feeding, a good mix is almost always better than individual seed types, and a high-quality mix is just what your winter birds are searching for this month. Cardinals, chickadees, finches, and nuthatches will pick out the high-calorie black-oil sunflower seeds from your mix, while flocks of sparrow species, such as White-crowned and Song Sparrows, are busy cleaning up the white millet knocked to the ground by the birds at the feeder. Watch "snow birds" (juncos) scoot across the snow, picking at millet and any high-energy shelled peanuts overlooked by your other birds.

Black-oil sunflower should be at least half of your mix this month because it is a high-energy, high-fat seed that the majority of wintering birds will eat. It is the favorite of grosbeaks, cardinals, and smaller birds such as chickadees, nuthatches, finches, and titmice. Chickadees grab and go. They like to flit from feeder to branch and back, again and again. Sunflower fuels this high-energy bird, and they are such fun to watch.

Whether fed alone or, better yet, as part of a mix, black-oil sunflower should be put in above-the-ground tube- or hopper-style feeders. All the birds that come to your elevated feeder want black-oil sunflower. They knock the rest (mostly millet) to the ground, where millet-loving ground-feeding birds eat it.

Juncos, often called "snow birds" because they arrive with the winter snow, are cute, ground-feeding birds that love white millet. You will often see small flocks of them in the winter. Juncos come with the snowy, colder weather, and move to higher elevations and northern Canada come spring. If there is snow cover, it is best to spread millet separately in a ground tray feeder so your juncos, doves, towhees, and sparrow species can find it. It may help to scatter some millet near bushes and shrubs in a snow-free area to encourage more junco and towhee activity. These birds will often scamper out to eat the seed then scoot back to the ground cover for protection from the cold. Watch for the telltale white

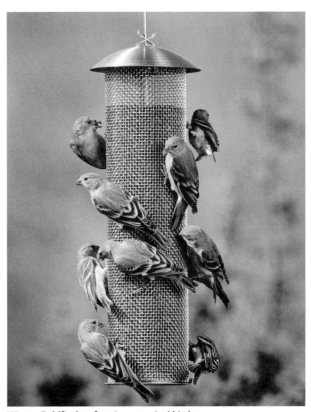

Winter Goldfinches feasting on nyjer/thistle.

Quick Seed Tips

- Feed a heavy black-oil sunflower seed mix for higher fat content to help keep birds warm.

- Sprinkle extra white millet on the ground in a snow-free area or on ground trays for juncos, towhees, and sparrow species.

- Feed nyjer for winter Pine Siskins and goldfinches.

- Use seed blocks loaded with sunflower and nuts for a steady supply of food.

- In cold weather provide seed late in the day and early in the morning to help birds stay warm at night and get a burst of energy at dawn.

FOOD

flash from a junco's tail feathers as it flies away. Dark-eyed Juncos are the most common to spot; two sub-species of the Dark-eyed Juncos are the Slate-colored Junco (found throughout the United States) and the Oregon Junco (found mostly in the West).

Safflower is a good, high-oil-content seed to mix with black-oil sunflower. High-fat food like safflower helps keep your birds warm. Safflower is expensive and not favored by as many birds as sunflower; if you use safflower in your mix it should constitute only a small percentage.

When put by itself in a feeder, safflower is a good problem-solving seed. Unwanted guests such as squirrels, blackbirds, grackles, and starlings tend to stay away. House Sparrows don't much like safflower either. Cardinals love safflower! Although it may not be their first choice, you can also expect to see House Finches, titmice, doves, and chickadees eating this high-calorie treat.

Shelled peanuts, added to your birdseed mix or fed alone in a cage-type peanut feeder, are the perfect high-fat, high-calorie food to help keep your birds warm on cold January nights. Chickadees, nuthatches, woodpeckers, jays, thrashers, and flickers are a few of the birds you may see eating them. It's fun to watch White-breasted Nuthatches come headfirst down the trunk of a tree to grab a peanut, then fly to a nearby branch to pick it apart. Don't forget your little snowbirds. We have customers who crush peanuts and sprinkle them on the ground for flocks of hungry juncos. In Albuquerque, Anne saw a Yellow-rumped Warbler at her peanut feeder in January. Warblers sometimes visit suet in the winter in southern regions, but it was a first for any of us to see one eating shelled peanuts.

Jays love peanuts and will eat them from a tray, a stump, your hand, almost anywhere. Jays are permanent residents and do not migrate in winter. Blue Jays are found in the Midwest and East, and Western Scrub-Jays, Pinyon Jays, and Steller's Jays are found in the West.

In most places you will see goldfinches all winter long. Much of the country can see Pine Siskins and American Goldfinches all winter, but look for Lesser Goldfinches only in the West. Goldfinches are not as dramatic-looking in cold months; they do not yet have the bright yellow breeding plumage they will need to attract a mate in spring and instead are a very dull yellow that is less attractive to winter predators.

Look for more Pine Siskin activity at your nyjer in winter. Hang your nyjer feeder in a separate location from other seed feeders to encourage more goldfinch and Pine Siskin activity. Remember, birds like elbow room, and these little finches can be shy. Once they are comfortable, they will hang on your feeder for long periods of time. Putting the nyjer feeder near a water source may also help attract finches. They love water, especially if it's moving.

Seed Blocks

This is a great month to use a good-quality seed block. Large ones usually last for a week or two, ensuring that your birds have seed even if you haven't had time to fill your feeders. Make sure the block is loaded with black-oil sunflower and nuts. Seed blocks are often held together with gelatin. If your blocks have plenty

Kids' Project

Roll pinecones in peanut butter and birdseed. Hang in a tree or bush. Watch chickadees, nuthatches, woodpeckers, and Bushtits cling to the pinecone to enjoy this tasty, high-energy treat.

of nuts, the combination of nuts and gelatin can draw suet-eaters like woodpeckers.

Place your seed block on a tray or stump or hang it from a specialized feeder you can find at wild bird specialty stories. Expect to see cardinals, chickadees, House Finches, grosbeaks, and woodpeckers on your seed block this month. In the West look for Mountain Chickadees; in the Midwest and East, Black-capped Chickadees; and in the Southeast, Carolina Chicka-dees. Downy and Hairy Woodpeckers can be found throughout the country all year long, while other types of woodpeckers are more regional. Check your field guide to know for sure.

Suet in January

COMMON BIRDS AT SUET

woodpeckers	titmice	nuthatches
Bushtits	chickadees	creepers
flickers	jays	

Feeding suet is the easiest way to increase the variety of birds visiting your yard. It is cold outside this month and suet—be sure to get the fatty variety—provides the birds with needed fat to help them stay warm. Watch for non-seed-eating birds like kinglets, creep-ers, woodpeckers, and Bushtits at your suet feeders. These birds live throughout North America, except for Bushtits, who are found mainly in the West and Southwest. Bushtits form large flocks in winter and are often seen darting in pine trees and swarming suet feeders. Their high-pitched twitters will alert you to their presence. Because of the colder weather you may also see seed-eating birds, such as juncos, gros-beaks, chickadees, and nuthatches, eat your suet for the extra boost of energy they need to stay warm.

Remember to hang your suet feeders where birds can find them and where you can see them. Suet-eaters like woodpeckers, nuthatches, kinglets, and

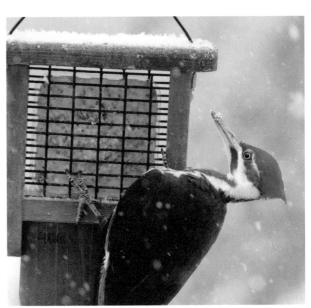

Suet packs a punch for this Pileated Woodpecker.

creepers look for natural food on tree bark, so mount a suet cage against a tree trunk and hang a suet log or tail-prop suet feeder from a tree branch. Feeding suet in more than one location is also helpful. After all, suet can last longer than loose seed and is easy to feed, so why not display it in multiple locations for you and your birds to enjoy?

If you are putting out suet for the first time or have not fed suet for a while, be sure to smear your suet feeder with peanut butter and press lots of birdseed onto the peanut butter to remind birds that it is food.

Quick Suet Tips

- Feeding suet will increase the variety of birds in your yard.
- Feed fatty suets in cold weather.
- Display your suet feeder in a tree for best results.

FOOD

Seed-eating birds like sparrows will recognize and come for the seed, and this activity will catch the curious eye of suet-eaters like woodpeckers. This trick will jump-start activity at a new suet feeder.

Don't be afraid to place suet in a tree very close to a window. Birds don't mind, and it's exciting to see woodpeckers, Bushtits, and other really cool birds up close.

Mealworms in January

COMMON BIRDS AT MEALWORMS

robins	warblers	starlings
thrashers	wrens	

For non-seed-eating birds, January can be a tough time to find natural food sources due to ice and snow cover and freezing temperatures. Mealworms can supply these birds with the extra protein they need to help them stay warm on cold winter nights. We recommend feeding roasted/dried mealworms in colder weather because freezing temperatures can kill live mealworms.

You may have noticed that not all robins migrate south in winter. Even in some northern states robins will stay if there is a natural food source or open (ice-free) water available. Anne has even seen flocks of robins in Minneapolis, near the Mississippi River, eating winter berries in the middle of January!

Robins, wrens, starlings, and some wintering warblers will gobble up your dried mealworms. It works best to display mealworms on or near the ground by your ice-free water—birds will be more likely to discover the mealworms while visiting your birdbath.

Adding dried fruit such as raisins, cherries, or cranberries to your mealworms may help to entice an even wider variety of birds. Always separate your mealworm feeder from your seed feeders. If birds are not discovering your mealworms, though, sprinkling in a little seed may get things started.

Nectar in January

POSSIBLE BIRDS AT NECTAR

hummingbirds

In most parts of the country, hummingbirds are long gone by January. For a few of you in the southernmost regions, we recommend continuing to feed and enjoy your wintering hummingbirds.

You won't have much activity, so one nectar feeder should be enough this time of year. It is still important to keep your nectar fresh by cleaning your feeder weekly and refilling it.

Fruit in January

COMMON BIRDS AT FRUIT

woodpeckers	sparrows	starlings
finches	grosbeaks	
robins	cardinals	

Birds may not be as active at your fruit in January, but you can still enjoy watching them at your fruit feeder. In bitter cold climates, dried fruit is better than fresh; it is preferred by robins and starlings at all times, actually. In moderate climates we recommend displaying apple halves on a prong fruit feeder or secured to tree branches to entice fruit-eating birds.

Remember, fruit-eaters may not want to hang out with seed-eaters, so display your fruit separate from your seed feeders and always near your birdbath. All the birds will visit your water and are more likely to discover the fruit there.

For an added boost of winter protein, try sprinkling dried mealworms in with your dried fruit. Wintering robins and starlings will find this hard to resist.

Water in January

COMMON BIRDS AT THE BATH

Everybody! Including:

cardinals	starlings	finches
juncos	chickadees	sparrows
robins	grosbeaks	
jays	nuthatches	

Providing ice-free water for birds in January is even more important than in the warmer months. Most, if not all, natural water sources are frozen in January in many parts of the country and can be difficult for birds to access.

We often hear our customers say that they live near a river or lake, so they do not need a birdbath. But a shallow, properly placed bath is always a lure for a wide variety of thirsty, dirty birds and allows you a close-up view. Non-seed-eating robins, mockingbirds, and Yellow-rumped Warblers overwinter in some regions and are just a few of the birds that will visit your birdbath all winter long. Open water also allows birds to drink daily. Eating snow is not a long-term option for birds.

Make sure your birdbath is made from a durable noncracking material such as metal, heavy plastic, or a natural stone like granite. Most important in January is to add a deicer. These are small electrical units that are designed to keep the water above freezing and your birdbath ice free. Many are thermostatically controlled, so they are only on when they need to be. Water will never become warm but will stay above freezing. Make sure your bath is in an area of your yard with close proximity to a grounded (three-prong-plug-type) outlet. Many people run an extension cord from an outlet on an outside porch wall. You may have to plug your deicer into a garage outlet and run the extension cord under the garage door if you don't have an outdoor option. Use a good

A cold robin, thankful for this birdbath deicer.

outdoor extension cord and reinforce it by wrapping it with electrical tape where the plug and extension cord meet. Keep your bath full and fresh.

If your climate is not too severe, you can also use a recirculating pump unit in your birdbath all winter long if you place a deicer very near to the pump unit so it does not freeze. It is lots of fun to watch flocks of grosbeaks, robins, bluebirds, or finches splashing away on the coldest of days.

There are also deicers available for deeper water sources such as ponds.

Providing ice-free water equals more birds, which means more fun for everyone.

NESTING and HABITAT

Nesting in January

COMMON BIRDS NESTING

Birds are not nesting this month, so if you haven't cleaned out last year's nesting boxes yet, now is a good time. Don't take down the nesting boxes, though. Birds love to roost in them at night to find shelter from the cold. You may also want to try roosting boxes, which are designed specifically for birds to use in winter months. Roosting birds will often huddle together for warmth. You have probably noticed birds perching close together on power lines in winter.

Roosting boxes can be mounted on a building under an eave or on a tree for best protection. Always face the entrance hole away from winter winds.

Backyard Habitat in January

COMMON BIRDS IN YOUR YARD

cardinals	creepers	finches
woodpeckers	sparrows	solitaires
grosbeaks	wrens	
juncos	towhees	

Did you know that towhees' main food source is not seed, but natural plant material? If you clean it all up, you won't see many towhees. Leave all that material in its place, and watch for towhees scratching around under your native bushes, such as juniper, honeysuckle, and holly, looking for insects and other snacks. Flocks of juncos and sparrow species will spend most of their time on the ground picking at seeds that have dropped from plants, trees, and feeders. We recommend not cutting your dried seedheads until later in winter.

Watch for robins, solitaires, waxwings, and flickers at winter berries in your pyracantha, Virginia creeper, holly, hawthorn, and mountain ash. These birds have few insects to eat this month and begin to depend on berry-producing plants and trees for food.

Birds in January are also looking for natural shelter from predators and the cold, and your overgrown shrubs and trees, especially evergreens, provide the perfect place. Creating a brush pile in your yard can offer the birds a great hiding place from predators. Birds may even bunch together in it at night to stay warm. Try tossing your used Christmas tree out in your yard—it can provide great winter shelter for your birds.

Sisters' Tips for January

From Mary:

Birds are thirsty! Provide fresh, ice-free water by adding a deicer to your birdbath, pond, or fountain.

- -

From Anne:

Scatter white millet in and around bushes in your yard and look for juncos. Because juncos feed on the ground, it's tough to see their white bellies and the undersides of their tail feathers, so watch for flashes of white as they fly away.

- -

From Geni:

Fill feeders just before dark so cold, hungry birds have a meal waiting at daybreak.

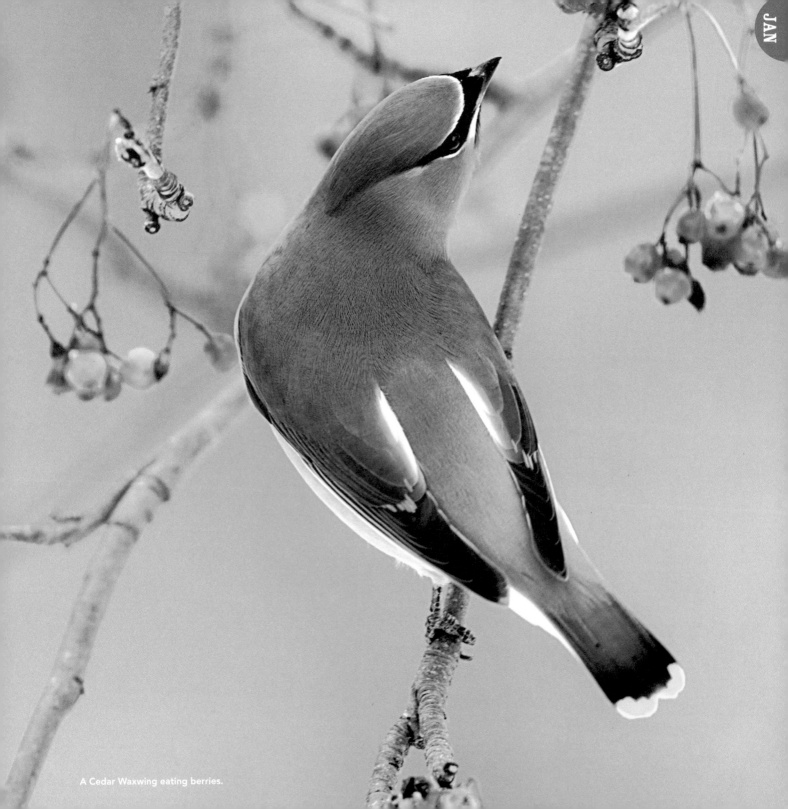

A Cedar Waxwing eating berries.

NOTES

date	birds sighted	notes

date	birds sighted	notes

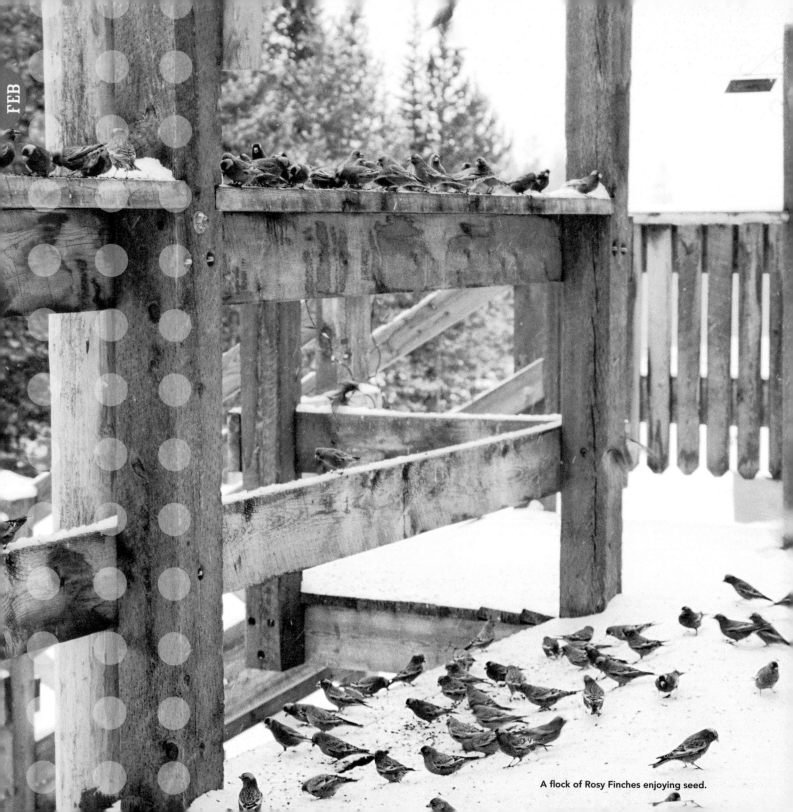

A flock of Rosy Finches enjoying seed.

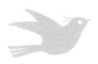

FEBRUARY

Let's face it, by February many of us are tired of winter. Your birds are tired, too. They have depleted many of their natural food sources, like leftover berries on bushes and seedheads on flowers. Although your feeders provide only a fraction of your birds' diet, you help them more in cold weather, especially when snow and ice cover the ground.

Especially in colder climates, use large-capacity seed feeders this month so you don't have to trudge through the snow every day. Large seed blocks last a long time and also cut down on the number of trips you make outside.

This is the month to look for huge flocks of beautiful Evening Grosbeaks at your sunflower feeders and bunches of cute little juncos eating millet on the ground. Juncos will leave come spring, so enjoy them now.

Insects are hard to come by in February, but the berries on your native bushes, trees, and vines will be a nice substitute for flocks of robins, bluebirds, flickers, and waxwings.

High-fat suet is an important source of calories for your birds during cold months and always a fun way to attract a wider variety of birds. In the East, South, and Southwest, look for wintering Yellow-rumped Warblers (the only warblers likely to be seen in winter) at your high-energy suet. This bird's mostly brown winter

Birds to Look For

(found in most regions unless otherwise noted)

Red Crossbill (extreme North and West)
Common Redpoll (extreme Northern U.S.)
Brown Creeper
Evening Grosbeak (North and West)
Yellow-rumped Warbler (South)
Northern Mockingbird (Southern two-thirds of U.S.)
Dark-eyed Junco
Purple Finch (Midwest and East)
White-crowned Sparrow (Southern half of U.S.)
Black-capped Chickadee (Northern two-thirds of
 North America)
Carolina Chickadee (Southeast)
Mountain Chickadee (West)
Red-breasted Nuthatch
White-breasted Nuthatch
American Goldfinch
Lesser Goldfinch (Southwest)
Northern Cardinal (Midwestern and Eastern U.S.)
Ladder-backed Woodpecker (Southwest)
Downy Woodpecker
Hairy Woodpecker
House Finch
European Starling
Tufted Titmouse (Eastern half of U.S.)
Juniper Titmouse (Southwest)
House Sparrow
Common Grackle (East)
Great-tailed Grackle (West)
Blue Jay (Midwest and East)
Scrub Jay (West and Southwest)
Spotted Towhee (West)
Eastern Towhee (Southeast and lower Midwest)

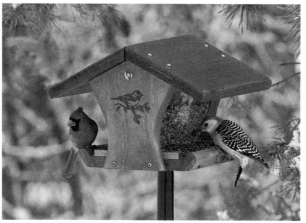

Birds love a mix heavy in black-oil sunflower.

Birdseed in February

COMMON BIRDS AT SEED

juncos	chickadees	doves
towhees	grosbeaks	finches
cardinals	woodpeckers	
sparrows	jays	

Best February Mix

50% black-oil sunflower, 40% white millet, 10% shelled peanuts, safflower, or striped sunflower

MORE TREES = MORE SUNFLOWER

If you live in a heavily wooded area, increase black-oil sunflower to 75%, decrease millet to 20%, and use 5% nuts, safflower, or striped sunflower.

plumage is offset by its conspicuous yellow rump. In early spring, the dull plumage will be replaced with vibrant black and even brighter yellow markings.

In southern regions, bluebirds are beginning to sing sweetly for a mate. Most of the North is still in the grip of winter.

Regardless of where you live, all your wintering birds will flock to ice-free water. Providing it is an easy way to attract non-seed-eating robins, waxwings, and bluebirds.

Sit back, stay warm, and enjoy this late-winter activity in your backyard.

It's cold outside, and black-oil sunflower seed is like a winter coat for the birds. Its high oil and fat content keeps all your birds warm and toasty. Whether as 50 percent of your mix or used alone, put black-oil sunflower seed in an above-the-ground tube-, tray-, or hopper-style feeder positioned where you can see it easily. Use large-capacity feeders for your heavy sunflower mix or black-oil sunflower, unless you want to fill them every day. On cold February mornings we like watching birds from inside a toasty-warm house while drinking a hot cup of coffee. This month, look for flocks of Evening Grosbeaks, cardinals, and little finches mobbing your sunflower seeds.

Feed a mix with at least 40 percent white millet (less in heavily wooded areas), or scatter millet by itself in a ground tray or directly on the ground. Clear snow from enough of your yard to accommodate ground-feeding birds. They can't find millet that sinks into the snow. Open ground tray feeders, sprinkled with extra millet and shelled peanuts, are a nice addition to your winter feeding area. We always put an open tray on our patio so we can see our flocks of juncos up close. Use covered trays in snowy areas; birds like dry seed.

Kids' Project

Cut a bagel in half, smear each half with peanut butter, and cover it with birdseed. Hang it in a tree or bush (use a nail or S hook) with seed facing out. Cardinals, finches, sparrows, and jays will love this winter treat.

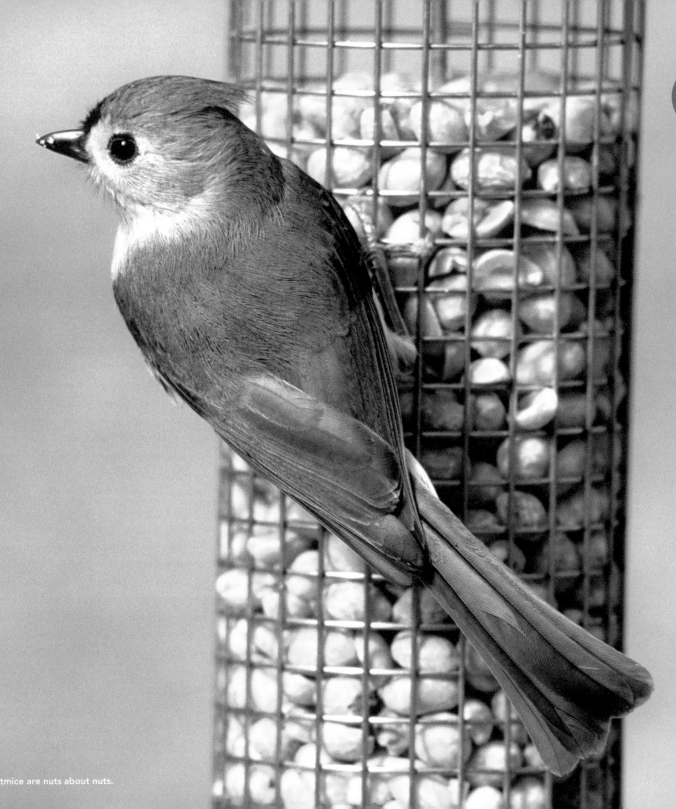

Titmice are nuts about nuts.

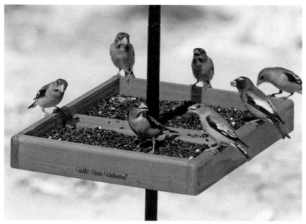
Evening Grosbeaks fill up on sunflower seeds to stay warm.

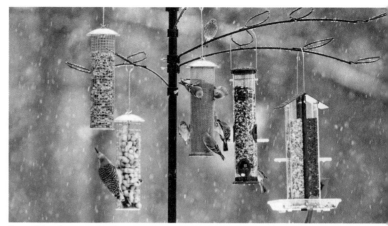
Something for everybody.

Use a mix with at least 5 to 10 percent high-in-fat safflower this month. Remember, squirrels, blackbirds, and House Sparrows don't readily eat safflower, so if you are having problems with these species monopolizing your feeders, then feed safflower by itself in your tube- or hopper-style feeders.

Don't forget that cardinals love safflower! They need a bit of room at the feeder, so add a tray to your tube feeder or use a hopper-style or tray-style feeder to help make them comfortable. House finches, chickadees, titmice, and doves also like safflower.

Quick Seed Tips

- Hang feeders where you can see and fill them easily.
- Feed a mix heavy with black-oil sunflower.
- Feed white millet on the ground or ground tray for more junco and sparrow activity.
- Put seed out late in the day and early morning to help the birds stay warm at night and give them a boost of energy in the early morning.
- Feed birds high-fat, shelled peanuts to keep warm.

If you want to attract wintering goldfinches and Pine Siskins, nyjer is the key. Its high fat content packs a punch for your birds. Your goldfinches' brilliant yellow summer plumage turns olive green in winter. Even so, you will enjoy watching these little birds mob your nyjer feeder on cold, dreary days. Pine Siskins, with their finely streaked feathers, are also a welcome sight. Both goldfinches and Pine Siskins are unlikely to visit your yard unless you offer nyjer.

Birds are nuts about high-calorie, high-energy nuts. Feeding shelled peanuts in a specialized nut feeder can attract woodpeckers, chickadees, nuthatches, jays, and Bushtits. Anne even saw the well-camouflaged Brown Creeper creep up a tree, pick natural food from under the bark, then make a quick detour to her peanut feeder. Adding shelled peanuts to a birdseed mix is also popular with the birds. Nuthatches and woodpeckers will often take a shelled peanut from the feeder, stash it under the bark of the tree, and then come back for more. Feeding shelled peanuts is a great way to attract non-seed-eating birds like woodpeckers, but don't be surprised to see seed-eaters like juncos or finches at your shelled peanut feeder looking for a high-calorie winter treat, too.

A nuthatch eating pinecone seeds.

Suet in February

COMMON BIRDS AT SUET

woodpeckers	chickadees	juncos
kinglets	titmice	finches
flickers	nuthatches	warblers
creepers	jays	

In February, think comfort foods—high-calorie foods like fatty suet. Display your suet feeder separate from your seed feeders, preferably in a tree or bush. Suet-eaters are elusive and are often found scouring tree bark looking for natural food. Northern Flickers, normally found eating ants on the ground, can be seen at suet and on the trunks of trees looking for bugs in February. Snow cover and fewer ground bugs drive flickers up to find food. These large, dramatic-looking woodpeckers with their distinctive black bibs are hard to miss, and they love suet. Stabilize your cage-style suet feeder against a tree trunk so birds like flickers aren't spooked by movement when they land. Other types of suet feeders can be hung from a branch.

Mary recently had luck luring the tiny Ruby-crowned Kinglet to her Albuquerque yard in winter. He came to

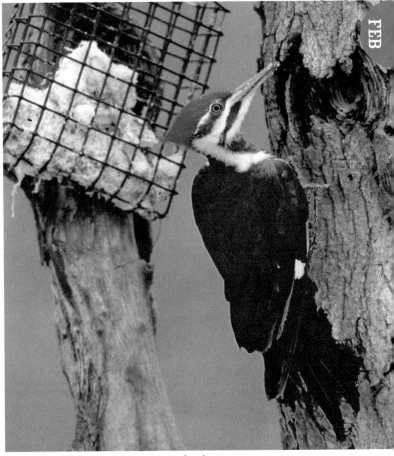

Hang suet on a tree trunk to attract woodpeckers.

the peanut butter she smeared on the tree trunk next to her suet feeder. Although he visited the suet, he seemed much more interested in the peanut butter.

By February, your birds' natural food supplies have diminished, so watch for woodpeckers, flickers, king-lets, Bushtits, chickadees, and nuthatches clinging to your suet feeder looking for a late-winter energy boost. All of these birds can be found throughout North America, except the Bushtit, which is mainly found in the West. Typically, you will have more suet-eating birds if you have more trees.

FOOD *and* WATER

Mealworms in February

COMMON BIRDS AT MEALWORMS

bluebirds sparrows finches
starlings thrashers woodpeckers
robins jays

In February insects are hard for your birds to find—mealworms to the rescue! They are high in protein and exactly what your insect-eating birds are looking for.

Live mealworms will die in freezing temperatures, so feed dried/roasted mealworms this month. Make sure they stay dry; wet mealworms are not as attractive. Feed mealworms in a mealworm feeder or shallow dish near your ice-free birdbath. Robins, bluebirds, and wrens are more likely to discover the mealworms while at your birdbath.

Nectar in February

POSSIBLE BIRDS AT NECTAR

hummingbirds

Few of us are lucky enough to have hummingbirds in February. Most of them migrate to Central and South America, though some will overwinter in the extreme Southwest and Florida. If you are among the lucky ones who see hummingbirds this month, continue to feed them as described in the nectar section of Backyard Birding Basics (page 30).

Fruit in February

COMMON BIRDS AT FRUIT

robins cardinals mockingbirds
starlings finches sparrows

You may not have as many fruit-eating birds this month, but continue to provide fruit anyway. In Minnesota, Anne commonly saw flocks of robins and Cedar Waxwings at Minnehaha Creek, where even in winter they could find leftover berries on bushes *and* running water. You may be able to lure some of these birds to your yard.

One of our customers in Albuquerque feeds grape jelly all winter long, not because she gets orioles in winter (which she doesn't), but because her House Finches love it and will eat it all year. If you live in a bitter cold climate you can't do this, but you can feed dried fruit instead.

Water in February

COMMON BIRDS AT THE BATH
Everybody! Including:

cardinals sparrows thrashers
finches jays nuthatches
robins starlings towhees
grosbeaks chickadees woodpeckers

Mary has watched woodpeckers pick at dripping icicles trying to get a drink of water. All birds need ice-free water in winter for bathing and drinking.

A birdbath deicer will keep the water just warm enough to stay ice free. Use only plastic, metal, or granite baths in winter—ceramic and concrete can crack in the cold. You can even buy a plastic bath with a built-in, thermostatically controlled deicer. Anne used one in Minnesota for years, and without fail it kept water ice free all winter long. Anne and her customers in Minnesota were amazed every winter to see little chickadees and finches bathe and drink at subzero temperatures. When it was really cold for long periods of time, customers would report seeing European Starlings bathe more than any other bird. These non-native, very common birds just didn't seem to know better.

Place your bath in a location that is visible to you, is easy to fill, and has access to an electrical outlet for the deicer. Remember, if you want birds to bathe, shallow is best (no deeper than two inches). Moving water is even more attractive, but if you live in a bitter

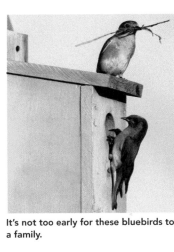

A heated birdbath is like a winter spa.

It's not too early for these bluebirds to start a family.

cold part of the country, that will be difficult to provide this month without freezing the pump.

Watch for flocks of robins, cardinals, starlings, and grosbeaks splashing away at your bath on the coldest February days. By the way, don't worry about birds freezing in the cold water. Their feet are like our fingernails and won't stick to surfaces when wet.

Nesting in February

POSSIBLE BIRDS NESTING
bluebirds
owls

For most birds, February is a bit early to begin nesting. Bluebirds are one notable exception. In the South and Southwest, they begin looking for nesting boxes this month. In the South, owls are beginning to look for nesting spots, too. For the most common screech-owl, make sure the large box has a three-inch entrance hole and is mounted ten to thirty feet high.

For bluebirds, mount boxes on a pole, five feet from the ground, facing the entrance hole away from prevailing winds but toward possible perching spots. Refer to the nesting section of Backyard Birding Basics (page 45) for more detailed information on attracting bluebirds to a nesting box.

We have often heard male House Finches sing as early as February. In southern regions, you will hear more singing and will even start to see birds pair up this month. We've even seen birds flying with nesting materials in their beaks in February.

For many of you, though, winter is still in full force, so put out a roosting box. All birds are looking for protection from the cold and will often use a roosting box or unused birdhouse for shelter during cold winter nights.

It's not too early to get all of your houses out. Be sure to choose a house that is the proper size for local

Quick Nesting Tips

• Watch for bluebirds at your bluebird boxes in southern regions.

• Owls begin nesting—watch for activity at your owl boxes.

• Visit a local backyard-bird-feeding store for accurate information on nesting boxes.

• Some birds will seek empty birdhouses or roosting boxes as shelter during cold nights.

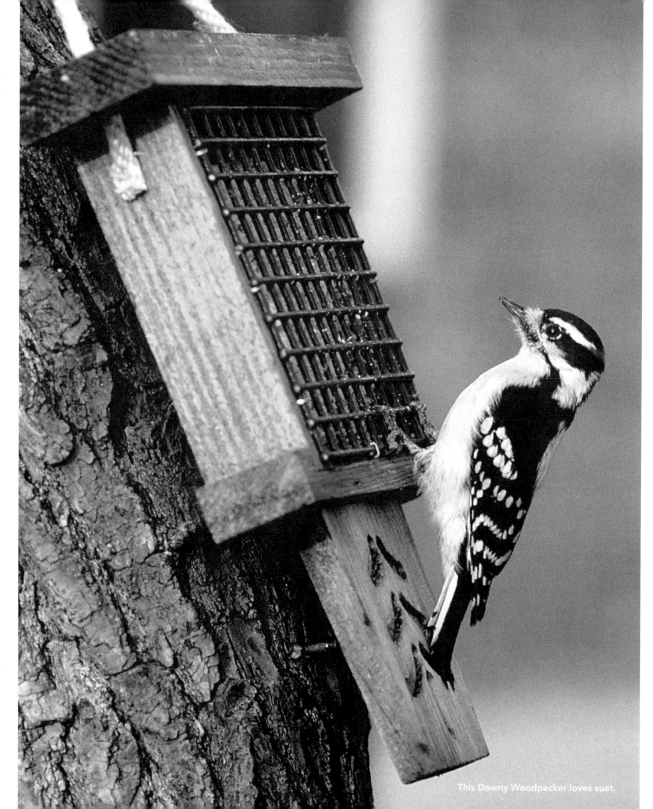

NESTING and HABITAT

This Downy Woodpecker loves suet.

birds. If you put up a nesting box with an entrance that is too large, you often welcome the non-native House Sparrow. Most of us who feed birds see lots of House Sparrows (actually a member of the finch family and not a true sparrow at all). House Sparrows, often called English Sparrows, are native to England and were brought to North America in the mid-nineteenth century. They thrive in cities and suburbs and adapt easily to a changing environment. As urban sprawl explodes, the House Sparrow population explodes with it.

House Sparrows are very aggressive at finding and defending a nesting box and their presence can drive down native bird populations. They will kill adult birds, nestlings, and eggs in order to take over the house of another species. House Sparrows thrive in a concrete world and love white millet, so you can discourage them by providing a native habitat and more sunflower, safflower, and suet, and by aggressively removing their nests from nesting boxes as they build them.

Backyard Habitat in February

COMMON BIRDS IN YOUR YARD

cardinals	woodpeckers	nuthatches
bluebirds	thrashers	juncos
grosbeaks	chickadees	titmice
robins	towhees	sparrows

Winter continues in the North, but in parts of the South and Southwest, spring is fast approaching. Your birds are preparing for spring. Are *you* ready?

Cut back plants and shrubs if new growth is starting but continue to leave old seedheads and berry bushes alone. Watch for flocks of robins, flickers, and waxwings eating the late-winter berries on your sumac, mountain ash, pyracantha, holly, and Virginia creeper. We have seen flocks of robins actually acting drunk after eating the overripened pyracantha berries.

Evergreens are a magnet for flocks of wintering Yellow-rumped Warblers and kinglets. These birds can be seen scouring the branches for cocooned insects found in the sappy bark. Chickadees and nuthatches love seeds from pinecones, and cardinals love the berries some pine trees produce.

If you have little natural cover, providing a brush pile can offer a safe place for your birds. You might want to consider doing some more planting, to get ready for next year. Check with your local nursery for the best advice on your specific area. And remember, copy nature. A dense, overgrown, forest-like habitat provides the best food and cover for birds year-round. As natural habitat shrinks due to sprawl and other factors, your yard can be the oasis birds need.

Sisters' Tips for February

From Mary:
Scatter millet on the ground separate from your other feeders to encourage more ground-feeding juncos and towhees. Clear the area of snow so your seed stays dry.

From Anne:
Use a large seed block loaded with black-oil sunflower and nuts to attract cardinals, chickadees, nuthatches, woodpeckers, and, at my house, flocks of Pine Siskins. Big blocks of seed last a long time . . . so I don't have to go out in the cold as often to replenish seed feeders.

From Geni:
Arrange your feeders so that you can easily see them from inside where it's warm.

date	birds sighted	notes

date	birds sighted	notes

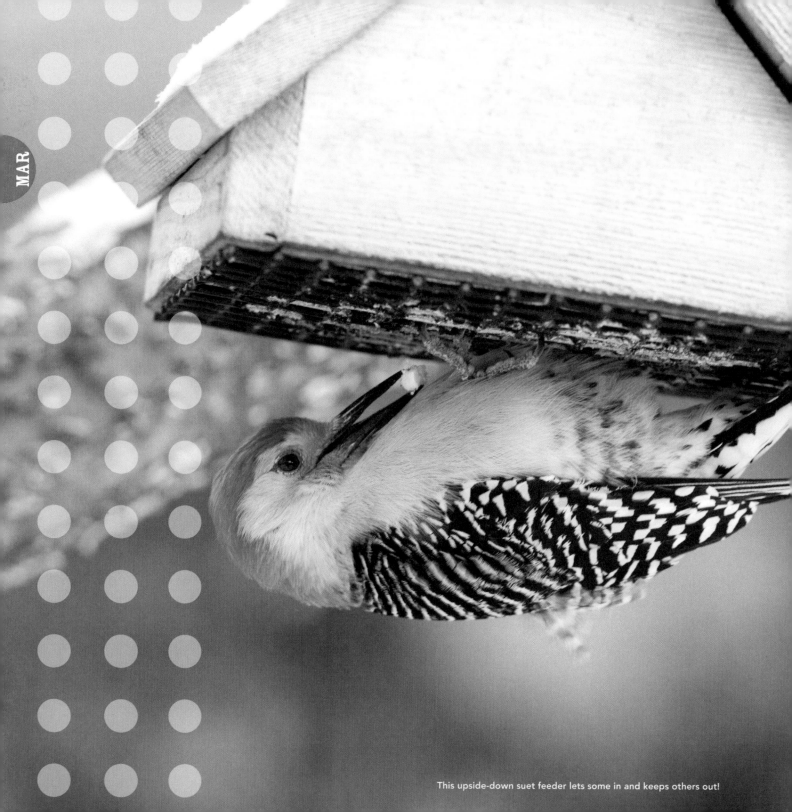

This upside-down suet feeder lets some in and keeps others out!

MARCH

MARCH It may not feel or look like it, but regardless of the weather, spring is in the air for the birds. Many juncos and sparrow species that have been regular winter visitors will begin to head north. You've probably heard male robins, cardinals, and finches singing to attract a mate. Look for the beautiful red male cardinal perched high in a tree, singing his heart out.

Some of your birds will be leaving for their spring migration, but others, like colorful tanagers, arrive to take their place later this month in southern regions. The Scarlet Tanager, found in the Midwest and East, is often overlooked, even though it has vibrant red plumage with black wings. That's because tanagers are elusive birds that sit high in the trees—you won't see them at seed feeders. Watch your birdbaths closely to catch a glimpse of them sneaking a bath or drink. Whether you live in the East or West, spring-arriving tanagers and robins will gobble up leftover fruit from mulberry, cherry, and hackberry trees.

Although you might be tired of trudging through the snow and mud to fill your feeders and birdbaths, keep at it. The rewards of springtime backyard birding are just around the corner.

Birds to Look For

(found in most regions unless otherwise noted)

Yellow-rumped Warbler (South)

White-throated Sparrow (Midwest, East, and South)

Song Sparrow

Dark-eyed Junco

American Robin

Black-capped Chickadee (Northern two-thirds of North America)

Carolina Chickadee (Southeast)

Mountain Chickadee (West)

Red-breasted Nuthatch

White-breasted Nuthatch

American Goldfinch

Lesser Goldfinch (Southwest)

Northern Cardinal (Midwestern and Eastern U.S.)

Ladder-backed Woodpecker (Southwest)

Downy Woodpecker

Hairy Woodpecker

House Finch

European Starling

Tufted Titmouse (Eastern half of U.S.)

Juniper Titmouse (Southwest)

House Sparrow

Common Grackle (East)

Great-tailed Grackle (West)

Blue Jay (Midwest and East)

Scrub Jay (West and Southwest)

Spotted Towhee (West)

Eastern Towhee (Southeast and lower Midwest)

Scarlet Tanager (Midwest and East)

Birdseed in March

COMMON BIRDS AT SEED

cardinals	chickadees	sparrows
doves	thrashers	woodpeckers
grosbeaks	finches	juncos
titmice	towhees	nuthatches

Best March Mix

60% black-oil sunflower, 30% white millet, 10% shelled peanuts, safflower, or striped sunflower

MORE TREES = MORE SUNFLOWER

If you live in a heavily wooded area, increase black-oil sunflower to 75%, decrease millet to 20%, and use 5% peanuts, safflower, or striped sunflower.

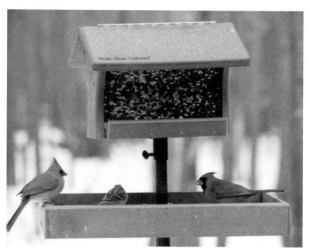

Cardinals love this heavy black-oil sunflower mix.

Use a heavier sunflower mix this month for your cardinals, chickadees, House Finches, and others. Chickadees in particular love sunflower. These brave little birds will sometimes eat the seeds from your hand—you'll be surprised how light chickadees are. They will flit down, grab a seed, and fly to a nearby branch. Holding the seed between their toes, they crack it open with their beak, eat, and quickly return for more. They will stay until the sunflower seeds are gone. Be patient—it takes time to earn their trust.

As usual, make sure your mix is at least 50 percent black-oil sunflower, placed in an above-the-ground tube, hopper, or fly-through feeder. Watch your cardinals, chickadees, nuthatches, finches, and grosbeaks rifle through the mix, knocking all the other seed to the ground, where it is eaten by ground-feeding birds.

Juncos are heading north in March, so you'll need less millet in your mix, but your sparrows, towhees, and doves will still expect some. Sparrow species, like White-crowned and White-throated Sparrows, are also on the move. Attract more of these birds to your yard by scattering extra white millet on the ground near bushes or other cover, away from other feeders. You may even see an elusive towhee or two scampering out of the bushes to eat the millet. An open ground tray works well, too.

A small amount of peanuts in your mix is a nice, high-energy treat for jays and woodpeckers, and cardinals and titmice always enjoy some safflower. Watch for the Tufted Titmouse in the East and the Juniper Titmouse in the West. These cute little gray birds with pointed crests travel in small flocks. They will pick a safflower seed or peanut piece from your feeder and fly to a nearby branch to enjoy their meal.

Shelled peanut pieces also work well when fed alone in a specialized feeder, proving irresistible to

Quick Seed Tips

- Continue feeding millet on the ground for juncos and sparrow species.

- Feed a mix with 30 percent white millet for juncos, towhees, and sparrow species. Black-oil sunflower should still be the main ingredient.

- Use seed blocks with nuts and fruit to attract robins, Bushtits, and woodpeckers.

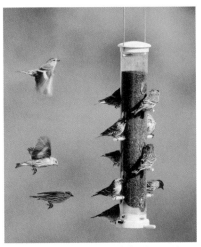

Attract Pine Siskins and goldfinches with a nyjer/thistle feeder.

These cardinals are happy to share some safflower seeds.

nuthatches. Hang your peanut feeder in or near a tree, where you are most likely to find nuthatches.

In March we see odd things happen at feeders. Some non-seed-eating birds like robins may come to your seed feeder in March. Why? Birds don't have much to eat early in the spring. Bugs are not plentiful, natural food is depleted from the long winter, and migrating birds who have just arrived home are hungry. Some of these birds have an easier time eating hull-less sunflower chips—no shell to crack open. All three of us have seen robins and orioles, also typically not seed-eating birds, eat our sunflower chips in early spring. Try feeding chips alone in a feeder with a tray to better accommodate large birds like robins.

In spring, seed blocks with added fruit can also be popular with robins, while cardinals, woodpeckers, chickadees, and others come for the black-oil sunflower and peanuts in the block. Pine Siskins are typically seen at nyjer feeders, but we've been surprised to see flocks of these birds swarm our sunflower-chip-loaded seed blocks this month (although nyjer seed is still their seed of choice).

Most of you can attract goldfinches and Pine Siskins year-round. Nyjer-loving goldfinches are still muted in color this month—you'll have to wait until April to see the bright yellow appear—but it is definitely worth the wait.

Hang your nyjer feeder where you can see it. Birds don't mind feeding near a window, and it is thrilling to have them so close. We have dozens of goldfinches and Pine Siskins feeding almost constantly, inches from our windows.

Kids' Project

Have fun building nesting boxes for the birds. Check with your local backyard-bird-feeding store for the most accurate information on types of boxes to build. You may even locate a birdhouse kit, which would make this project much easier. Make sure the kit is appropriate for your local birds.

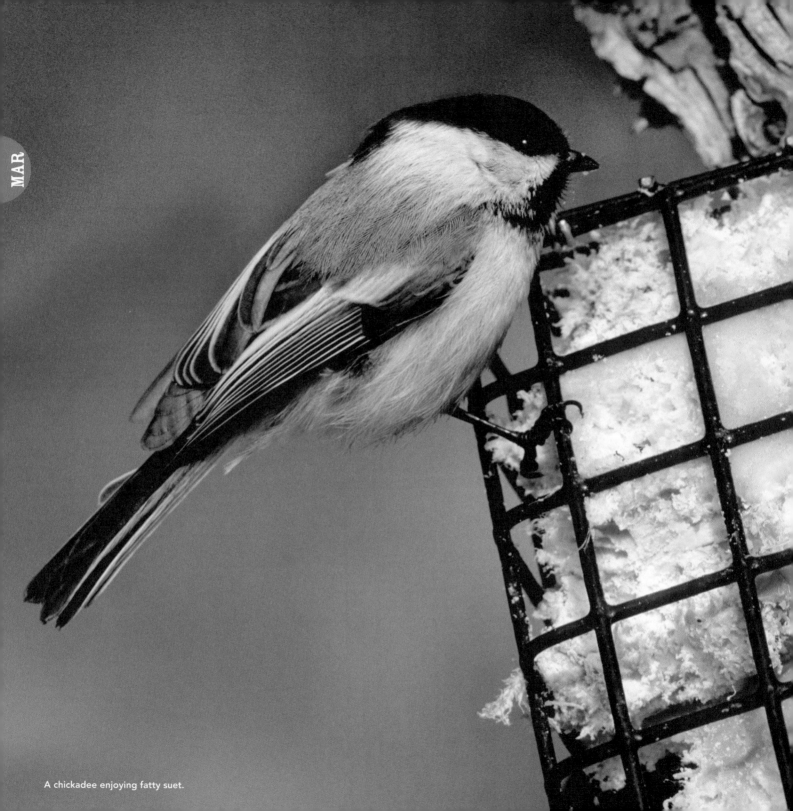

A chickadee enjoying fatty suet.

Suet in March

COMMON BIRDS AT SUET

woodpeckers	jays	titmice
Bushtits	chickadees	juncos
flickers	warblers	kinglets
creepers	starlings	robins
nuthatches	wrens	

Suet feeding can be tricky. Remember, you are trying to attract non-seed-eating birds like Brown Creepers. Found throughout North America, these tiny birds start at the very bottom of a tree trunk and literally creep upward in a spiral, searching for insects and larvae hidden under the bark. Woodpeckers, Bushtits, warblers, and kinglets also normally look for insects in trees or bushes, so put your suet feeder in a tree. Suet cages work best mounted against a tree trunk for stability. Other styles of suet feeders can hang from tree branches. Feeding suet in more than one location and using different styles of suet feeders can bring in more activity. This month continue to feed the fatty suets. You'll switch to no-melt suet doughs when it gets warmer.

Watch your robins closely. We often see robins at our blueberry suet in the spring, picking out the berries.

Starlings can dominate suet. Discourage them by using a feeder that can only be accessed from the bottom. Woodpeckers, nuthatches, and chickadees can easily hang upside down, but starlings have trouble with that. Sometimes log-style suet feeders discourage starlings, too—as long as they are smooth and difficult to cling to.

Mealworms in March

COMMON BIRDS AT MEALWORMS

bluebirds	starlings	sparrows
thrashers	tanagers	mockingbirds
robins	wrens	
orioles	warblers	

Birds like bluebirds are crazy about mealworms. One of our customers was dive-bombed by desperate, hungry bluebirds as she was trying to fill her mealworm feeder. Finally, she gave up and threw the worms on her driveway, then jumped back and watched as the birds happily swooped down to gobble up the treats. Mealworms are loaded with the protein that nesting birds crave, so if you have never fed mealworms, March is a great time to start.

Although birds find live mealworms more attractive because of their movement, below-freezing temperatures can kill them. Choose dried/roasted mealworms if it is still too cold where you live; we recommend initially sprinkling some birdseed or dried fruit in with the mealworms to help the birds discover them, since they don't wiggle around and catch a bird's eye.

Once your robins discover this treat, they will be hooked. Ours chirp loudly until we fill their dish with mealworms—they have us trained.

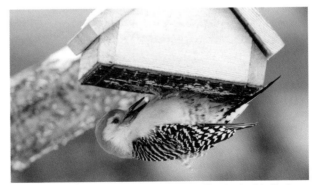

Upside-down suet feeders let some birds in, like this Red-bellied Woodpecker, but keep starlings out.

FOOD

MAR

Nectar in March

COMMON BIRDS AT NECTAR
hummingbirds

By the end of this month, a few hummingbirds will be arriving in the South and West, even if it's still wintry. Don't assume that these tiny birds are watching the weather forecast. They migrate regardless of weather conditions. In early spring we have had to knock snow off our hummingbird feeders to allow the humming-birds to get at the nectar. In the north, though, birders can wait and get nectar feeders out next month.

Fruit in March

COMMON BIRDS AT FRUIT

robins	tanagers	starlings
cardinals	finches	grosbeaks
orioles	mockingbirds	
woodpeckers	sparrows	

If you haven't already been feeding fruit, then March is the perfect time to start.

Feeding different types of fruit, especially in the spring and summer, can lure robins, waxwings, mock-ingbirds, and orioles to your yard. Many of the fruit- and insect-eaters migrate south in the winter and re-turn come spring. Welcome them home.

As usual, a combination of fresh and dried fruit works well to attract both new arrivals and permanent residents. European Starlings will come to fruit as well as seed and suet, and they are interesting to watch in March as their winter plumage begins to change. Starlings are covered with white and gold spots all winter but turn a glossy purple-black in spring. Their bills also change from black to yellow.

Be patient: it can take a while for birds to discover fruit. Keep your fruit fresh. In the South, watch for newly arriving hummingbirds buzzing around your orange and apple halves, picking off the insects stuck on the fruit.

Water in March

COMMON BIRDS AT THE BATH
Everybody! Including:

finches	chickadees	thrashers
cardinals	nuthatches	towhees
grosbeaks	titmice	robins

In many areas, March is still cold and snowy. Continue to use a birdbath deicer if needed. For more deicer information, refer to the water section of Backyard Birding Basics (page 40).

Sparrow species like White-throated, White-crowned, Song, and Chipping Sparrows have begun their spring migration this month, and because they travel in flocks they can be easy to spot. Watch your birdbath in March for groups of sparrows swooping down for a quick drink before they continue on their way.

Get your water moving and your birds will find it irresistible. As migrants like robins and bluebirds re-turn, they are hungry *and* thirsty.

Moving water is irresistible to chickadees and other birds.

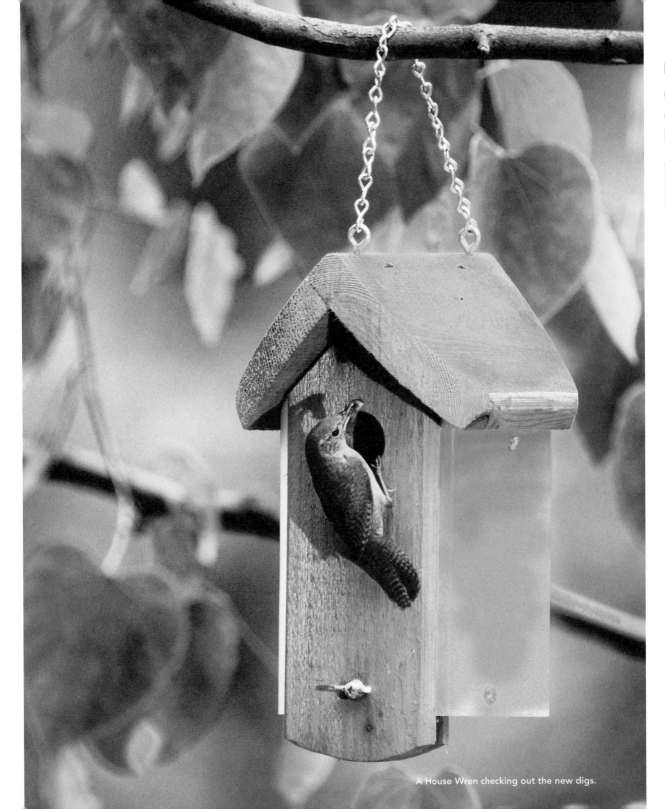

A House Wren checking out the new digs.

NESTING

Nesting in March

COMMON BIRDS NESTING

bluebirds	nuthatches	woodpeckers
chickadees	finches	robins
sparrows	titmice	starlings

All winter, your birds have flocked together to find food, but this month look for birds like bluebirds and robins leaving the flock to find a mate. Watch male finches or cardinals grab a seed from your feeder and give it to a female. Some birds will begin singing to attract a mate. Such mating rituals continue throughout the summer months. Robins' cheery song is often the first we hear in March. Listen for them mostly at dawn and dusk. Many of our customers take note of when they spot the first American Robin in their yard, sometimes as early as March.

Many robins migrate south for the winter, but some actually overwinter, even in very cold climates.

They spend the winter flocking in wooded areas where they can find a steady source of food, like leftover berries, and open water, perhaps from a creek. When you spot the first robin in your yard, you may not realize that the bird has spent its winter just a few miles—or blocks—from your house at a nearby park.

March is the time to have your nesting boxes ready. Your birds are busy looking for a place to raise a family. This is especially true in the South and Southwest, where natural foods like insects are usually more available than they are in the North. Nesting timing for many birds is influenced by availability of natural food sources.

In the North, you can wait until April to put out your housing (with the exception of bluebird boxes), but it doesn't hurt to be ready in March. If you live in an open, rural area, you can attract bluebirds with bluebird boxes, which should be out in all regions of the country by mid-March. Refer to the nesting section of Backyard Birding Basics (page 45) for more detailed information on bluebird boxes.

Hang or mount your birdhouse where it is most attractive to your birds. Wren and chickadee houses can be hung in a tree, and bluebird houses should be mounted in the open on a pole or post. Separate nesting boxes from seed feeders—birds want privacy when raising a family.

Sisters' Tips for March

From Mary:

In the South and West get your hummingbird feeder out at the end of March.

From Anne:

Hang a tray with only safflower. Cardinals love it, and squirrels do not. In Minnesota I loved to watch beautiful red cardinals at my feeder framed by a soft, late-winter snowstorm.

From Geni:

It's bluebird time. Make sure your bluebird boxes are clean and ready for nesting birds.

Backyard Habitat in March

COMMON BIRDS IN YOUR YARD

cardinals	titmice	robins
nuthatches	thrushes	chickadees
towhees	starlings	sparrows
woodpeckers	juncos	

In late winter weather, natural food is scarce.

This is the month to prepare for spring arrivals. The juncos that have been feeding faithfully at your feeder all winter are leaving. Other birds, like insect- and fruit-eating warblers, tanagers, and orioles, will be arriving to take their place. Does your yard have the natural cover and food these birds are looking for?

Remember, natural is always better. Birds love your seed feeders, but rely on natural food sources for their survival. March is a transition month for your yard. Not much is growing yet in many parts of North America, but it's a good time to prepare. Make sure native plants and shrubs are pruned back to encourage spring growth. Early spring is also a good time to plant new trees and shrubs. Berry- and fruit-bearing shrubs typically produce fruit their first summer; usually trees take another year to yield much food for your birds. Rose-breasted Grosbeaks in the East and Black-headed Grosbeaks in the West will eat mulberries, blackberries, and raspberries all summer long.

Check with your local nursery and backyard-bird-feeding specialty stores for the best advice on what to plant that will provide natural food for your birds throughout the year.

date	birds sighted	notes

date	birds sighted	notes

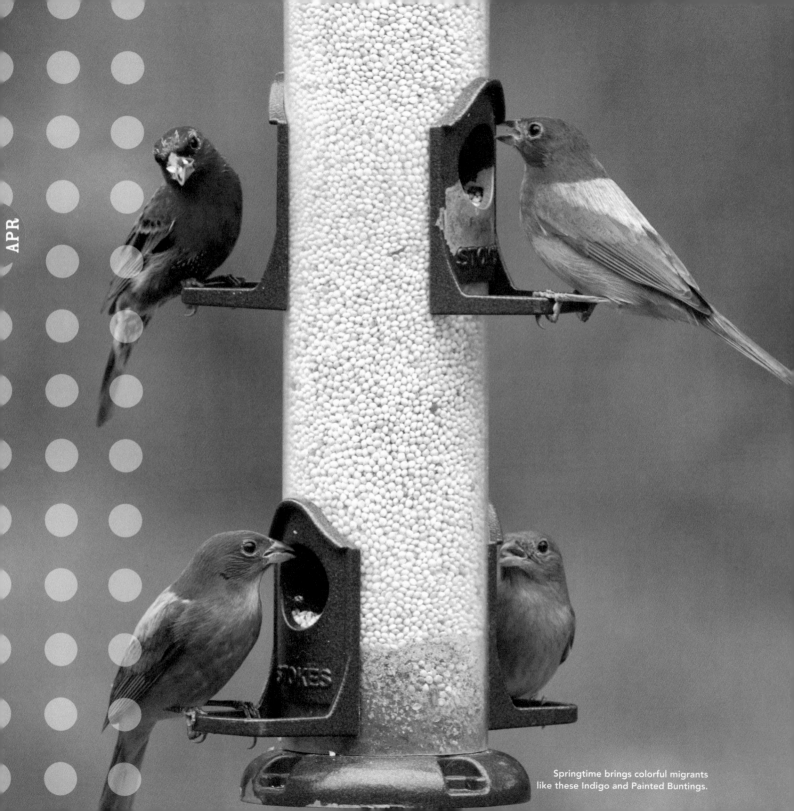

Springtime brings colorful migrants like these Indigo and Painted Buntings.

APRIL Often we hear people say, "I stop feeding birds when it gets warm because they can fend for themselves." They don't want to interfere with the birds' natural survival ability. Don't worry—birds don't become dependent on us. We provide only a fraction of their total diet. Birds can find natural food all year. Also, we feed because it's fun. If you don't provide food, water, and shelter, birds won't visit your yard as often. Don't miss the really colorful birds that come in spring and summer.

Now that it's April, say good-bye to your cute little ground-feeding juncos, but say hello to a wide variety of colorful new spring arrivals. This month is the true beginning of spring migration. Watch for beautiful orioles, tanagers, warblers, and hummingbirds swinging through your yard for a much-deserved rest as they move north.

Buntings are another exciting bird to look for in April. Not commonly seen at seed feeders, in spring they will sometimes visit a feeder with millet. Buntings mostly prefer brushy habitat, but watch for the male to move high in a tree to practice his high-pitched warble. In the East, look for Indigo Buntings. The male is bright blue, and the female a plain brown. In the West you are most likely to see the Lazuli Bunting, whose male is also a beautiful blue. South-central states, like Texas,

Birds to Look For

(found in most regions unless otherwise noted)

Baltimore Oriole (Southern U.S.)

Bullock's Oriole (West)

Orchard Oriole (Southern U.S.)

Scott's Oriole (Southwest)

Ruby-throated Hummingbird (South and Southeast)

Black-chinned Hummingbird (West)

Broad-tailed Hummingbird (West)

Yellow-rumped Warbler

American Robin

Northern Mockingbird (Southern two-thirds of North America)

Black-capped Chickadee (Northern two-thirds of North America)

Carolina Chickadee (Southeast)

Mountain Chickadee (West)

White-breasted Nuthatch

American Goldfinch (Northern two-thirds of U. S.)

Lesser Goldfinch (Southwest)

Northern Cardinal (Midwestern and Eastern U.S.)

Ladder-backed Woodpecker (Southwest)

Downy Woodpecker

Hairy Woodpecker

House Finch

European Starling

Tufted Titmouse (Eastern half of U.S.)

Juniper Titmouse (Southwest)

Common Grackle (East)

Blue Jay (Midwest and East)

Scrub Jay (West and Southwest)

Spotted Towhee (West)

Eastern Towhee (Southeast and lower Midwest)

Mourning Dove

House Wren

Different feeders and food will attract a wider variety of birds.

Birdseed in April

COMMON BIRDS AT SEED

cardinals	finches	nuthatches
thrashers	sparrows	titmice
grosbeaks	chickadees	
jays	towhees	

Best April Mix

60% black-oil sunflower, 30% white millet, 10% sunflower chips, safflower, or shelled peanuts

MORE TREES = MORE SUNFLOWER

If you live in a heavily wooded area, increase black-oil sunflower to 75%, decrease millet to 20%, and use 5% chips, safflower, or peanuts.

Oklahoma, Arkansas, and Missouri, are lucky also to have the Painted Bunting, whose male has a blue head and red-and-green body and wings. With buntings, he is unmistakable . . . she is not.

Make sure your yard is ready for these migrants and some may decide to call your yard home. A little effort in April can pay off with a summertime full of nesting birds, baby birds at your feeder and bath, and an all-around great show.

Quick Seed Tips

- Continue to use a mix with at least 30 percent white millet for migrating sparrow species.
- Feed daily to encourage early-arriving migratory birds.
- Continue to provide white millet on the ground for sparrow species.
- Place your feeders close to your patio or porch for best viewing.
- Desperate robins will sometimes come to a feeder with sunflower chips or a seed block containing fruit.

As usual, a good mix welcomes more birds. Use a heavy sunflower mix this month for cardinals, chickadees, nuthatches, House Finches, and most other sunflower-eaters. Rose-breasted Grosbeaks in the East and Black-headed Grosbeaks in the West often show up this month looking for sunflower. Watch for male cardinals feeding sunflower seeds to the females this month as part of a mating ritual.

Your millet-eating juncos are gone, so 30 percent white millet in your mix should be enough to satisfy ground-feeding towhees, doves, and sparrows.

This is the month to start looking for Lincoln's, Lark, Chipping, and White-crowned Sparrows on the ground searching for seed. Check your field guide: sparrow species can be tricky, but once you see the differences, they are easy to spot. A good clue can be how they move on the ground. If you think that little brown bird is moving in an unusual way, it probably is something different—grab your binoculars and check it out. White-crowned Sparrows (found throughout the United States) are often described by our customers as "standing upright" or "at attention" while scratching on the ground looking for seed.

If you want to welcome more ground-feeding birds, and your yard isn't too heavily wooded, scatter white millet by itself directly on the ground or put it in a ground tray near bushes or other cover.

Sunflower chips and shelled peanuts might attract non-seed-eaters like orioles and robins desperate for food. These nuts can be a part of a mix or fed alone.

Woodpeckers, jays, chickadees, nuthatches, Brown Creepers, and others will continue to eat shelled peanuts even as weather warms. Feed shelled peanuts in a specialized peanut feeder separate from your other seed feeders. Nut-eating birds search tree bark for food, so hang your nut feeder in a tree where they are most likely to find it.

If you like Blue Jay antics, place in-shell peanuts in a tray feeder or on any flat surface like a stump or a table. Jays can easily crack the shell open and will often pick up several nuts before choosing the heaviest—picky, picky, picky! Smaller birds have more trouble with these. We've seen a chickadee attempt to open an in-shell peanut—we gave up watching before the chickadee gave up trying.

Continue feeding fresh nyjer seed in your nyjer feeders. This is the month your male goldfinches will go from drab to the bright yellow plumage that helps attract a mate. It is something you don't want to miss, so make sure those thistle feeders are where you can see them. Don't be afraid to hang a nyjer feeder very close to a window—the birds don't mind. Pine Siskins continue to feed on nyjer but do not change plumage.

April is a good time to get a seed block with added fruit and nuts. It will be a welcome sight for robins and woodpeckers. You might even attract newly arriving warblers and kinglets.

A common mistake many people make is to stop feeding birds when the weather warms up. Keep in mind, the growing season is just beginning, and

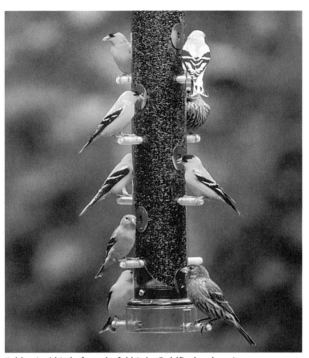

Add nyjer/thistle for colorful birds. Goldfinches love it.

your winter birds have depleted the supply of old seeds and berries. Returning robins, tanagers, and other non-seed-eaters will sometimes eat seed out of desperation in April if bugs are not yet plentiful.

Kids' Project

Cut oranges in half. Scoop out one side of the orange and fill it with grape jelly. Keep the other side intact. Secure both onto dead tree branches near your birdbath.

Orange halves can often be reused—just keep filling them with jelly. Orioles, tanagers, mockingbirds and robins will love a beak full of grape jelly or orange.

Suet in April

COMMON BIRDS AT SUET

woodpeckers	jays	thrashers
creepers	nuthatches	wrens
chickadees	titmice	kinglets

All winter you may have had the usual suspects at your suet feeders; woodpeckers, creepers, chickadees, and nuthatches commonly eat suet year-round. This is the month to look for unusual and different birds at the feeder. We have seen robins, warblers, and orioles eating suet in early spring and well into the summer months, looking for a much-needed energy boost. Remember, there is not much natural food yet available in April, so feeding is important.

Continue to use fatty high-energy suets. Berry and fruit suets may encourage more robin and oriole activity.

Larger, suet-eating flickers can scare away the smaller birds like Downy Woodpeckers, kinglets, and titmice, so feed suet in multiple locations and always where you can easily view the birds.

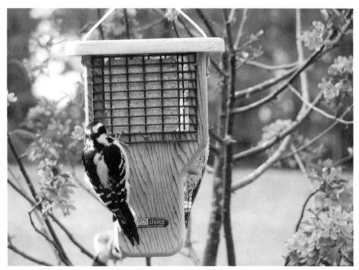

Tail-prop suet feeders help woodpeckers feed comfortably.

Mealworms in April

COMMON BIRDS AT MEALWORMS

bluebirds	orioles	warblers
thrashers	tanagers	wrens
robins	flycatchers	

If you haven't been feeding mealworms, April is the time to start. All your birds are searching for live food, which provides the protein they need to begin nesting.

Watch for migrating warblers, like Wilson's and Yellow-rumped, in your yard. Live mealworms and a birdbath will give them plenty of reason to stop at your house. Robins, wrens, and mockingbirds often load their beaks to capacity with live mealworms to share with a mate or bring to a nest of hungry youngsters. (Live mealworms are always preferred over roasted because their movement attracts attention, but continue to feed dried/roasted mealworms if the temperatures in your area have not been consistently above freezing.)

Migrating birds this month, like phoebes and flycatchers, are especially attracted to water and are more likely to discover the mealworms while visiting your bath or fountain if you position them nearby. These birds usually grab insects in the air, but will not pass by an easy meal of squirmy mealworms.

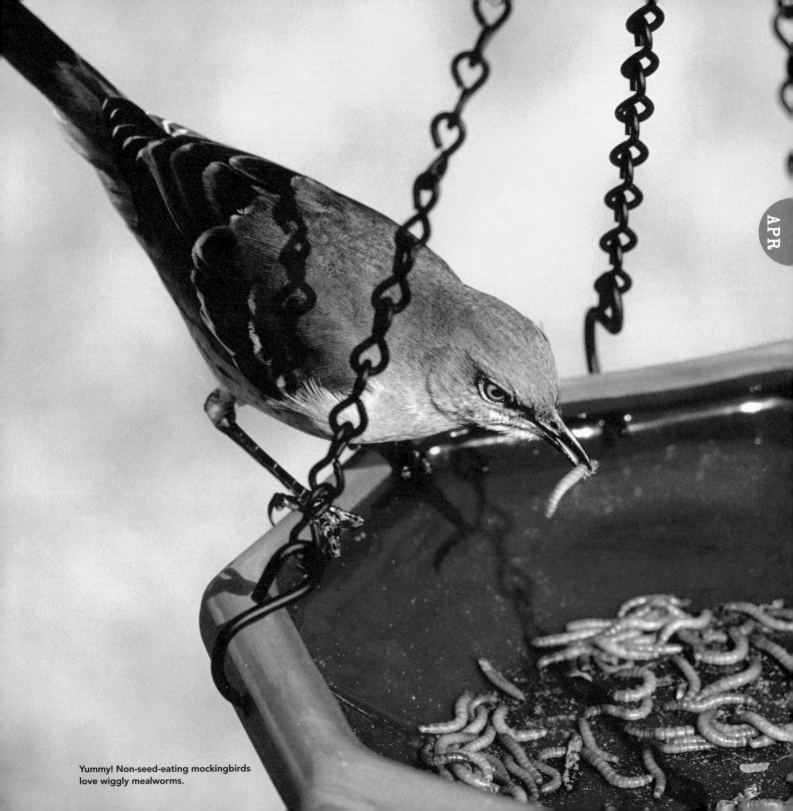

Yummy! Non-seed-eating mockingbirds love wiggly mealworms.

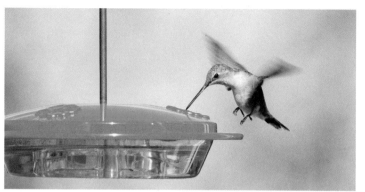

Saucer-style nectar feeders are easy to use and easy to clean.

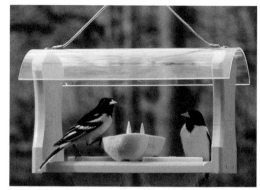

Oranges and orioles go together.

Nectar in April

COMMON BIRDS AT NECTAR

hummingbirds

orioles

Hummingbird Feeding

April 1 is the time to put out your hummingbird feeder in the southern half of the United States (Southwest included). In northern states, put it out by late April or early May. Hummingbirds leave their wintering grounds and migrate north regardless of weather conditions. They know to migrate by the length of the days, so don't assume that because there is snow on the ground or it's cold out that it's too early for hummingbirds. In fact, they need your feeder even more in bad weather. In

April, some of our New Mexican customers who live in the mountains report brushing snow off hummingbird feeders to allow the birds to feed.

This month, only put out one hummingbird feeder. Add more feeders later as summer populations increase. Watch your migrating hummers closely. They won't linger—they'll just stay long enough for a quick drink on their way to summer nesting grounds.

Always hang your feeder close to a window or near your patio where you can see the first hummers arrive. In the West, the Broad-tailed Hummingbird is an early arrival. It is easily identified by the loud, musical trill its feathers make while in flight. East of the Mississippi, you can expect to see only Ruby-throated Hummingbirds, so watch for their return this month in the South. On occasion you might see another variety blown off course by a storm, but this is unusual.

We often hear people say that they do not put out their hummingbird feeder until they actually see a hummingbird. If you wait until you see a hummingbird, odds are that many have traveled through your area unnoticed, without stopping. So don't be late!

Oriole Feeding

Timing is everything in attracting orioles, and for many of you, April is the time. In southern and south-

Quick Nectar Tips

• Use 4 parts water to 1 part white table sugar; bring to a boil; cool and serve.

• No red coloring.

• No honey, brown sugar, molasses, etc.

• Change nectar every three to five days; fresh nectar is a must.

western states, for certain, put out your oriole feeder this month. In northern states, wait a bit longer, but do it by early May. The Baltimore and Orchard Orioles are most common in the East, and the Bullock's and Scott's are found in the West. The arrival of these brightly colored, orange or yellow birds is a sure sign of spring!

In the eastern half of the United States, we've found orange halves are a good food to attract orioles at first; grape jelly and nectar can keep them around all summer long. Oranges don't work quite as well in the West, in our experience. We've fed orioles everywhere we've lived and have noticed different feeding patterns in different climates. Baltimore Orioles in Anne's Minnesota yard loved oranges, but the Bullock's Oriole in Mary's Albuquerque yard seemed much more interested in grape jelly.

Orioles are very colorful, larger birds that live everywhere but are often overlooked because they like to hang out high in the tree tops. Proper placement of your oriole nectar feeder is very important in luring these birds into your yard. Remember, the birds have to see it from the tree tops. Don't hide it under a tree or awning. Place it out in the open and near your birdbath. Moving water is effective at luring in the orioles as well.

Fruit in April

COMMON BIRDS AT FRUIT

robins	woodpeckers	tanagers
cardinals	orioles	starlings
mockingbirds	grosbeaks	House Finches

As winter loses its grip, migrants and year-round residents are hungry. This is a good time to try a variety of food. Dried raisins, cherries, and cranberries are preferred by robins and starlings. These can be easily fed on or near the ground in an open dish near your

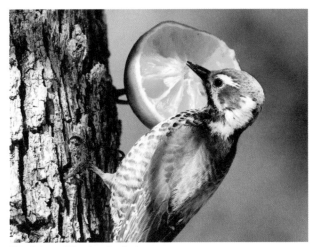

This Arizona Woodpecker loves oranges.

birdbath or fountain, away from your seed feeders. It may help initially to sprinkle some birdseed in with the fruit to help the birds discover it.

For even more activity, mix some dried/roasted mealworms in with your fruit. Robins will often bring their young to feast on the fruit-and-mealworm mixture.

Mockingbirds, orioles, tanagers, cardinals, and grosbeaks love orange and apple halves. And don't be surprised to see hummingbirds buzzing the fruit. They are after the insects that are after the fruit. Proper placement of the fruit is important. Use a prong fruit feeder separate from your seed feeders near your birdbath or fountain, or spear orange halves, pulp side up, on tree branches. Birds are more likely to find the fruit while visiting your bath. Keep fresh fruit fresh—once it has dried out, it's no longer attractive.

Grape jelly can also attract orioles. For best results, use an open-dish-style jelly feeder—a plastic dish works well. Display your jelly feeder near your birdbath. Orioles are more likely to discover the jelly while at the bath. Change the jelly often to keep it fresh. Don't be surprised to see robins or finches also eating the grape jelly.

Water in April

COMMON BIRDS AT THE BATH
Everybody! Including:

cardinals	thrashers	orioles
grosbeaks	warblers	robins
finches	bluebirds	tanagers
hummingbirds	woodpeckers	

It's always exciting to see new and different birds in your yard. And April is the month to look for many of the migratory birds. Often when people see a new bird in their yard it is at their birdbath instead of their seed feeder. Watch for warblers, buntings, Cedar Waxwings, and grosbeaks at your birdbath.

We love to watch birds bathe. It's fun and unpredictable. Ever notice how small birds, like warblers and titmice, move into the water gingerly, while robins and starlings jump in with gusto and splash until most of the water is gone? Moving water is even more attractive to your birds, especially hummingbirds. We rarely see hummingbirds bathe in a birdbath, but turn on a sprinkler and there they are, flying through the moving water. The sight and sound are irresistible—as a babbling brook would be.

There are many easy ways to provide moving water. We like a pump-driven, rock waterfall that sits in the birdbath. Refer to the birdbath section of Backyard Birding Basics (page 37) for more specific information on how to get your water moving. One April, in her

Quick Bath Tips

- Change water daily.
- Use a bath no deeper than 2 inches.
- Get your water moving for increased bird activity.
- Watch for non-seed-eating birds at your bath.

rural Illinois yard, Geni spotted a Winter Wren splashing in her birdbath. Winter Wrens usually go unnoticed because they are very small and quite elusive birds that you would not typically see at any feeder. This was the only time any of us have ever seen this species. We suspect this particular bird was lured by the bubbler in Geni's bath. After a bath and a drink he disappeared—probably continuing his northern migration.

Hawks are moving around more than usual this month, establishing their nesting territories. Because they are so active in April, people notice them more than usual. We have routinely heard customers in Minnesota and New Mexico describe hawks flying to their baths, scaring all the other birds away, and then spending up to thirty minutes just standing in the water. Although it is an odd sight, it is nice to have time to get a really good look. It makes identifying a particular hawk species much easier.

Nesting in April

COMMON BIRDS NESTING

wrens	phoebes	titmice
flycatchers	chickadees	finches
bluebirds	nuthatches	

This month, all the birds, including robins, cardinals, finches, and thrashers, are singing to find a mate. By April some early birds have already had one batch of young and are beginning a second.

Since birds nest and raise young all spring and summer, it is never too late to put out nesting boxes. Even houses hung in the summer might be used, but early spring is best.

Not all birds nest in houses—many build open nests in shrubs, trees, or porch overhangs. We have seen Barn Swallows and Say's Phoebes return year after year to nest on top of light fixtures under

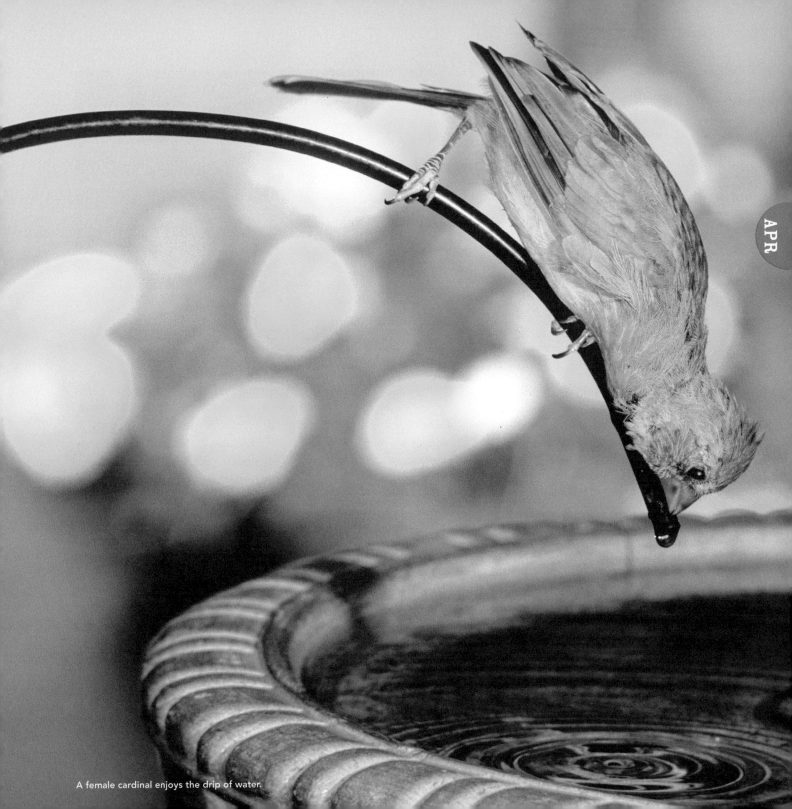

A female cardinal enjoys the drip of water.

This Eastern Bluebird prepares to land.

What a great place for you and your birds to hang out.

porches. House Finches will often nest in hanging flower baskets.

Curve-billed Thrashers, who live in the Southwest, commonly build their nests in cactus. Our customers are often amazed when watching these birds, and their babies, easily navigate the prickly plants. Enjoy your nesting birds, whatever place they choose to call home.

Common birds looking for a house include bluebirds, woodpeckers, nuthatches, wrens, and chicka-

Quick Nesting Tips

* Make sure your boxes are cleaned out from last season's nesting.
* Don't disturb an occupied nest.
* Look for nests in your trees and shrubs; not all birds use nesting boxes or houses.
* You can put out a nesting box any time of year for roosting, but birds nest in spring and summer.

dees. By getting your house out early, by April, you give your birds more time to raise several broods there. It's good for the birds and fun to watch. When hanging or mounting a birdhouse, make sure it is securely fastened and place it away from your feeders. Check with your local backyard-bird-feeding specialty shop for the most accurate information on nesting and the correct size nesting boxes for your area. Refer to the nesting section of Backyard Birding Basics (page 41) for some specifics.

It can be a lot of fun watching the young stick their heads out of the entrance hole begging for food, so put nesting boxes where you can easily see them—though you may want a bit of distance from the action. Some years ago, when living in Illinois, Geni made the mistake of hanging a wren box near her back porch. The House Wrens loved it, but their constant chatter made it impossible for anyone to quietly enjoy the porch. The wrens won! Geni's family and all visitors stayed off the porch much of the summer, while her little wrens raised several broods in peace.

If you live in an open, rural area and have bluebirds, refer to the nesting section of Backyard Birding Basics (page 45) for detailed information on providing bluebird nesting boxes.

Backyard Habitat in April

COMMON BIRDS IN YOUR YARD

wrens	phoebes	titmice
flycatchers	chickadees	finches
bluebirds	nuthatches	

Your backyard is an extension of your home, and April's spring weather gives you the perfect opportunity to make your yard inviting not only to you but also to the birds. Actually, providing birds with a natural habitat is more important than filling your birdfeeder or birdbath. Birds rely on nature for survival, not on our feeders or baths. The raspberries and sumac, the bug-filled shrubs, the coneflowers and black-eyed Susans, all provide cover and nesting spots as well as food.

Birds can be desperate for food in April, whether they migrate or not. Make your yard a haven for them.

Quick Habitat Tips

* A natural yard attracts a wider variety of birds—copy nature.

* Choose plants native to your area that provide seeds and berries for the birds.

* An overgrown-looking yard can be more attractive to wildlife, as well as beautiful for you.

* Check with your local nursery and backyard-bird-feeding specialty shop for the best plants and advice on making your yard a haven for the birds.

* Use a no-mess birdseed to avoid unwanted sprouting in your yard.

Start planting a garden for you and your birds to enjoy all year long.

Choose native seed-producing plants for finches, cardinals, grosbeaks, and goldfinches. Sunflowers and purple coneflowers are two popular examples. Choose nectar-producing flowers like red-hot pokers and salvia for hummingbirds, orioles, and Verdins. We've seen orioles pulling the blooms off hanging geraniums in April. Berry-producing trees and shrubs will attract robins, waxwings, grosbeaks, mockingbirds, and tanagers. Mountain ash, hawthorn, and holly are popular choices. Watch as migrating warblers, tanagers, and buntings hop from branch to branch on flowering fruit trees, picking off the blooms to eat. Also, consider letting your yard get a bit overgrown, rather than going for the manicured look. You'll find that brings in a greater variety of birds.

Sisters' Tips for April

From Mary:

It's hummingbird and oriole time. In the South and West, get your feeder out by April 1. In the north, do it by the end of April or in early May. Feeders that are out early attract more birds.

From Anne:

Add a bubbler to your birdbath and attract spring migrants like buntings, orioles, and tanagers. The newly bright-yellow goldfinch loves to sit right on top of the bubbler.

From Geni:

Enjoy the birds singing and watch for male birds to feed a sunflower seed to a female bird as part of the spring mating ritual.

date	birds sighted	notes

APR

date	birds sighted	notes

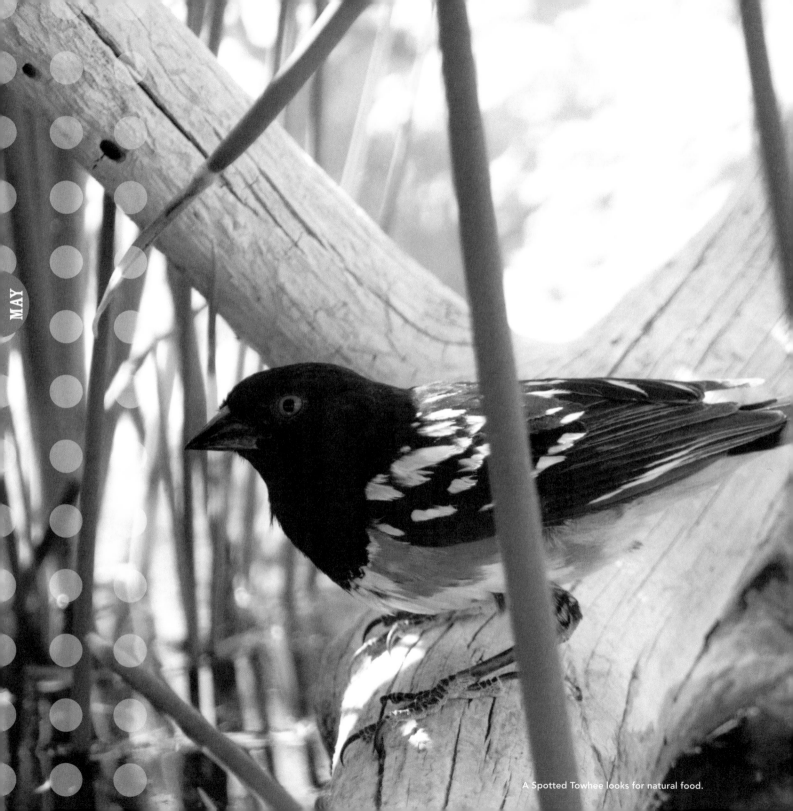

A Spotted Towhee looks for natural food.

MAY is without a doubt the most exciting time to feed and watch the birds. All the colorful migrants will pass through your yard. Birds such as Yellow Warblers, Western Tanagers, and Indigo Buntings need a pit stop to refuel as they continue northward. Some are after water, others want nectar or seed, and some are looking for bugs in your vegetation. Many will even stick around for the nesting season.

By May, hummingbirds and orioles have returned to all regions of the country, and people scramble to accommodate them. We sell more nectar feeders for hummingbirds and orioles in May than any other month.

As your yard sheds its winter coat, so do the birds. Male birds wear their brightest colors and sing their hearts out trying to attract a female. Birds pair up for nesting this month, and you'll notice males get more aggressive as they defend their territory against competitors. Male cardinals commonly peck madly at their reflection in your windows as they try to scare away the strange male cardinal they think they see there.

Everything happens in May! So get your yard ready, grab your binoculars, and enjoy the show!

Birds to Look For

(found in most regions unless otherwise noted)

Baltimore Oriole (Eastern half of U.S.)

Bullock's Oriole (West)

Ruby-throated Hummingbird (Eastern half of U.S.)

Black-chinned Hummingbird (West)

Black-headed Grosbeak (West)

Rose-breasted Grosbeak (Eastern half of U.S.)

Indigo Bunting (Eastern half of U.S.)

Lazuli Bunting (West)

American Robin

Northern Mockingbird (Southern two-thirds of North America)

Black-capped Chickadee (Northern two-thirds of North America)

Carolina Chickadee (Southeast)

Mountain Chickadee (West)

White-breasted Nuthatch

American Goldfinch (Northern two-thirds of U. S.)

Lesser Goldfinch (Southwest)

Northern Cardinal (Midwestern and Eastern U.S.)

Yellow-rumped Warbler

Ladder-backed Woodpecker (Southwest)

Downy Woodpecker

Hairy Woodpecker

House Finch

Tufted Titmouse (Eastern half of U.S.)

Juniper Titmouse (Southwest)

Common Grackle (East)

Great-tailed Grackle (West)

Blue Jay (Midwest and East)

Scrub Jay (West and Southwest)

Spotted Towhee (West)

Eastern Towhee (Southeast and lower Midwest)

Mourning Dove

House Wren

A tanager back home for summer.

A bunting feasting on mealworms.

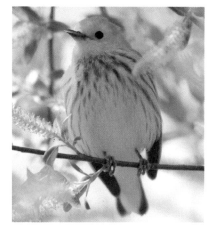

A warbler singing to attract a mate.

Birdseed in May

COMMON BIRDS AT SEED

buntings	grosbeaks	titmice
cardinals	jays	towhees
chickadees	sparrows	
finches	thrashers	

Best May Mix

60% black-oil sunflower, 30% white millet, 10% shelled peanuts, safflower, or striped sunflower.

MORE TREES = MORE SUNFLOWER

If you live in a heavily wooded area, increase black-oil sunflower to 75%, decrease millet to 20%, and use 5% peanuts, safflower, or striped sunflower.

It's peak migration time for many birds. Feeding a high-quality mix with seeds that birds are looking for is the best way to attract the widest variety of birds to your yard. The black-oil sunflower in the May mix will delight your cardinals, nuthatches, chickadees, House Finches, and many more. May heralds the arrival of grosbeaks to your yard. The beautiful Rose-breasted Grosbeak, most common in the East, can also be seen on occasion in the West this month. Black-headed

Grosbeaks are common throughout the West, especially in May. Grosbeaks are usually seen feasting on black-oil sunflower seeds. Almost all the birds that come to your above-the ground feeder want sunflower seeds—even small birds like chickadees and House Finches can easily crack open the large shell.

Whether fed alone or in a mix, put black-oil sunflower seed in feeders that hang or mount above the ground. The white millet in your mix will fall to the ground, where other birds are waiting.

Sparrow species like Lincoln's, White-throated, and Song may be a bit elusive, but they can often be seen searching the ground under seed feeders for their favorite, white millet. You'll also find towhees (Canyon and Spotted in the West, and Eastern Towhees in the East) scratching around there, too.

You can also feed white millet in an open ground tray, or simply toss it on the ground. We recommend separating the types of feeding stations in your yard to lessen competition and attract a wider variety of birds. Birds like elbow room!

One thing to do only in May: Feed white millet or a millet mix in a tube feeder this month, and you may see the beautiful blue Indigo Bunting. Buntings return

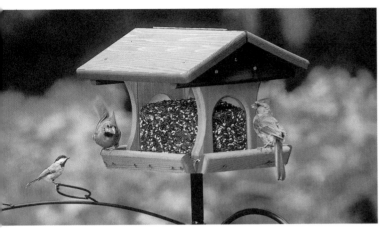

Heavy black-oil sunflower seed mix in a hopper feeder—everybody is happy.

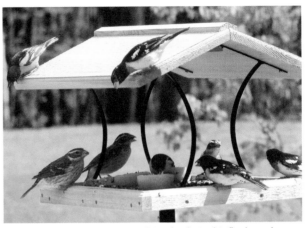

So easy to see the Rose-Breasted Grosbeaks in this fly-through feeder.

in May and, although they usually don't eat seed, they are desperate for food when they first arrive. Insects are not quite plentiful enough yet, and millet helps bridge the gap.

Sunflower chips and no-mess blends have no shells, so they leave no debris and won't sprout. All your seed-eating birds will be satisfied with a good no-mess blend because it contains hull-less sunflower and millet. It will attract most of the same birds as a good blend with shells. Cardinals, chickadees, House Finches, Pine Siskins, and ground-feeders like doves, towhees, and sparrows will be happy with no-mess. Keep in mind that hulless seeds are more vulnerable to spoilage, especially in wet climates, so don't put out more than your birds will eat in a few days.

Continue to feed nyjer seed, and you will see the goldfinches turn bright yellow for the nesting season. The males are much brighter than the females, and they are trying hard to attract a mate with their beautiful color and song.

For best results, hang a mesh-style nyjer feeder—with no perches—near your moving water source. A regular birdbath is okay, too. Other species have difficulty feeding from mesh, and this will help reserve

your nyjer for goldfinches and Pine Siskins. Sparrows and House Finches will tend to dominate a nyjer feeder that has perches.

In warmer temperatures, keep your supply of nyjer in a refrigerator and only purchase the seed from a specialty store that rotates its stock regularly. Fresh nyjer is important in attracting goldfinches.

Hang your mesh nyjer feeder near a window so you can enjoy the bright yellow birds, but keep it fifteen feet or so from other feeders. Goldfinches are shy!

Quick Seed Tips

- Feed daily to attract the widest variety of migrant birds to your yard.

- Watch your nyjer feeder, as the goldfinches are turning a brilliant yellow.

- Local backyard-bird-feeding specialty stores will provide the freshest and most preferred seeds for your area.

- Use a mix that is at least half black-oil sunflower, with the rest mostly white millet.

Suet in May

COMMON BIRDS AT SUET

chickadees	jays	woodpeckers
creepers	nuthatches	wrens
finches	thrashers	
kinglets	warblers	

In fall and winter, Bushtits flock, sometimes twelve at a time, to your suet feeder, but don't be surprised to see them alone or with a mate this month. Like all birds, Bushtits pair up in the spring.

Now that it's getting warmer, we usually recommend switching from the fatty suets, which can melt, to the no-melt suet doughs. In northern climates, though, you may be able to continue using fatty suets all summer long if your suet feeders are in the shade.

Look for suet doughs with added calcium to help the birds develop strong eggshells during the nesting season. In the wild, birds get calcium in a variety of ways. Chickadees have been observed eating ash; Anna's Hummingbirds, a species often found in the far West, sometimes eat calcium-loaded sand. Offer suets with added fruit such as blueberries and raisins for the warblers and woodpeckers. Suets with nuts are always popular. Woodpeckers, creepers, warblers, and kinglets, who traditionally feed on insects on tree trunks and in bushes, will love suet.

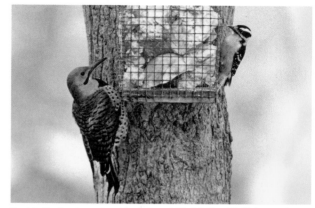

Suet is the best way to attract "trunk birds" like this flicker and Downy Woodpecker.

Birds can't smell and don't recognize suet as a food source at first. It helps them discover the suet if you smear the suet cage with peanut butter and birdseed. Opportunistic birds such as sparrows and finches will recognize the seed and be attracted to the suet feeder. This bird activity will help lure in the more elusive suet-eating birds. Once you have attracted the birds to your suet feeder, it is no longer necessary to smear it with peanut butter and birdseed. For best results, display your suet cage directly on a tree trunk (not swinging) or secured in a bush.

Kinglets love peanut butter and suet and small flocks of them can be seen in much of the United States as they head north for nesting. Blue-gray Gnatcatchers nest in the southern two-thirds of the United States. They move into kinglet winter territory just as the kinglets are leaving. May provides an opportunity to briefly see these two birds together. Even though gnatcatchers don't eat peanut butter or suet, they sometimes flock together with kinglets.

Suet log feeders are very natural and popular with all suet-eating birds. While most suet feeders need to be stabilized for less movement or swinging, a suet log can be hung freely. However, it is still best to put

Kids' Project

Fill netting bags such as mesh onion bags with pet fur, wool, or very short yarn pieces (no more than three inches long) and hang them from a tree branch. Birds will gather the soft materials to line their nests.

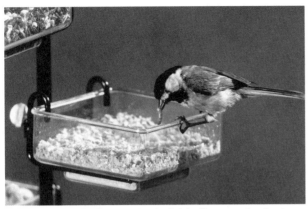

This chickadee will tell you: a simple dish is all you need to feed mealworms.

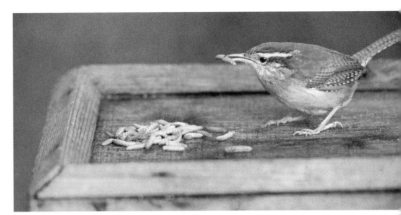

Mealworms in May—perfect for a Carolina Wren.

it in a tree rather than on a free-standing pole. After all, trees are where the birds are!

We recommend feeding suet in more than one location in order to attract a greater variety of birds. If there is no activity at your suet for the first month, change location and try again. Be patient! It can take time for birds to find your suet. It's different than seed feeding.

Remember to separate your suet feeder from your seed feeders. Too much seed-eating bird activity can scare away the suet-eaters.

Mealworms in May

COMMON BIRDS AT MEALWORMS

bluebirds	robins	warblers
flycatchers	tanagers	wrens
orioles	thrashers	

Mealworm feeding is a great way to attract non-seed-eating birds. Spring is the best time to begin offering mealworms because of the increasing number of hungry nesting birds. Baby birds can easily eat live mealworms and other soft-bodied insects brought to them by their parents. We recommend using live mealworms this month, because hungry migratory birds common in May are attracted to their movement.

Place your mealworm feeder near your birdbath. Mealworms are best displayed near a water source where the non-seed-eating birds can easily see them. It may help to sprinkle some seed near the mealworms to attract bird activity. Avoid placing your mealworms in direct sunlight.

Watch robins, flycatchers, and orioles fill their beaks with mealworms to feed to their young. They will return to this high-protein live food again and again, and soon you'll see the young birds feeding from your mealworms as well. In Minnesota, Anne saw Black-capped Chickadees at her mealworm feeder every spring. They ate mealworms just like they eat seed—one at a time. It seems inefficient to grab one small morsel of food, fly away with it, and come back over and over again, but it's awfully fun to watch.

Place your mealworms where you can easily watch the birds eating them, but be prepared to move the dish if raucous birds get too loud. One May, while visiting a cabin in southeastern Arizona, Mary watched a pair of brave Bewick's Wrens at a mealworm feeder on the cabin's front patio. These little birds were unafraid and literally chased Mary inside. They were probably busy feeding their young and refused to be deterred by a mere human.

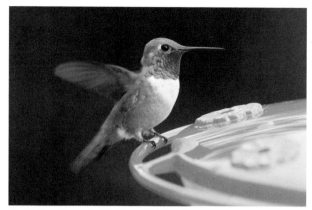

The Rufous Hummingbird loves this feeder.

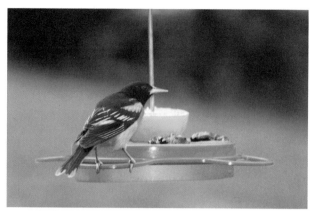

An oriole debates: oranges, grape jelly, or nectar?

Nectar in May

COMMON BIRDS AT NECTAR

hummingbirds tanagers
orioles

Hummingbird Feeding

People in all regions of the country see hummingbirds in May. Because May marks the beginning of the hummingbird season for so many of us, some basic hummingbird information bears repeating here. Remember to use a ratio of four parts water to one part white table sugar in your nectar feeders. Change every three to five days to maintain freshness—even if it's still full. Use a hummingbird feeder that is easy to

Quick Nectar Tips

- Never use brown sugar, honey, or molasses—only white table sugar.
- Prepackaged nectar should contain no additives of any kind.
- There will be more activity later in the summer, after the hummingbirds have nested.

clean, as you will be cleaning your feeder often. We recommend the flat, saucer-style feeders. They are easy to clean, don't drip, and are bee-resistant.

Red food coloring is not needed to attract the hummingbirds and is not recommended. Most feeders have enough red on them to do the trick.

Southerners should already have their feeders out. If you live in the North, get your hummingbird feeder out by May 1.

Hang your feeder where you can best view the hummingbirds. These birds are bold and will come close to your windows. Place your feeder away from any obstacles that can impede the hummingbirds' movement. For example, if you hang your feeder from a porch eave, it should be at least a foot below the eave so the hummingbirds can easily see and fly around the feeder. If you hang your feeder in a tree, make sure it's away from an area with too many branches so it is visible and the hummingbirds can fly around the feeder. Watching hummingbirds feed is only part of the fun. Hummingbirds gather nesting materials in May, and if you pay close attention you can see them harvest spider webs, which make a flexible but tough building material.

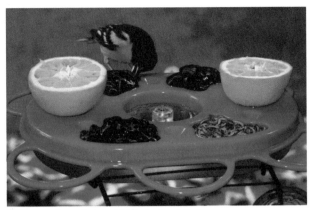

"Mmm...where do I start? Maybe the jelly."

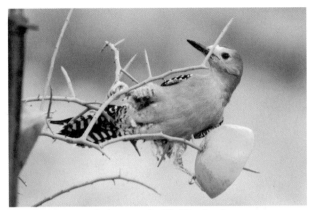

An orange attracts the interest of a Gila Woodpecker.

Oriole Feeding

Orioles live everywhere. They are often not seen because they hide high in trees and need a reason to visit your yard. You probably won't see them unless you feed them. If you live in the North, put your oriole feeder out by May 1; people who live in the South and West should already have it out. Timing is important in attracting orioles—so don't be late.

Oriole feeders are similar to hummingbird feeders, but they have larger feeding ports and perches, and they are orange instead of red. Use the same four-to-one water-to-sugar ratio in your oriole feeder. No coloring is recommended. Change nectar every three to five days to maintain freshness.

Remember, orioles are in tree tops, so when you hang your feeder, it must be out in the open, visible from the sky. Near a water source is best, as orioles are attracted to moving water.

Orioles are among the most colorful birds, so it is well worth the effort to lure them to your yard. Don't get discouraged if it takes a season or two—it often happens that once a family starts feeding in your yard, they will visit year after year!

Some of our customers who live in remote or mountainous areas where tanagers nest see these birds drink nectar from their oriole feeders. Tanagers are even more elusive than orioles, so if your oriole feeder is displayed near your moving water and mealworm feeder, they are more likely to discover it. May is the most likely month to see tanagers.

Fruit in May

COMMON BIRDS AT FRUIT

cardinals	orioles	tanagers
grosbeaks	robins	
mockingbirds	starlings	

Fruit feeding is an easy way to attract non-seed-eating birds all year, but you'll get the most activity in the spring and summer. Keep in mind that May is peak migration time and when you are most likely to see the widest variety of birds. Don't skip feeding fruit this month. By starting fruit feeding in the spring, when birds are establishing nesting territories, you may entice some of them to keep coming all summer long. Tired spring migrants like Scarlet Tanagers will be thrilled to find fruit in your yard this month, especially since natural berries and other fruit are not yet mature.

Fruit types that may entice your birds include dried raisins, cherries, cranberries, and blueberries; apple

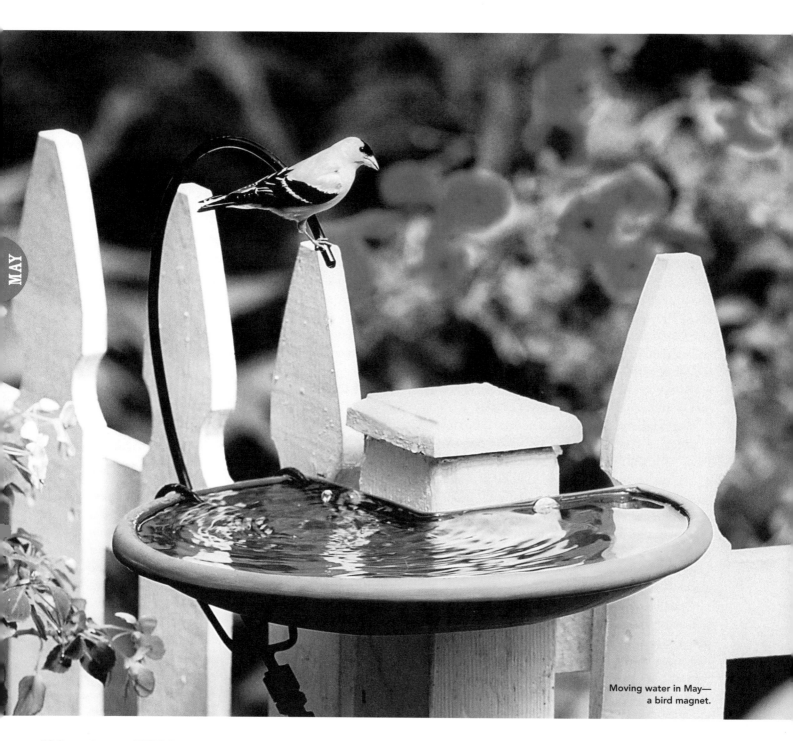

Moving water in May—
a bird magnet.

and orange slices; and grape jelly. Don't be afraid to experiment with different types of fruit. Display dried fruits on or near the ground close to your moving water for best visibility. The robins, mockingbirds, and starlings that prefer these like to feed on the ground and are most likely to find the fruit there. For the best visibility, place apple and orange slices above the ground in an open area near your nectar feeders or moving water. Skewering apples or orange halves on dead tree branches works well, too. This allows the grosbeaks, orioles, and tanagers a place to perch while eating. Even a nail on a fence or on a tree will do. Keep fruits fresh, especially in warmer weather.

Don't be surprised to see Downy and Hairy Woodpeckers eating your apples this month as they look for the extra energy they need to begin the nesting season. Display the grape jelly in a dish above the ground in an open area near your nectar feeders or moving water. A successful and easy way to feed grape jelly is to cut oranges in half and mix the jelly with the pulp. Then secure it on dead tree branches. The orange halves can be used again and again as a perfect holder for the grape jelly. This month watch grosbeaks, orioles, robins, House Finches, and tanagers enjoy it.

Water in May

COMMON BIRDS AT THE BATH

Everybody! Including:

buntings	grosbeaks	orioles
cardinals	warblers	robins
finches	hummingbirds	starlings
flycatchers	jays	tanagers

If you only do one thing to attract birds to your yard in May, put out a birdbath. Because it's peak migration time, May is the mother lode of bird activity in your yard. Many birds don't eat seed, may not be attracted by suet, and may not be interested in your birdhouse, but they all need water every day. Fleeting migrants like the Scarlet Tanager can be exciting to see at the bath this month, but it's also fun to watch nesting birds enjoy a drink and a soak. You may notice that nesting birds bathe more in the spring—gathering sticks, mud, and grass and building nests is dirty work.

We recommend a birdbath no more than two inches deep. Small birds and young birds can drown in a deeper bath and will be hesitant to use it.

Correct placement of your birdbath is important to get more activity. When wet, birds are vulnerable to predators like house cats. Place your birdbath in an open area at least six feet away from trees or bushes. Watch for the birds to perch in the trees and bushes prior to using your bath—they're looking for predators. The birds will often return to these branches to groom after bathing.

Remember, hummingbirds, many of which are returning this month, love to bathe—especially at moving water. Be sure to place some dead twigs and branches against your birdbath for perching. Enjoy watching the hummingbirds land on these to groom.

Ever notice how many birds show up when you run your sprinkler? Birds love moving water. Add water to your yard and double the variety of birds. Make it move, and double the variety again! Adding a dripper or a bubbler to your bath is a good way to get your water moving. Look for all birds, including tanagers, buntings, goldfinches, warblers, grosbeaks, and robins

Quick Bath Tips

- Change water daily year-round.
- Bird-friendly baths are no deeper than 2 inches.
- If you're providing moving water, allow it to run all day to attract more birds.

at your moving water in May. These birds can all be found throughout North America. Pay close attention to your American Goldfinches this month. They have just finished molting and are newly bright yellow. This makes it easier to see them as they perch on the top of your birdbath dripper for a drink.

Check with your local backyard-bird-feeding specialty store for the best selection of bird-friendly baths and ways to get your water moving.

With water, more is better. If possible, offer a variety of birdbaths in different locations and at different levels. Elevated pedestal baths and ground baths both work well. Birds are used to bathing in puddles on the ground. Hanging baths are not as bird friendly, but they are safest from cat attacks.

And remember—all birds come to water!

May is a great time to go out birding because so many different types of birds are on the move. If you do, go early in the morning and go to a wooded area with a stream or lake—some type of natural water source that acts as a magnet for migrating birds. One May a few years ago, Geni was birding in Texas and saw more than thirty Blackburnian Warblers land all at once on a tree next to the stream where she was sitting. This behavior is called "fallout" and most often occurs during migration, when exhausted flocks of birds seem to fall out of the sky at the same time.

Nesting in May

COMMON BIRDS NESTING

bluebirds	House Finches	wood ducks
chickadees	nuthatches	wrens
flycatchers	screech-owls	woodpeckers
kestrels	titmice	

All birds nest in May. Not all will nest in boxes—many build nests in trees, shrubs, or even on the ground—but for those that do, make sure your houses are out.

When purchasing a nesting box, make sure it's appropriate for your area and properly constructed. You won't have much luck with a bluebird box if you don't have bluebirds. And don't assume that your local hardware or big-box store sells the right type of nesting box for your area. Check with your local backyard specialty store for accurate local information. You'll also find more details in Backyard Birding Basics (page 41).

Your box should be constructed with correct dimensions and entrance hole size. Never use a box with a perch, as this just allows easy access for predators. Natural, untreated, and unpainted wood is the best material used. Correct thickness of wood is important in keeping the box insulated against heat and cold. Boxes should have adequate drainage, ventilation, and an overhanging roof to keep out rain. Display the box away from feeding areas. Birds are territorial and want privacy during the nesting season.

Hanging Boxes vs. Mounted Boxes

If you use a hanging box, be sure to protect it from winds that may rock the box and break eggs. It helps to wedge the box between branches for added stability. Chickadees and wrens exist in almost all of North America and they are all easily attracted to nesting boxes. Both species will use a hanging house. Listen for "chickadee-dee-dee," the distinctive song of the chickadee—it's where his name comes from. This song can be easily heard all year, but the telltale, singsong "spring's here" is usually heard only in spring. You can hear both songs in May. Anne's daughter mastered the chickadees' songs when she was very little and loves to tell us when she hears one. All varieties of chickadee share very similar songs.

If you are mounting your house, do so on a tree trunk that's at least ten feet high. Bluebird boxes are the exception: Bluebirds prefer a box mounted on a pole

about five feet from the ground. They live in rural and suburban areas and need a meadowlike habitat. Urban dwellers are unlikely to attract bluebirds even with the perfect box. If you do live in bluebird country, you should have your boxes out very early in the spring. But if you don't get your box out until May you might still have luck. Bluebirds have several broods a season and are finicky about nesting sites. They may have reason to move after their first brood—perhaps a predator ate their young, or maybe the location was too windy. Your box might offer a nice second home for your bluebirds. Check Backyard Birding Basics (page 45) for more detailed information on providing bluebird boxes.

The demand for housing in May is fierce, but this titmouse found a good home.

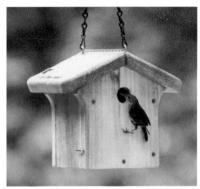

The wren is happy to have a nesting box.

In May, and for most of the summer, you will see very busy birds gathering materials for their nests. Watch as birds fly over and over again to their construction site, their beaks filled with grass, twigs, paper . . . almost anything will do. If you pay attention to where they fly with these materials, you can usually figure out where their nest is.

Hang wool, pet fur, or short pieces of yarn in a nesting bag (an old onion bag works well) to give them extra building materials. Nest construction is in full swing this month, so enjoy the show.

Observing nesting birds can be fun and very educational, but be careful. Don't disturb the nesting site, as that may cause parent birds to abandon their young. Even if you try to be careful and quiet around your birds' nesting sites, there may be a few instances when interfering a bit is just fine. A customer in Albuquerque told us that she held an umbrella over a vulnerable hummingbird nest during several rainstorms one summer. Disruptive? Maybe, but the female hummingbird brought up two healthy batches of babies that season. Another customer who had Barn Swallows nesting on top of her porch light decided to do her birds a favor. Hoping to make them more comfortable, she removed the light before nesting season, replacing it with a nesting shelf. The swallows never returned; instead they moved down the street to a neighbor's porch light. It's hard to know what is best. Common sense doesn't always work when we are dealing with wild animals.

Nesting season is a dangerous time for baby birds. Predators such as other birds and snakes can raid the nest. It can be tough to watch, so be prepared to experience nature at both its best and worst. Although you don't really want to interfere with nature, it's just fine to shoo cats and other predators away from your nesting birds. In her Minneapolis yard, Anne once spent a late May afternoon trying to keep an Eastern Blue Jay away from a Mourning Dove nest. In the end she and the dove lost out.

May is the beginning of the season when you will see baby birds in your yard. If they are very small, with few or no feathers, locate the nest and put them back. It is an old but stubborn myth that birds will smell your human scent and abandon any bird you have touched. If the baby bird is fairly large and has feathers, it is a

fledgling, and you should leave it alone. Fledglings fall or get pushed out of the nest by a parent and usually spend a couple of days on the ground learning to fly. They are vulnerable during this period, but a parent is usually nearby watching their youngsters and bringing them food.

Sisters' Tips for May

From Mary:

Water! Water! Water! Get your water moving so it makes sound and splashes. This will increase your bird variety tremendously. Take time to relax and notice what birds are visiting your water—Indigo Buntings, tanagers, warblers, grosbeaks, to name a few. The variety will surprise you!

From Anne:

Fill your tube feeder with white proso millet in May to attract Indigo Buntings (bright blue and beautiful). You may also see one on your nyjer mesh-style feeder. May is the only month most of us can attract these stunning birds to our feeders.

From Geni:

Use a seed block with black-oil sunflower and fruit such as cranberries. We've seen hungry robins picking the fruit out of the block in May.

Backyard Habitat in May

COMMON BIRDS IN YOUR YARD

cardinals	orioles	towhees
grosbeaks	robins	
hummingbirds	tanagers	

There's No Place Like Your Own Backyard

Birds love dense, overgrown woods. Take a good look at your yard and ask yourself if a bird would find natural food, water, and cover there. A natural yard can be as beautiful as a well-manicured one.

In most regions of the country, May is a good time to plant. Always choose native plants for your area, because this is what the local birds are looking for. Many birds don't eat seed and are looking for berry-producing shrubs and trees or nectar-producing flowers. For example, robins and waxwings love mountain ash, pyracantha, holly, Virginia creeper, and cotoneaster berries. Tanagers, orioles, and grosbeaks love mulberry, raspberry, and cherry trees. Hummingbirds are attracted to tubular nectar-producing flowers such as the trumpet vine, honeysuckle, red hot pokers, desert willow, and penstemon.

Seed-eating birds will not only be attracted to your feeders, but will rely on natural seed-producing plants for the majority of their diet. The finches, towhees, and chickadees will eat seeds from native sunflowers, coneflowers, maximillians, pinecones, and chamisas.

Don't cut seedheads from your plants too early. Birds will eat from natural seedheads and other plant material well into winter months, as well as come to your feeder to supplement their diet.

Our bird stores offer a birdscaping service that includes advice on what native plants to plant, as well as feeder styles and best feeder placement in your yard. Check with your local bird store or garden center to see if they offer this service.

A perfect spot for birds to live.

date	birds sighted	notes

date	birds sighted	notes

MAY

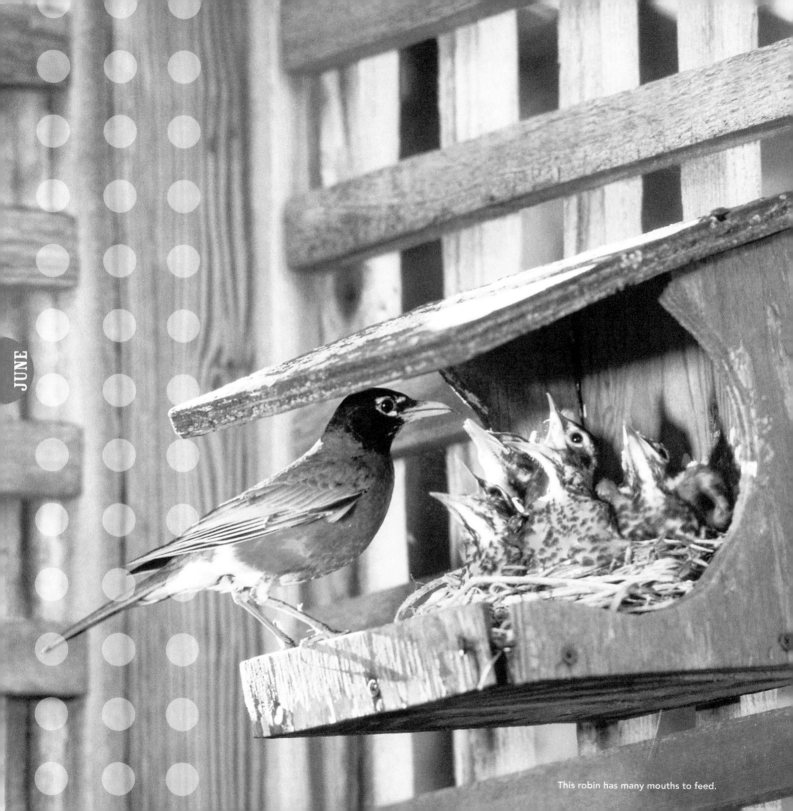

This robin has many mouths to feed.

JUNE

Babies, Babies, Babies

Spring migration is over, and your birds are settling in to raise their families.

This month watch for baby birds at your feeder. Pay attention, because these fledglings may already be the same size as their parents. You can tell they are young birds by their behavior. Watch them beg their patient parents for food by flapping their wings frantically and squawking with beaks opened wide. We have seen young, impatient orioles, barely able to hang on to our oriole nectar feeder, squawk loudly as their parents fill their beaks with nectar. In the summer we commonly see young sparrows eagerly hopping on the ground behind their parents, or any adult bird, begging to be fed.

Mourning Doves, who nest throughout North America, build unkempt nests using sticks and twigs. These sloppy nests don't always hold together well, but Mourning Doves can afford to lose an egg now and then since they have four to five broods each nesting season. It is not uncommon to see young doves who have fallen from these nests hiding under bushes, where their parents bring them seed until they learn to fly and fend for themselves.

Many of us wake with "bed hair" in the morning. Young birds awake with what we like to call "nest

Birds to Look For

(found in most regions unless otherwise noted)

Western Tanager (West)

Summer Tanager (Midwest, Southeast, and Southwest)

Scarlet Tanager (Midwest and East)

Baltimore Oriole (Eastern half of U.S.)

Bullock's Oriole (West)

Broad-tailed Hummingbird (West)

Ruby-throated Hummingbird (Eastern half of U.S.)

Black-chinned Hummingbird (West)

Black-headed Grosbeak (West)

Rose-breasted Grosbeak (Eastern half of U.S.)

American Robin

Northern Mockingbird (Southern two-thirds of North America)

Black-capped Chickadee (Northern two-thirds of North America)

Carolina Chickadee (Southeast)

Mountain Chickadee (West)

White-breasted Nuthatch

American Goldfinch (Northern two-thirds of U. S.)

Lesser Goldfinch (Southwest)

Northern Cardinal (Midwestern and Eastern U.S.)

Ladder-backed Woodpecker (Southwest)

Downy Woodpecker

Hairy Woodpecker

House Finch

Tufted Titmouse (Eastern half of U.S.)

Juniper Titmouse (Southwest)

Common Grackle (East)

Blue Jay (Midwest and East)

Scrub Jay (West and Southwest)

Spotted Towhee (West)

Eastern Towhee (Southeast and lower Midwest)

Mourning Dove

head." In addition to constant begging, a rumpled appearance is often a good way to identify a fledgling. Watching the behavior of young birds and how they relate to their parents and their environment is one of the best parts of summer feeding.

Remember, what we provide the birds is only a fraction of their diet. They do not become dependent upon it. In the summer especially, we feed the birds more for us than for them—it's such a great show. Just because birds have more natural food available to them is no reason to stop bringing them up close.

Birdseed in June

COMMON BIRDS AT SEED

cardinals	sparrows	doves
grosbeaks	chickadees	woodpeckers
jays	starlings	titmice
finches	nuthatches	

Best June Mix

60% black-oil sunflower, 30% white millet, 10% safflower, striped sunflower, shelled peanuts. A little cracked corn is okay, too.

MORE TREES = MORE SUNFLOWER

If you live in a heavily wooded area, increase black-oil sunflower to 75%, decrease white millet to 20%, and use 5% peanuts, safflower, or striped sunflower.

It's nesting season, and adult birds need the high energy the black-oil sunflower in your mix provides to help them keep up with the demands of their youngsters. Adult birds often crack open the black-oil sunflower shell and feed the meat inside to their young. Raising a family is hard work. Mom and Dad need calories, and their young need plenty of food to survive. After leaving the nest, young sunflower-eating birds will be better equipped with large beaks able to crack the shells.

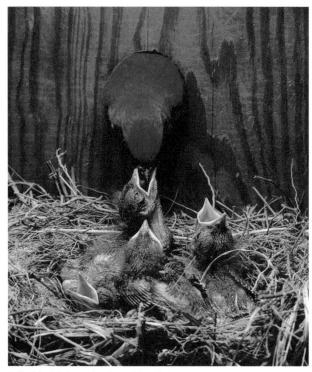

Baby bluebirds anxiously waiting their turn.

Continue to feed white millet as always, but less of it. This is the month we often hear people complain of excess millet lying uneaten on the ground. By June, you may not have as many ground-feeding birds in your yard. Your wintering juncos have migrated north, and other millet-eating birds like sparrows and doves are busy finding mates and are no longer forming large winter flocks. Use a mix with no more than 30 percent white millet in your tube- or hopper-style feeders. If you use an open tray or scatter millet directly on the ground, only offer what your birds can eat in one day; this will avoid unnecessary buildup.

If you don't want any sprouting or shells in your yard this summer, use sunflower chips or a no-mess blend that is at least 50 percent sunflower chips in your tube, hopper, or tray feeder. The other half of the mix should

be mostly hull-less millet, but a little cracked corn or shelled peanuts may bring more birds.

Adding some safflower or shelled peanuts can really jazz up your mix and may attract a few woodpeckers or titmice. In Minnesota, we've seen a Red-bellied Woodpecker grab a peanut out of our mix and fly off. Red-bellied Woodpeckers have lots more red on their head than on their belly and are often misidentified as Red-headed Woodpeckers, whose male is solid red from the neck up.

Shelled nuts can be part of a mix, but your woodpeckers, Bushtits, chickadees, and nuthatches may come more often to a feeder offering only shelled peanuts. Nut-eating birds don't like a crowd and look for natural food in trees, so hang your shelled nut feeder in a tree away from your other feeders. You can also use a hanging wire-cage-type feeder or an open tray for shelled peanuts.

Watch adult woodpeckers bring their young to your nut feeder. Sometimes they will break the peanut into little pieces for their baby, who is impatiently clinging to the side of a tree. Baby woodpeckers can be very chatty when begging their parents for food, so keep your ears open as well as your eyes.

As usual, bold jays will love to eat in-shell peanuts from your hand, a tray, a stump . . . almost anywhere. We've heard jays loudly squawking until we bring another handful of peanuts out to their feeder. They have trained us well!

Goldfinches and Pine Siskins prefer nyjer thistle. Feed it in a specialized nyjer feeder, separate from your other seed feeders. We recommend the mesh-style nyjer feeder, either a nyjer sock or a stainless-

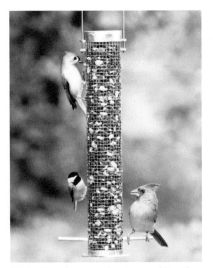

Black-oil sunflower and nuts are a hit with this titmouse, chickadee, and cardinal.

Lesser Goldfinches eating nyjer thistle.

steel mesh. Remember, goldfinches are shy and like to be off by themselves. If House Finches are dominating your finch feeder, try using a feeder designed to make the birds hang upside down to access the seed. Goldfinches and Pine Siskins can easily do this, but House Finches and sparrows cannot.

Goldfinches and Pine Siskins love moving water, so hanging your nyjer feeder near your moving water or birdbath greatly increases your chance of attracting

Quick Seed Tips

- Feed daily to encourage newly fledged young birds to visit your feeders.
- American goldfinches have turned brilliant yellow for the nesting season. Continue to feed them nyjer thistle.
- Watch your seed feeders closely. Adult birds will often feed their young there.
- Use a mix with at least 60 percent black-oil sunflower seed.

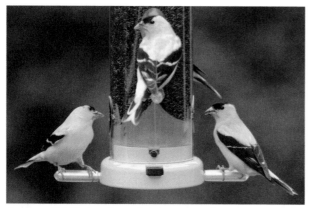

American Goldfinches show off their summer plumage.

them. Birds find food by sight—put the feeder out in the open so finches will spot it.

American Goldfinches have turned bright yellow by June, so put your feeder where you can easily see these beautiful birds.

This month listen for the sweet, musical, twittering song of your goldfinches and the buzz of the Pine Siskins.

Kids' Project

Plant a garden for the birds. Sunflowers are always a good choice. Coneflowers and nectar producers like impatiens and honeysuckle can bring in birds, too. Check with your local nursery and backyard-bird-feeding store for the best selection and advice on bird-friendly plants for your area.

Have fun tending the garden and enjoy the wide variety of birds visiting this natural habitat. Remember to copy nature.

Suet in June

COMMON BIRDS AT SUET

woodpeckers	jays	starlings
titmice	thrashers	chickadees
Bushtits	mockingbirds	nuthatches

Since it's nesting season, your birds could use added calcium to help produce strong eggshells. Continue to use suets that contain added calcium and choose "no-melt" suet doughs unless you live where it stays cool all year. Check with your local backyard-bird-feeding store for the best selection and freshest suet.

This month, nesting birds are craving more energy to raise their young. Some birds get very excited about berries, so suets with added berries are sure to attract a wide variety—mockingbirds, cardinals, and woodpeckers will love them. The male Ladder-backed Woodpecker at Mary's suet in Albuquerque raises his bright red head feathers and squawks loudly when picking blueberries out of the suet to feed his babies in June.

Suets attract even more birds when hung in a tree or bush where suet-eating birds like Downy Woodpeckers, flickers, nuthatches, and kinglets naturally search for food. This month you may see larger woodpeckers, like the Northern Flicker (red-shafted in the West and yellow-shafted in the East), brace their tails against the tree trunk for leverage while eating the suet. You will also see flickers eating ants on the ground—they are the only members of the woodpecker family to do that. So, if you see a big woodpeckerlike bird pecking at the ground, you know it's a flicker.

Nesting birds will often feed suet to their young. Watch adult woodpeckers grab a chunk of this high-calorie treat and fly to a hungry youngster waiting impatiently on a branch. Soon you will see fledglings feeding themselves at your suet feeder. It's such fun to watch parents teach their young how to eat the food you provide—enjoy the show.

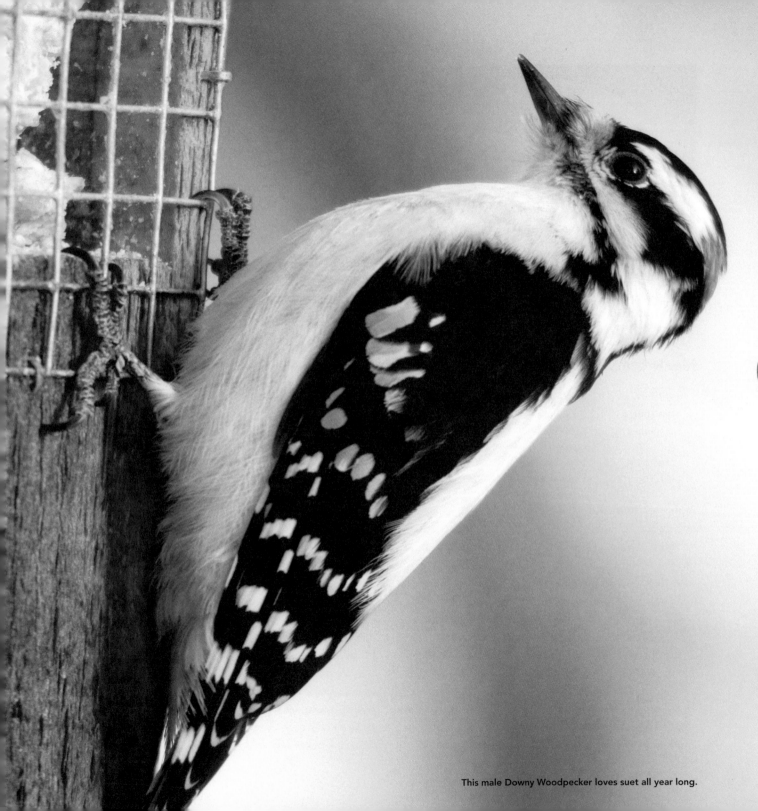

This male Downy Woodpecker loves suet all year long.

A bluebird gathers mealworms to bring back to the nest.

Mealworms in June

COMMON BIRDS AT MEALWORMS

bluebirds	thrashers	sparrows
orioles	starlings	warblers
mockingbirds	wrens	flycatchers
tanagers	finches	
robins	chickadees	

Birds will find lots of insects in nature this month, but it's fun to watch them go after your worms. Say's Phoebes, found in the West, often build nests under the eaves of a porch, making it easy to watch them raise their young. We have customers who sprinkle live mealworms on their porch railing and watch as these brave parents fly down and grab a beak full of squirmy mealworms to take to their hungry youngsters.

Robins also love mealworms. We have seen baby robins chasing after their parents, beaks wide open, begging for this tasty treat.

Birds prefer live mealworms, but if the temperature is too high, dried/roasted mealworms can be offered. Display mealworms in an open dish or mealworm feeder near water, where your birds are more likely to find them. Live mealworms will crawl away unless your feeder has slippery sides. A cereal bowl works well for this.

Be patient: Mealworm feeding can be tricky. Mixing seed or dried fruit with your mealworms may help your birds discover them faster. Once your birds find the mealworms, watch them load their beaks to capacity and take this tasty morsel back to their nest.

Nectar in June

COMMON BIRDS AT NECTAR
hummingbirds
orioles

Hummingbird Feeding

Every June people ask us, "Where have all the hummingbirds gone? I had a lot more hummingbirds last year." The fact is that hummingbirds are still around, but they have settled down to nest. They are eating insects and nectar from flowers so don't be surprised if there's less activity at your feeder. Most people are remembering the increased activity they had the previous July, August, and September.

Hummingbirds use their long tongues to catch small gnats in the air. You may notice hummingbirds hovering above you while you are gardening. Your movement often disturbs insects, making them fly into the air—these make nice snacks for hovering hummingbirds.

June is a good time to watch and listen to male hummingbirds performing their mating dance. This can be entertaining for us as well as for the intended female. The male Black-chinned Hummingbird in the West flies at high speed, making an abrupt U-turn to change course. He will do this over and over again, trying to impress a watching female.

Continue providing fresh nectar so you'll be ready when the hummingbirds come back, though. Humming-

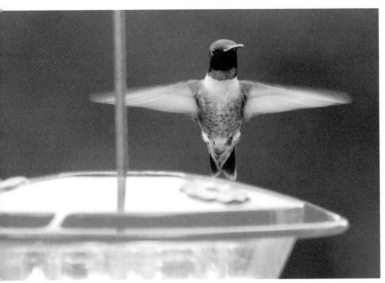

"Is this all for me?"

"I'll share if I have to."

birds' southward migration begins at the end of June. That's also about the time the young begin to leave the nest. In many areas, the end of June and early July see increased hummingbird activity as babies start feeding *and* migrants from further north start to come through.

Most hummingbirds are territorial and very aggressive at nectar feeders. Often one will chase away all the others trying to feed. Young hummingbirds have just left the crowded nest and have not learned to be aggressive yet. If you see many hummingbirds feeding together, they are most likely young ones.

If one or two hummingbirds are monopolizing your feeder, put out another feeder or two. This will spread out the competition and allow access for more hummingbirds. Refer to the hummingbird feeding section of Backyard Birding Basics (page 30) for more information on hummingbird feeders.

Oriole Feeding

Orioles arrive in April in the South and May in the North, but June is not too late to start trying to attract these beautiful birds to your yard. To make nectar for them, use four parts water to one part white table sugar. Keep your nectar fresh. Change it every three to five days—more often in hotter weather—whether or not the birds are coming.

Use an oriole nectar feeder for orioles, not a hummingbird feeder. The oriole feeder has more perching space, as well as larger holes to accommodate the oriole's large beak. (Orioles have been known to yank off the plastic yellow flowers on some hummingbird feeders to expose a larger hole and give them better access to the nectar.) We like an orange-colored saucer-style oriole feeder, but others work well, too. Refer to the oriole feeding section of Backyard Birding Basics (page 32) for more information on feeders.

Feeder placement is critical in attracting orioles. Display your nectar feeder in the open near your birdbath or fountain. Orioles perch high in trees and are often lured in by the sight and sounds of water. They are more likely to discover the nectar while visiting your bath.

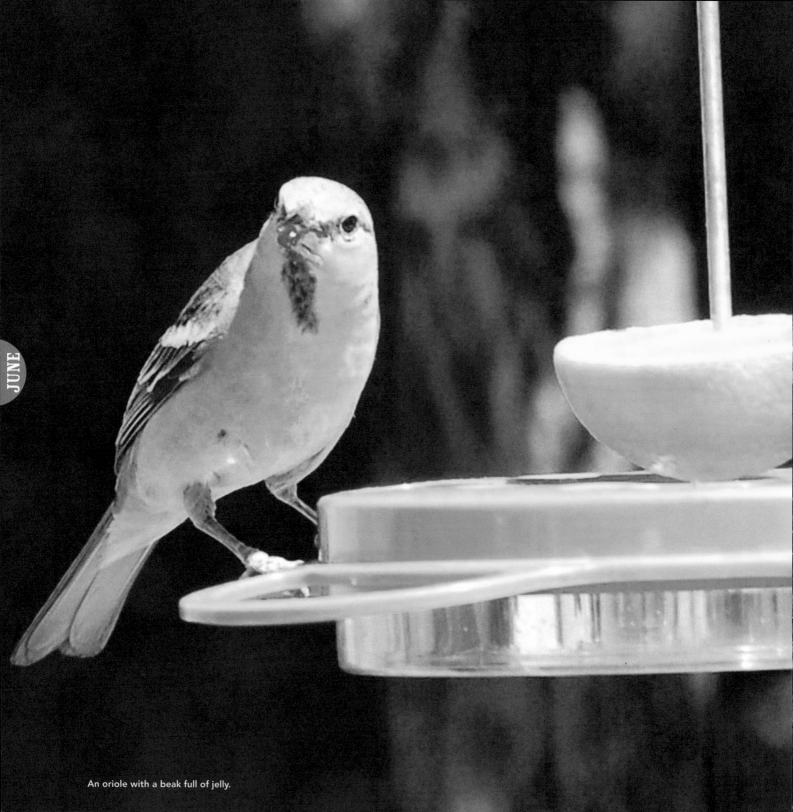

An oriole with a beak full of jelly.

When orioles first arrive they will feed together, but by June they have begun to nest so one parent always stays with the nest while the other searches for food. It may seem that your feeder has less activity, but they are just taking turns. It's also possible to have increased activity in June because it is a transition month for orioles. They may not have all settled down quite yet, so territories may overlap. Most have paired off and found their own nesting and feeding areas, but not all males have found a mate yet. Mary has seen as many as eight male orioles at her Albuquerque nectar feeder in June. Some were probably bachelors, and they all seemed to be jockeying for dominance at the feeder, most likely an extension of their competition for territory and mates.

Fruit in June

COMMON BIRDS AT FRUIT

orioles	woodpeckers	sparrows
tanagers	mockingbirds	grosbeaks
cardinals	robins	
finches	starlings	

It may surprise you to learn how many birds will eat fruit, and June is a great month to feed it. Birds like tanagers and orioles, who are only here in the spring and summer, love fruit, and they may bring their babies to your feeder.

Your summer orioles, tanagers, woodpeckers, and grosbeaks love oranges and apples. Display the fresh fruit meat side up on a prong fruit feeder or secured to dead tree branches where birds can easily perch while feeding. Don't be surprised to see hummingbirds buzzing around the orange halves, picking off the insects that get stuck to them.

Grape jelly is a favorite of orioles. Once they discover your grape jelly, they keep coming back for

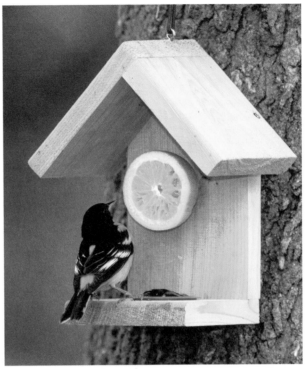

A Baltimore Oriole hits the jackpot.

more. These beautiful birds will cause excitement for you and your neighbors. We made a deal with a neighbor that if we hung our oriole feeder where she could see it, she would provide the jelly. This worked out well for us: She ended up buying jelly in bulk to save money because of all the entertaining summer activity at our feeder.

Robins, starlings, and waxwings are attracted to dried fruit like dried cranberries, cherries, and raisins. Display it in a dish on or near the ground by your birdbath or fountain. Sprinkle some birdseed in with your dried fruit to help the birds discover it, if necessary.

Be patient and persistent when feeding fruit. Birds are active at fruit feeders sporadically. Keep your fruit fresh and keep trying. You are most likely to be successful in spring and summer months.

Water in June

Everybody! Including:

orioles	tanagers	cardinals
goldfinches	buntings	finches
bluebirds	robins	sparrows
grosbeaks	warblers	

We all flock to the water in summer, and so do the birds. Providing water is the best way to increase the variety of beautiful summer birds visiting your yard. Remember, all birds need water every day—they don't all eat seed or drink nectar. Tanagers are just one of the many beautiful summer birds that perch high in tree tops, making it difficult for us to see them, especially in dense June leaf cover. Luring them down to your water is the best way to catch a glimpse. Geni

saw bright red Scarlet Tanagers most summers in rural northern Illinois. She knew they were nesting somewhere on her property but never got a good look at them unless they were visiting her birdbath.

Use a birdbath no deeper than two inches to encourage youngsters and smaller birds like goldfinches and chickadees to bathe. Always place your bath in a location that is visible to you, as June at the bath can be quite a show. All birds are nesting this month and it can be a very messy job. We have seen ragged-looking robins at our bath trying to clean up before going back to their nest.

Stick dead tree branches in the ground next to your bath. This provides perches for birds to view the bath and on which they can sit to groom after bathing. It's also a great way for you to see more of your birds. Hummingbirds love to bathe in the early

Bluebirds contemplate a bath.

morning hours or at dusk. Throughout the summer we have watched hummingbirds dive into our bird-bath to wet their feathers and then sit on the dead branches we placed next to the bath to groom. We love watching clean birds groom themselves out in the open—they are so meticulous.

Provide water in more than one location for even more activity.

Summer is the easiest time to add moving water. You don't have to worry about pumps freezing, and it's a pleasant time to be outside tending to your bird-bath. Try adding a dripper or rock waterfall to your bath. Birds love a shallow, bubbling brook—they are attracted to the sound, so if you can create a mini babbling brook in your backyard you will attract many more birds. We have seen summer tanagers, gold-finches, and hummingbirds bathing in our moving water while ignoring our other baths.

This month look for young birds discovering your bath for the first time. It will bring a smile to your face when you see a young bird jumping around the edge of your bath, trying to figure out how to get into the water.

Nesting in June

COMMON BIRDS NESTING

bluebirds	titmice	finches
swallows	kestrels	sparrows
chickadees	wrens	
phoebes	flycatchers	

June is the month all birds are nesting, whether or not they use nesting boxes. We have seen hummingbirds nesting on wind chimes and Say's Phoebes nesting on front porch lights. House Finches commonly build their nests in hanging flower baskets—making it difficult for you to water. It's fun to watch birds build a nest and raise their young, and a great lesson for kids.

Peak nesting season keeps this Mountain Bluebird busy.

June is not too late to put out a nesting box. Many birds will have three or four broods of young over the course of the nesting season and may still be in the market for a home.

Make sure you place your box away from your seed feeders. Nesting birds prefer privacy when raising their young. Don't face the nesting box toward the wind—a quiet, sheltered place is best. Use nesting boxes suitable for your local birds. Check with your local backyard-bird-feeding store for the best advice and selection of nesting boxes. Also refer to the nesting section of Backyard Birding Basics (page 41).

Never disturb nesting birds in a box or elsewhere in your yard. Too much disruption may cause birds to abandon their nests. Bluebirds are especially sensitive—they will often build a nest in a box, then suddenly abandon it for no apparent reason. If you live in an open, rural area and hope to attract bluebirds to a nesting box, refer to the bluebird nesting section of Backyard Birding Basics (page 45) for detailed bluebird information.

Put out nesting material for the birds. Sparrows, flycatchers, and finches love to use pet fur to line their nests. Its warmth and strength make it the perfect building material, and we're thrilled to find a good use for what seems like an endless supply of pet fur. Put pet hair on the ground where birds can see it, or hang it in a mesh or wire cage (i.e., an empty suet cage), and pull some strands partway out to make it more visible.

Orioles and other birds love to use yarn to weave their nests. Place yarn in a netting bag or mesh cage, and use only short strands of yarn, no more than three inches long (longer pieces can wrap around the necks of baby birds). Hang the yarn supply from a branch against a tree trunk. This allows the birds a place to perch while pulling it out. Use different colors of yarn to make it easier for you to spot the nest once it is built.

Quick Nesting Tips

• Never disturb nesting birds.

• Watch your nesting boxes for increased activity.

• Young birds will be learning to fly. Watch for young birds hopping around in your yard while parents bring them food.

• Summer is a good time to keep your pet cats inside or supervised if outdoors. Many young birds are more vulnerable to cat attacks during nesting season.

In June, don't be surprised to see young birds (often the same size as their parents) hopping around your yard, unable to fly. Don't pick them up; they are probably not injured. Birds often leave the nest before they can fly—learning to do that takes time. No need to worry, the adult birds will bring food, and soon the young ones will be able to fly on their own.

Backyard Habitat in June

COMMON BIRDS IN YOUR YARD

cardinals	goldfinches	buntings
hummingbirds	tanagers	wrens
finches	sparrows	jays
orioles	grosbeaks	woodpeckers

June is a great month to spend time in your yard. Birds are singing and nesting, and temperatures are comfortable. The bird sounds hit their peak. Birds with beautiful voices, like cardinals, buntings, warblers, robins, and thrashers, stand out with their lovely songs. Curved-bill Thrashers in the West and Brown Thrashers in the East may not be as colorful as the summer orioles and tanagers, but they make up for it with their rich music. In the same family and found in much of the country, the Gray Catbird makes a mewing sound that can even fool your feline. Its cousin, the widespread Northern Mockingbird, imitates many other bird songs.

Look around your yard. Is your yard a haven for you and your birds? Encourage more bird activity by providing a natural space for you and your birds to enjoy. Natural and overgrown yards are beautiful and just what your birds want. It's the habitat that counts most—the type of feeder, birdbath, or suet that you provide is important but not as important as habitat.

Plant native, nectar-producing flowers for your hummingbirds, orioles, Verdins, and tanagers. We often see hummingbirds at our feeders who appear to

have yellow beaks. That color is the pollen they have gathered while feeding at flowers. Hummingbirds are pollinators, and they love trumpet vine, honeysuckle, impatiens, and many other flowers.

Plant natural, seed-producing plants and shrubs that your birds can feed on during summer, fall, and winter months. We have noticed goldfinches swarming our Russian sage, sunflowers, and purple coneflowers, picking at the blooms and seeds all summer long.

Berry-producing trees, vines, and shrubs can attract grosbeaks, tanagers, and orioles. Mulberry and juniper trees are popular. Always check with your local nursery and backyard-bird-feeding specialty store for the best information on what to plant for your local birds and you to enjoy.

Birds love natural seedheads from flowers, berries from shrubs and trees, and nectar from other flowers; they also need the cover for protection and for nesting. Woodpeckers need trees where they can find insects and larvae. If your backyard naturally provides a variety of food and cover, you will have more birds.

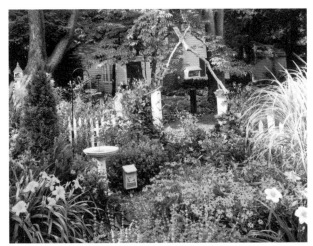

Pull up a chair and enjoy.

Quick Habitat Tips

- Create a natural yard. Overgrown is good—it copies nature.
- Plant flowering, nectar-producing plants for hummingbirds, orioles, and bees. Native plants, shrubs, and trees are best.
- Create a livable space outdoors for you and your birds.

Sisters' Tips for June

From Mary:

Watch your feeders for baby birds flapping their wings, with their beaks wide open, begging for food from their parents. They are often as big as their parents.

From Anne:

All the goldfinches are in their bright yellow plumage for summer. Continue to feed fresh nyjer seed to attract these beautiful birds. I like mesh-style finch feeders best. Hang them away from other feeders, but close enough where you can see the birds.

From Geni:

Continue to feed a mix heavy in black-oil sunflower seed (at least 60 percent sunflower). Nesting birds need the high oil and fat content this seed provides. Watch adult birds offer a black-oil sunflower seed to a mate as a courtship ritual.

date	birds sighted	notes

date	birds sighted	notes

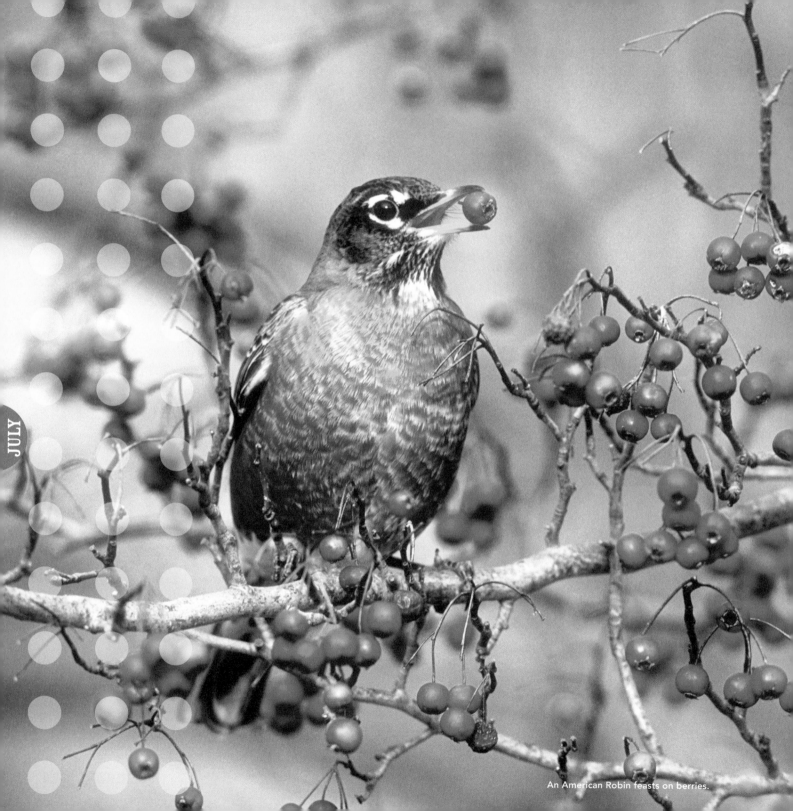

An American Robin feasts on berries.

Birds to Look For

(found in most regions unless otherwise noted)

Western Tanager (West)

Summer Tanager (Midwest, Southeast, and Southwest)

Scarlet Tanager (Midwest and East)

Baltimore Oriole (Eastern half of U.S.)

Bullock's Oriole (West)

Rufous Hummingbird (West)

Broad-tailed Hummingbird (West)

Ruby-throated Hummingbird (Eastern half of U.S.)

Black-chinned Hummingbird (West)

Black-headed Grosbeak (West)

Rose-breasted Grosbeak (Eastern half of U.S.)

American Robin

Northern Mockingbird (Southern two-thirds of North America)

Black-capped Chickadee (Northern two-thirds of North America)

Carolina Chickadee (Southeast)

Mountain Chickadee (West)

White-breasted Nuthatch

American Goldfinch (Northern two-thirds of U.S.)

Lesser Goldfinch (Southwest)

Northern Cardinal (Midwestern and Eastern U.S.)

Ladder-backed Woodpecker (Southwest)

Downy Woodpecker

Hairy Woodpecker

House Finch

Tufted Titmouse (Eastern half of U.S.)

Juniper Titmouse (Southwest)

Common Grackle (East)

Blue Jay (Midwest and East)

Scrub Jay (West and Southwest)

Spotted Towhee (West)

Eastern Towhee (Southeast and lower Midwest)

JULY By midsummer, all your birds have established their nesting territories and are busy raising their second or third batch of babies. We receive many calls this month about "injured" birds—really, fledglings that have naturally left or been pushed out of the nest by their bigger siblings. Leave them alone. Their parents will feed them until they are able to fly on their own. This usually takes two or three days.

Young "nest heads" are looking for an easy meal. Fledglings are at your feeders, learning to shell sunflower seeds on their own and still wildly begging their parents for food.

Woodpeckers will appear with their babies at your suet feeders. Multiple babies will cling to the tree trunk, waiting for the parent to feed them.

Hummingbirds and orioles are busy at your nectar feeders, stocking up for their long migration south. Parts of the West can see up to five varieties of hummingbirds. We have customers who go through more than a gallon of sugar water a day and buy their sugar twenty pounds at a time!

Your yard is in full bloom this month; flower seedheads and berries are providing natural food for your birds, and dense shrubs and trees are giving needed shelter and nesting spots for all. July is a great time to enjoy this midsummer activity in your backyard.

Birdseed in July

COMMON BIRDS AT SEED

cardinals	towhees	finches
doves	nuthatches	thrashers
grosbeaks	sparrows	Pine Siskins
titmice	woodpeckers	goldfinches
chickadees	jays	

Best July Mix

60% black-oil sunflower, 30% white millet, 10% safflower or striped sunflower

MORE TREES = MORE SUNFLOWER

If you live in a heavily wooded area, increase black-oil sunflower to 75%, decrease millet to 20%, and use 5% safflower or striped sunflower.

In summer, make sure your hopper- and tube-style feeders are filled with a mix that is at least 60 percent black-oil sunflower, the favorite of birds like cardinals, grosbeaks, chickadees, House Finches, and nuthatches. They will often feed this high-calorie seed to their young. Parents also need the boost that sunflower provides. It's not easy raising two to four batches of babies within a few months' time.

Watch little chickadees and nuthatches grab a sunflower seed from your feeder and fly off to a

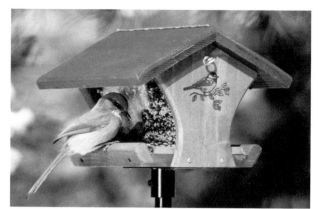

A Scrub Jay has the feeder all to himself.

tree branch. These smaller-beaked birds will hold the sunflower seed between their toes and use their sharp beaks to crack the shell. Chickadees go back and forth many times from feeder to tree. They are busy-looking birds and appear to use all their energy flitting from place to place. Finches and cardinals, with their larger beaks, quickly crack the shell while at your feeder.

July's mix is mostly sunflower but has enough millet, which gets kicked to the ground, to satisfy your ground-feeding dove, towhee, and various sparrow species. The millet-loving juncos spend the summer nesting in Canada, so your mix doesn't need as much now that they are gone. You can toss millet by itself on the ground or put it in a ground feeder. Watch young towhees, sparrows, and doves scratch on the ground, looking for millet and other food. Now and then, you'll see a batch of big, wobbly babies chasing after their parents, copying their every move—very fun to watch. We've even seen young birds pick at pebbles, thinking they were food. They eventually figured out the difference.

Cardinals and doves love safflower seed. Titmice, chickadees, and House Finches like it, too. Remember, squirrels, blackbirds, and sparrows don't like saf-

Quick Seed Tips

- Feed a mix with at least 60 percent black-oil sunflower seed. Birds are looking for the extra calories during summer nesting.

- Watch for young birds at your feeders. They have an unkempt, "nest-head" appearance.

- Hang your feeders where you can see them from inside your house or from your patio or porch.

- American Goldfinches are nesting—provide nyjer seed to attract these brilliant yellow birds.

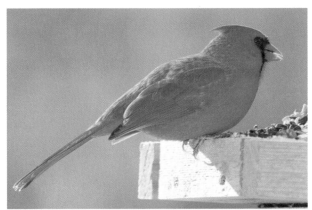

"I love safflower."

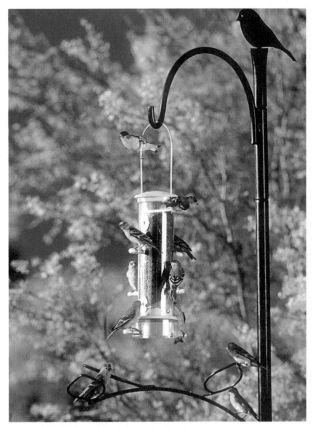

Lesser Goldfinches crowd this nyjer feeder.

flower very much when fed by itself. Safflower is the perfect high-calorie seed to mix with your black-oil sunflower seed in your tube- or hopper-style feeders. Nesting birds need all the calories they can get. Your larger cardinals, grosbeaks, and doves will find it easier to eat seed from an open-tray feeder.

Summertime is no-mess seed time. Sunflower chips or a no-mess blend is a clean, easy way to feed your birds. These hull-less seeds leave no shell and can't sprout, so . . . no messing up your summer garden and lawn. When first feeding chips or a no-mess blend, mix with some black-oil sunflower. Birds will recognize black-oil sunflower as a food source more quickly and this will jump-start your hull-less seed feeding.

No yard is complete without a nyjer feeder being mobbed by beautiful yellow goldfinches and cute little Pine Siskins. We highly recommend using the mesh-style nyjer feeders, either a nyjer sock or stainless-steel mesh. Goldfinches and Pine Siskins love these feeders but they discourage other birds.

In July it's not uncommon to hear customers complain that they've "lost their goldfinches since it's been really hot." Upon inquiry, we usually find that their seed is old. Hot weather can spoil seed quickly. The seed in the feeder may have been out for more

that a few weeks; or the main stash of seed may have been sitting in a storage can in the heat, or simply gotten old and stale. Wet weather can also be the cause of quick nyjer spoilage. Once customers toss out this old seed and fill the feeder with fresh, the finches usually return.

Woodpeckers, chickadees, nuthatches, and titmice love shelled peanuts. It is common in July to see these birds bring their young to a shelled-peanut feeder for a high-calorie treat. Grosbeaks and jays will often grab a peanut to bring back to a nest full of hungry youngsters. Peanuts give a needed energy boost to your nesting birds.

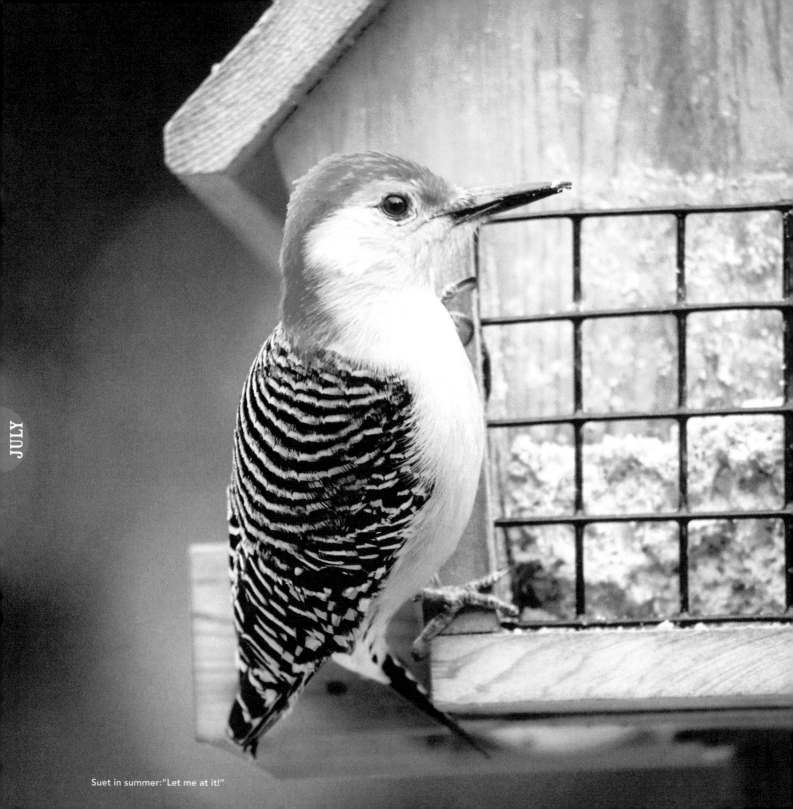

Suet in summer: "Let me at it!"

Squirrels love nuts, too, so if you have squirrels and don't want them eating your nuts, hang your peanut feeder under a squirrel baffle.

Nuts are oily and can spoil in warm weather. Store shelled peanuts in a cool, dry location. We prefer storing our peanuts in metal cans, which usually keep mice and squirrels away.

Planning a vacation? Want to make sure the birds keep coming to your yard for food while you're gone? Don't forget to display several seed blocks loaded with sunflower seed and nuts. We and our customers love seed blocks not only because they are popular with a wide variety of birds, but also because they can last a couple of weeks.

Suet in July

COMMON BIRDS AT SUET

woodpeckers	nuthatches	Bushtits
finches	titmice	mockingbirds
jays	chickadees	grosbeaks
starlings	robins	thrashers

Every summer we hear hundreds of customers say they only feed suet in the winter. These folks are missing out on quite a show. In the summer, you will likely see parent woodpeckers and others bring their babies to eat suet. You don't want to miss the woodpeckers loudly calling their young to the suet feeder. Watch the adult woodpecker grab a hunk of suet and shove it down a begging youngster's throat. Bushtits, normally seen in flocks, have been paired off since spring and are raising their young. In July, look for large families of Bushtits to return to your suet feeders.

Use no-melt suet doughs in warm weather, unless your temperatures are cool and you can keep your suet in shade. If you can feed fatty suet in the summer without it melting, go ahead.

Suet can spoil—always store your unused supply in a cool, dry location. We keep our extra suet cakes in the freezer.

Offer a variety of suet flavors. Robins and mockingbirds love the berry suets. All the nesting birds will appreciate the suets with added calcium to help strengthen their eggshells. Display your suet in a specialized suet feeder where you can see it. Suet cages are easy to use and inexpensive. Tail-prop and log-style suet feeders work well, too, and will work best when hung in a tree.

Check with your local backyard-bird-feeding specialty store for the best selection and freshest suets available. Make sure the ingredients are all natural with no dyes or preservatives.

Mealworms in July

COMMON BIRDS AT MEALWORMS

robins	wrens	mockingbirds
bluebirds	phoebes	starlings

You may not think mealworms taste good, but your birds do, and so do their babies. Orioles and mockingbirds fill their beaks to capacity with mealworms to take back to a nest of hungry young. We have watched robins perch on our empty mealworm feeder, chirping loudly, begging for more. Robins, bluebirds, warblers, mockingbirds, wrens, orioles, and others will visit again and again for this high-protein treat.

When we talk to people about feeding mealworms to their birds, we often hear "Yuck! Gross! No way!" On the other hand, we have customers who are hooked on mealworm feeding; in summer (peak nesting season), some go through more than a thousand mealworms every week. Like doting parents, they talk endlessly about their young nestlings' every move.

Live mealworms are preferred, but hot weather and direct sun can kill them. Feed dried/roasted mealworms as an alternative in hot weather.

Display mealworms in a mealworm feeder near your birdbath or fountain. All birds need water and are more likely to discover the mealworms while at the water. Mealworm feeders for live worms need to have slippery sides so your worms cannot crawl away—a slick-sided dish like a cereal bowl works just fine. The roasted variety can be fed in any open tray. If your birds don't find your mealworms, sprinkle a little seed with the worms. This will lure seed-eating birds, and their activity will catch the eye of the insect-eaters you are trying to attract.

Nectar in July

COMMON BIRDS AT NECTAR
hummingbirds tanagers
orioles

Hummingbird Feeding

This is the month to look for increased hummingbird activity. Females have raised one batch of young and are starting another. All hummingbirds are on the move. Early July is the beginning of the hummingbirds' southward migration. In western states, look not only for more activity from hummers that nest in

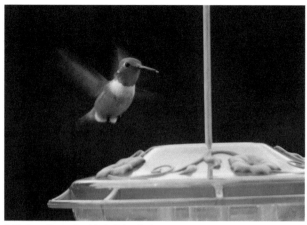

A Rufous Hummingbird diving in for some nectar.

your area, but a wider variety of species stopping at your feeders for a drink.

In southwestern states, the Rufous Hummingbird arrives in July. This beautiful copper-colored hummingbird is often referred to as "Attila the Hum," due to its aggressive behavior toward all the other hummingbirds. We hear many complaints of how just one of these hummingbirds will spend all its time chasing the others away from the nectar feeder.

East of the Mississippi River, you will commonly see only the Ruby-throated Hummingbird. The male lives up to its name with its distinctive, iridescent red throat. The female lacks the red throat but shares the male's beautiful green back and top of the head. They readily come to hummingbird feeders but will also drink nectar from flowers and eat insects. Ruby-throated Hummingbirds migrate six hundred miles across the Gulf of Mexico, so feed heavily in late summer and early fall to help them store up enough fat to make the trip.

July is the time to add more hummingbird feeders to keep up with increased activity. In our stores, this is the month many customers commonly buy several thirty-two-ounce or larger-capacity feeders, trying to keep up with the demand.

Kids' Project

Keep a bird journal. Make a list of all the different birds that you have seen in your yard. Watch for baby birds begging for food from their parents—look for "nest head," ruffled baby feathers that look like people's "bed hair."

Learning about birds can be fun, and the variety may surprise you.

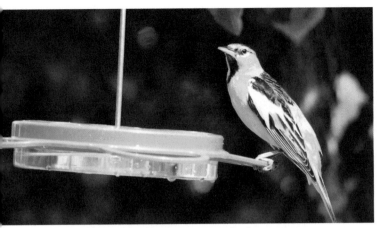

A male Bullock's Oriole on a nectar feeder.

Display your hummingbird feeders near a window or patio so you can easily view these little birds. Watch for hummingbirds hovering in midair, grabbing tiny gnats with their long tongues. This "bugging" behavior is best viewed with binoculars.

All hummingbird feeders attract hummingbirds, but use one that will work best for you. We like the saucer-style hummer feeders; they are easy to clean, don't drip, and discourage bees. Fresh nectar is the key to hummingbird activity. Change your nectar every three to five days.

Oriole Feeding

This is the month to look for adult orioles bringing their adult-size young to your grape jelly and oriole nectar feeders. Watch for the youngsters fluttering their wings and screaming for food while perched in a tree or on your feeder. The adult birds will grab a beak full of jelly or nectar and shove it in the young bird's mouth, but this doesn't stop the young birds from squawking for long. We have seen this begging behavior go on for more than a week before the young birds are able and willing to feed themselves.

As with hummingbird nectar, use a ratio of four parts water to one part white table sugar (no coloring)—bring to a boil, cool, and serve. Some experts recommend a five-to-one ratio for orioles, which works just fine. Hang your oriole feeder in an open area of your yard. The orioles, perched high in tree tops, have to see the feeder, so hang it in the open, not hidden under trees or overhangs. You need to be able to see it, too, of course.

You will start to see young orioles at your feeder in July. The vivid orange coloring of the adult male Bullock's Oriole in the West and male Baltimore Oriole in the East is unmistakable. Young first-year males are often confused with females, however, because of their drab orange-yellow coloring. They will have to wait until their second year to brighten up.

Be patient and keep the nectar fresh, even if orioles don't come at first. Once you attract them, they will return year after year. We've had customers tell us that it took several years before they finally attracted orioles, and it was worth the wait. Persistence does pay off.

Fruit in July

COMMON BIRDS AT FRUIT

cardinals	tanagers	starlings
grosbeaks	robins	
orioles	mockingbirds	

Robins, orioles, tanagers, grosbeaks, and cardinals are just a few of the birds that love fruit and grape jelly. This month, watch adult-sized young mockingbirds, just out of the nest, fight orioles for a beakful of grape jelly. You might even see young robins and their parents compete for a taste.

Always display fruit halves on a prong fruit feeder or secure onto dead tree branches. This gives the larger birds a place to perch while eating. Remember

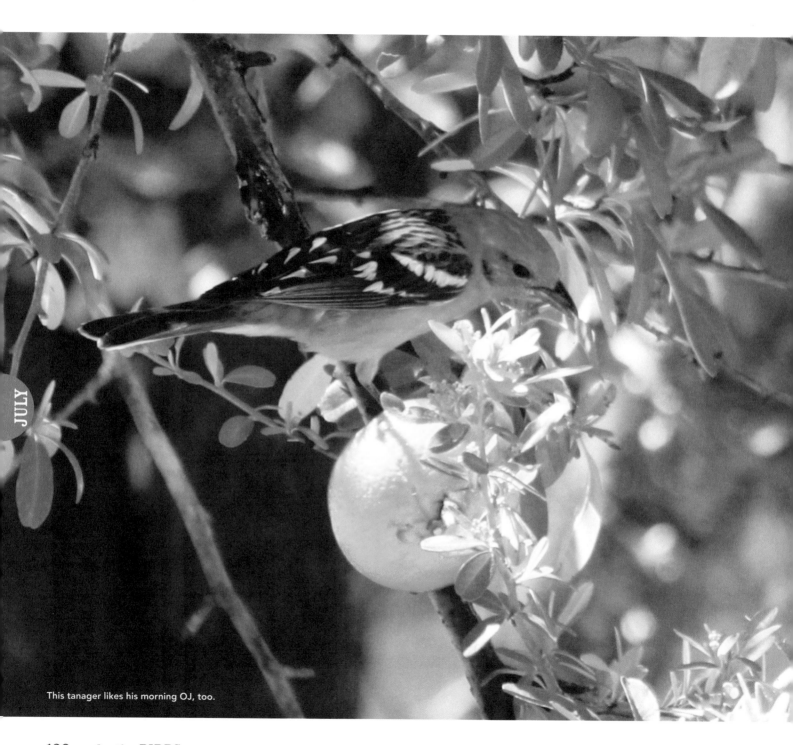

This tanager likes his morning OJ, too.

to watch for hummingbirds grabbing insects attracted to the fruit.

Robins are crazy about dried fruit. This month watch for juvenile "spotty"-chested robins flocking to your raisins, cranberries, or blueberries. Display dried fruit in an open dish on or near the ground. Robins look for natural foods on the ground and are more likely to discover the fruit there.

Fruit and water is a great mix: Display your fruit near your birdbath or fountain. More birds will discover the fruit while at the bath. Sprinkle a little seed in with your dried fruit to jump-start activity.

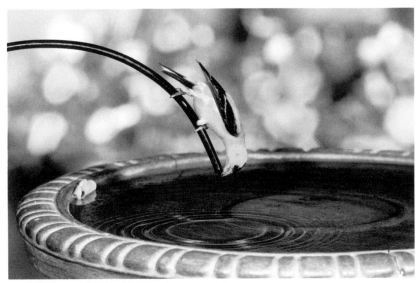

A goldfinch quenches his thirst on a hot summer day.

Be patient: Fruit feeding can be tricky. Keep trying, and it will be worth the wait, especially in July when so many birds bring their young to your feeder.

Water in July

COMMON BIRDS AT THE BATH

Everybody! Including:

orioles	finches	starlings
robins	grosbeaks	warblers
hummingbirds	buntings	
tanagers	waxwings	

Almost anywhere you live, July can be hot. All the birds are looking for a way to cool off and quench their thirst. Even if you already have a lake, pond, or creek nearby, adding a bird-friendly bath to your yard will bring a wider variety of birds closer so that you can see them.

We have watched young birds hop around the edge of our bath, working up the courage to dive in. Once in the water, they splash around until they are so waterlogged they can barely fly away.

This month it's especially important to position your bath away from bushes or other cover where predators can hide. Lots of young birds are learning to fly and are especially slow when wet. Even adult birds have trouble making a "clean" getaway just after bathing.

Fill your bath with fresh water daily, especially during hot months like July. In hot weather we've seen American Robins sit in a bath for long periods of time with their wings spread apart and beaks open. Moving water will bring increased bird activity. Drippers and misters that fit onto your bath and connect to an outside water source draw more birds and help to keep your bath full and fresh—especially important in July when evaporation can empty your bath quickly. Hummingbirds are especially attracted to moving water. Because of increased hummingbird activity this month, watch for more than one at a time at your moving water. One summer we had a customer awakened every morning by the buzzing and squeaking of hummingbirds fighting over her moving water.

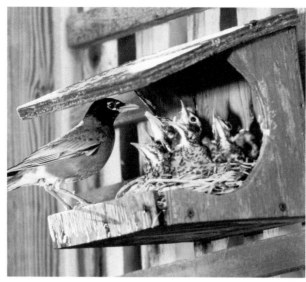

Raising young will keep this robin busy all summer.

Sisters' Tips for July

From Mary:

Put out extra hummingbird feeders this month. More feeders often bring more activity.

From Anne:

Add an easy extra bath! A large plastic dish, no more than two inches deep, is perfect. Place it on the ground with a large rock in the middle for perching. The rock also keeps the dish from blowing away if the water all evaporates.

From Geni:

Add a vacation block, a large seed block loaded with sunflower and nuts. This will keep both seed-eaters and woodpeckers happy. You'll like it too because blocks last a long time.

Nesting in July

COMMON BIRDS NESTING

goldfinches	chickadees	bluebirds
sparrows	finches	wrens
nuthatches	titmice	

By July, most of your birds have already had one or two batches of young. Your sparrows, doves, and finches will continue nesting until fall, often having up to five batches of babies. Most birds have established their nesting territories, but it is never too late to put out a nesting box.

Birds may not always nest in a box put out this month, but fledglings may use it to roost at night. If you haven't learned yet that you shouldn't disturb nesting birds, you may learn it this month. We have been dive-bombed more than once by blackbirds, robins, jays, and mockingbirds when we have unknowingly wandered too close to their nests.

Keep in mind also that most birds leave the nest before they can fly. If you see a fledgling bird hopping around your yard, don't worry. Parent birds will usually continue to bring food until it can make it on its own. Your best way of helping is to keep cats inside during summer months when fledglings are so vulnerable.

Because July is peak nesting season, continue to put out nesting material like pet fur and short strands of yarn. Watch for female hummingbirds grabbing spiderwebs to reinforce their nests as they prepare for their second batch of young.

Backyard Habitat in July

COMMON BIRDS IN YOUR YARD

cardinals	titmice	tanagers
chickadees	grosbeaks	finches
jays	wrens	hummingbirds
nuthatches	orioles	robins
thrashers	towhees	goldfinches

A bird haven.

Your Backyard

Summer means aphids and other bugs that birds love to eat and feed to their babies. Watch for Bush-tits and gnatcatchers swarming your trees and plants feasting on the creatures they find there.

Just think, birds eat lots of insects and will help keep your yard insect-free all summer long—without the use of chemicals!

This is the month that American Goldfinches in the East and Lesser Goldfinches in the West begin picking the seeds from your coneflowers, sunflowers, and sage plants.

Providing birdseed and water will help attract the birds, but a natural habitat will keep the birds coming all year long, and summer is when your yard provides the most for your birds.

Fruit-producing trees like hawthorn, mulberry, plum, apple, and apricot will keep birds like mockingbirds and robins happy.

Watch out, though. Mockingbirds are very protective of their territory and food supply. They will often dive-bomb you when you get too close to their food, even if it is *your* apple tree!

Quick Habitat Tips

- Copy nature: Birds are looking for a natural habitat, not a well-manicured lawn.
- Native plants attract more birds.
- Native berry shrubs are a great way to feed your birds naturally.
- Provide water all year long.
- Take time to enjoy your yard this month.
- Seed-producing flowers like coneflowers and sunflowers are favorites of goldfinches and many other birds.

JULY

date	birds sighted	notes

date	birds sighted	notes

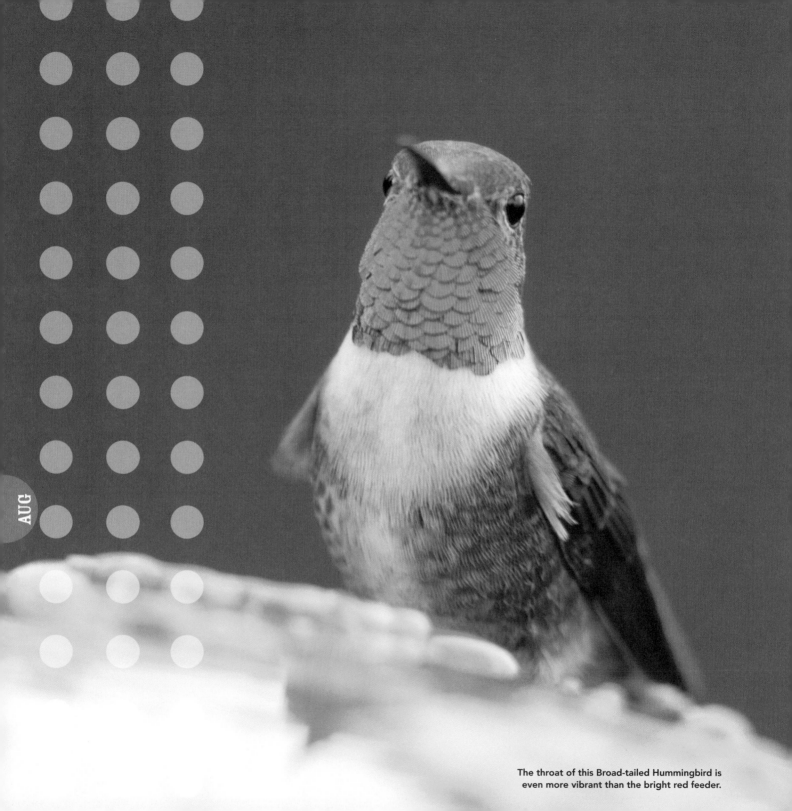

The throat of this Broad-tailed Hummingbird is
even more vibrant than the bright red feeder.

AUGUST In August as the summer is winding down, young birds are busy learning to survive on their own. Many adult birds have raised three to five batches of young in the past few months, and these young birds are out in full force searching for food. This can be the busiest time of year at your feeders.

The hummingbirds' southward migration is still going strong. Watch exhausted hummingbirds stop by for a drink from your nectar feeder. You may also see orioles stop.

Natural food is abundant this month. Flowers, shrubs, and trees are mature and ready for your birds to harvest. Whether it's goldfinches picking seed from your purple coneflowers, robins eating berries from hawthorn trees, or hummingbirds drinking nectar from honeysuckle, birds have many natural food options this month.

Insect-eating tanagers, buntings, swallows, king-birds, and flycatchers are just beginning their journey to southern wintering grounds. The birds are beginning to move, so grab your binoculars and prepare for the late-summer excitement unfolding in your backyard.

Birds to Look For

(found in most regions unless otherwise noted)

Baltimore Oriole (Eastern half of U.S.)

Bullock's Oriole (West)

Calliope Hummingbird (West)

Rufous Hummingbird (West)

Broad-tailed Hummingbird (West)

Ruby-throated Hummingbird (Eastern half of U.S.)

Black-chinned Hummingbird (West)

Painted Bunting (South and Southeast)

American Robin

Northern Mockingbird (Southern two-thirds of North America)

Black-capped Chickadee (Northern two-thirds of North America)

Carolina Chickadee (Southeast)

Mountain Chickadee (West)

White-breasted Nuthatch

American Goldfinch (Northern two-thirds of U.S.)

Lesser Goldfinch (Southwest)

Northern Cardinal (Midwestern and Eastern U.S.)

Ladder-backed Woodpecker (Southwest)

Downy Woodpecker

Hairy Woodpecker

House Finch

European Starling

Tufted Titmouse (Eastern half of U.S.)

Juniper Titmouse (Southwest)

House Sparrow

Common Grackle (East)

Great-tailed Grackle (West)

Blue Jay (Midwest and East)

Scrub Jay (West and Southwest)

Spotted Towhee (West)

Eastern Towhee (Southeast and lower Midwest)

House Wren

FOOD

Birdseed in August

COMMON BIRDS AT SEED

cardinals	towhees	nuthatches
finches	chickadees	thrashers
sparrows	titmice	grosbeaks

Best August Mix

60% black-oil sunflower, 30% white millet, 10% safflower or striped sunflower

MORE TREES = MORE SUNFLOWER

If you live in a heavily wooded area, increase black-oil sunflower to about 75%, decrease millet to 20%, and use 5% safflower or striped sunflower.

Most seed-eating birds prefer black-oil sunflower and need the high calories it provides to help fuel them through the nesting season. By August, most adult birds are weary from raising families, some more than

House Finches and White-Crowned Sparrow—everyone is welcome at the table.

others—House Finches, House Sparrows, and Mourning Doves can raise three to five families a summer. This month, continue to use a mix heavy in high-energy black-oil sunflower. Feed sunflower by itself or as part of a mix in your tube-, hopper- or tray-style feeders. Hanging tray feeders make it easier for you to watch young birds beg their parents for food. Cardinals, grosbeaks, finches, chickadees, nuthatches, and others love black-oil sunflower. It's amazing to see how quickly baby birds learn to crack open the shell. If you have allowed a few stray sunflower seeds to grow, or planted some on purpose, they are in full bloom this month. Watch goldfinches and even cardinals cling to the seedheads to eat.

Avoid excess millet buildup on the ground by using no more than 30 percent of it in your mix. This is enough for summer birds like doves, towhees, and sparrows, who like millet.

Don't want leftover shells or birdseed sprouting in your yard? Feed sunflower chips or a no-mess blend. You'll keep the birds happy and make your summer feeding easier. These hull-less seeds cost more but, for many of us, it's worth it.

As always, a mix attracts a wider variety of birds, so we prefer a no-mess mix over chips. No-mess is welcomed by lots of your millet-eating, ground-feeding birds in addition to all your sunflower-eaters

Kids' Project

Place a shallow birdbath (a plastic dish works fine) on the ground below a tree. Hang a plastic milk jug filled with water on a branch above the dish. Fill the bath with water and make a small hole at the bottom and top of the jug. This should enable a small drip, drip of water into the bath. If the water pours out too quickly, make the bottom hole larger and stuff a rag into the hole. The rag will become saturated but keep the water down to a drip. If the hole is small enough the water should last a day.

Birds love moving water and the sound of the drip attracts more birds.

AUG

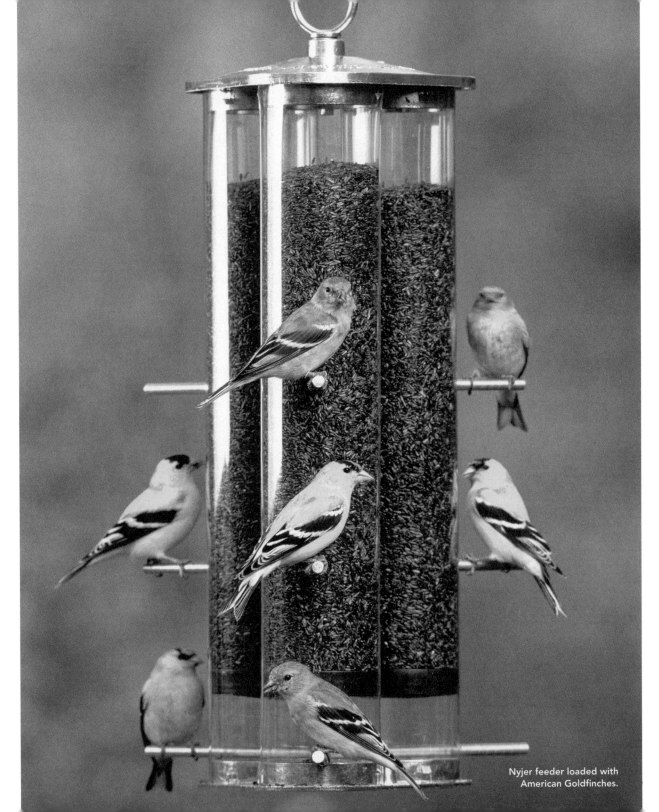

Nyjer feeder loaded with
American Goldfinches.

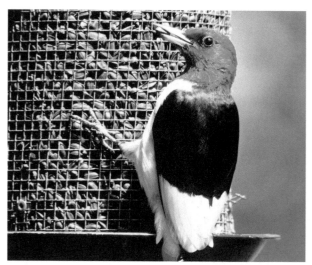

A Red-headed Woodpecker grabbing a safflower seed.

Safflower seed fed from a tray is a magnet for cardinals—they like a larger perching area and the extra headroom that a tray provides. Doves, titmice, chickadees, and House Finches like safflower, too.

Remember, when fed by itself, safflower is a problem solver. The increasing number of squirrels, grackles, and starlings in late summer usually stay away from a safflower feeder. This seed is not liked much by the House Sparrow, either.

Striped sunflower, although more expensive than black-oil sunflower and not liked by as many birds, has its place. Jays and woodpeckers will eat striped as

Quick Seed Tips

- Continue providing a heavy black-oil sunflower mix.

- Keep your nyjer seed fresh for goldfinches and Pine Siskins.

- Watch young birds mob your seed feeders. They are often as big as their parents, so look for begging behavior and "nest head."

long as it is offered in a feeder with adequate perching room for these large birds.

Because goldfinches' natural food sources, like cosmos, sunflowers, and coneflowers, are abundant this month, some people report less activity at their finch feeder as birds focus on native seeds. But for other people, this is a fabulous time to feed goldfinches. Goldfinches are late-summer nesters, so their population can really explode this month. If you haven't yet had luck feeding nyjer, don't give up. Empty that old feeder, fill it with fresh nyjer, and hang it near a bath out in the open, where you and the birds can see it. You've got a good chance to attract goldfinches in August.

Nyjer shells can pile up under the feeder. If you think that the black pile under your finch feeder is the whole seed, look more closely. The shell does look similar to the whole seed. But watch your goldfinches and Pine Siskins quickly and skillfully remove each tiny nyjer shell. You'll need binoculars to really see this.

Peanut pieces can be fed in the summer and may bring more White-breasted and Red-breasted Nuthatches. These birds are found throughout North America and are most abundant where you find lots of trees. White-breasted will come headfirst down the trunk of a tree. This is unique behavior that will tip you off to the species. Red-breasted are very bold. We've had customers report trying to refill a feeder but having trouble because the Red-breasted Nuthatch wouldn't move. Stubborn little guys.

In-shell peanuts attract jays to your yard. One customer in the mountains near Santa Fe, New Mexico, told this story about the cunning Steller's Jay. A family of Acorn Woodpeckers took over her in-shell peanut feeder, beloved by her jay. This particular feeder was a challenge for the woodpeckers to use and as they struggled for a few measly peanuts, they knocked plenty to the ground for the jay to easily scoop up. Who was smarter here?

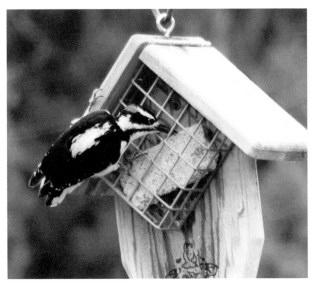

A male Hairy Woodpecker enjoying late summer suet.

calcium are still important for your nesting birds. You'll see lots of baby birds in August and suet is an easy-to-eat meal for young birds just out of the nest. Watch young "nest heads" flap their wings and chirp with delight as they discover this tasty, high-energy treat for the first time. Woodpecker families are particularly fun to watch in August. Although woodpeckers do not normally flock together, you can commonly see family groups feeding together this month. Every August at her house in Albuquerque Mary watches an adult Ladder-backed Woodpecker call its two or three babies to the suet feeder and shove chunks of suet down their throats.

Mount your suet cage in a tree or shrub so it is stable. If birds don't find it after a week or so, smear the cage with peanut butter and seed to jump-start activity. Log-style and tail-prop feeders also work well and are best hung in a tree where suet-eating birds are searching for food. Store unused suet in the refrigerator to keep it fresh.

Mealworms in August

COMMON BIRDS AT MEALWORMS

| robins | wrens | chickadees |
| bluebirds | thrashers | starlings |

August heat and sun can easily kill live mealworms. In many places it is best to use dried/roasted mealworms in your mealworm feeder this month. Because birds don't always recognize dried/roasted mealworms, mix seed with them to jump-start activity. If it's not too hot, use live worms in a slick-sided feeder. A shallow cereal bowl works well. Place your mealworm feeder near your birdbath. More birds will discover them while at the bath.

Young wrens, bluebirds, robins, and thrashers are out of the nest and will enjoy this high-protein treat. If you are in bluebird country (rural, meadowlike areas),

By August, there are lots of young birds out of the nest, searching for food. Lure them to your yard by feeding daily. Yes, birds have plenty to eat in nature this month, but why not bring the show up close? Feeding does not make your birds dependent, it is always just a fraction of their diet. So go ahead, watch those babies beg their exhausted parents for more food—right outside your window.

Suet in August

COMMON BIRDS AT SUET

woodpeckers	Bushtits	finches
nuthatches	wrens	creepers
jays	gnatcatchers	chickadees
titmice	thrashers	

You don't feed suet in the summer? You are missing out!

August is a hot month. Be sure to use no-melt suet doughs in your feeders for your woodpeckers, chickadees, Bushtits, and nuthatches. Suets with added

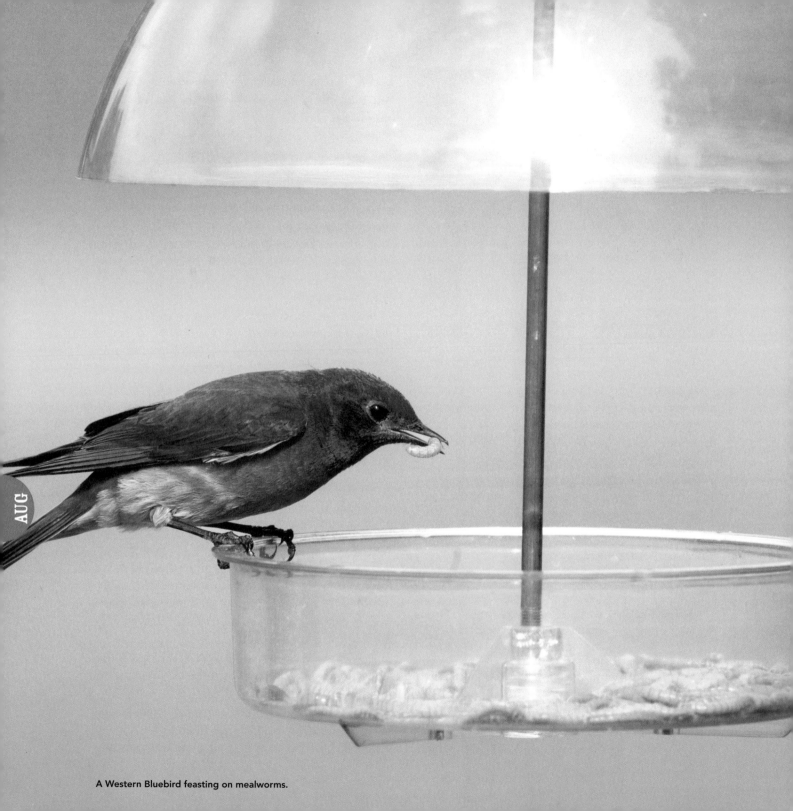

AUG

A Western Bluebird feasting on mealworms.

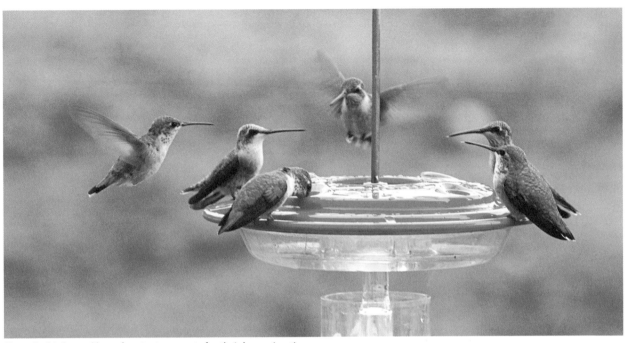

Hummingbirds need lots of nectar to prepare for their long migration.

feeding mealworms is a delight all summer. Bluebirds love mealworms and love to feed them to their babies. By August, young bluebirds have left the nest. In Minnesota and New Mexico we've talked to customers who report seeing as many as six young bluebirds at a time at their mealworm feeder in August. One customer just outside of Santa Fe reported feeding live mealworms from his hand to a trio of baby Western Bluebirds.

Nectar in August

COMMON BIRDS AT NECTAR
hummingbirds
orioles

Hummingbird Feeding

Hummingbirds, hummingbirds, and more hummingbirds. August is the most exciting time to feed them.

Their southward migration is at its peak this month. In late summer you are not seeing the same hummingbirds at your feeder day to day—you are seeing wave after wave of migrants refueling on their way south. The males leave first, so by August and September you are mostly seeing waves of females and babies at

Quick Nectar Tips

- More nectar feeders can bring more activity.
- Hang nectar feeders close so you can easily see the birds.
- Use four parts water to one part white table sugar (no coloring); bring to a boil, cool, and serve.
- Keep feeding: hummingbirds know when to migrate whether you feed them or not.

your feeder. And they are hungry. We have had these tiny birds dive-bomb us when we take their feeders inside for a refill. We've even had them land on the feeder for a drink as we try to rehang it.

We like the saucer-style hummingbird feeder because it's easy to clean, durable, bird friendly, and bee-proof. If you need a huge capacity, you will probably prefer a large bottle-style feeder. If ants are getting into your feeder this month, add an ant trap, a moat of water that hangs above your feeder—ants can't swim!

Oriole Feeding

By August, orioles have raised their young and are heading south for the winter.

You may not have as much activity at your oriole feeder, but continue providing fresh nectar. Your backyard-nesting orioles may have left, but other migrating orioles may stop by to refuel. Late summer can bring oriole species you are not used to seeing. In Albuquerque, customers sometimes report seeing off-course Orchard Orioles at their feeders. These reports almost always come in August, when fall migration is beginning and birds are on the move.

Fruit in August

COMMON BIRDS AT FRUIT

mockingbirds	tanagers	grosbeaks
orioles	cardinals	starlings
robins	woodpeckers	House Finches

Your robins, starlings, finches, and woodpeckers will continue eating fruit. Change the fruit frequently to maintain freshness during this hot and humid month. If that orange half or apple looks worse for the wear, it is. Spear fresh orange and apple halves on a tree branch or on a spike-type feeder. Serve dried cherries, cranberries, and raisins in an open tray, and if the birds don't come, sprinkle in a little birdseed to jump-start activity. Place both dried and fresh fruit near your birdbath.

Your late-summer grosbeaks and orioles may come to a grape jelly feeder as they load up in preparation for their southward migration. By August, birds are depleted from the long nesting season and are desperate for high-energy food. Migrating takes a lot of energy and fruit is loaded with natural sugars to fuel the trip.

Water in August

COMMON BIRDS AT THE BATH

Everybody! Including:

grosbeaks	finches	starlings
robins	hummingbirds	bluebirds
cardinals	orioles	

Birdbaths in August

Have you ever noticed your birds perched with their wings slightly apart from their bodies and their beaks open? This is just one way they can cool themselves on hot days.

Offering water is something you can do to help your birds stay cool this month.

Moving water is a bird magnet. We've seen hummingbirds hover over our moving water, then dive in for a quick rinse. Goldfinches love sticking their heads into the bubbles. Bring a wider variety of birds to your yard this month by providing a birdbath or fountain. Birds are attracted by the sound. A shallow babbling brook will be irresistible to your birds, even if it is really a shallow dish with a bubbler.

Add a bath or two (or three) to your yard this month. Even a simple, shallow, plastic dish on the ground works well. Birds are used to bathing in puddles, so they will adapt quickly to ground baths.

Birds are most vulnerable to cat attacks on the ground, so if cats are a problem in your yard, con-

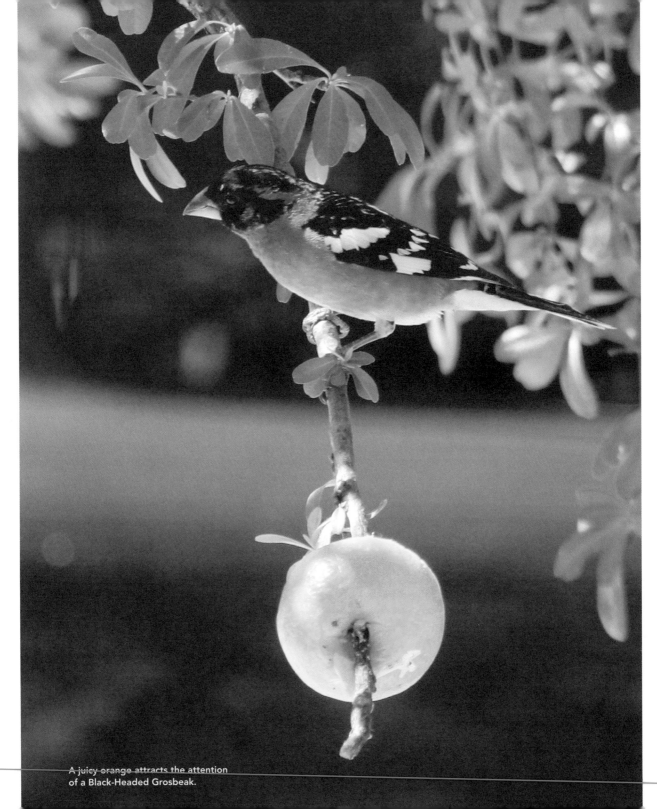

A juicy orange attracts the attention
of a Black-Headed Grosbeak.

A sparrow cools off in a shallow bath.

sider a hanging bath. Although not as bird-friendly as a ground or pedestal bath, a hanging bath is safer. Sprinkle seed on the rim of a hanging bath or place a rock topped with birdseed in the middle to jump-start activity there.

Remember to use a shallow bath, no more than two inches deep, with a gradual, sloping side. This will be easier for timid baby birds to use. Place it near your window so you can see the show.

Hot months mean more algae in your birdbath. We recommend adding chemical-free natural enzymes to your bath to help keep it clean. They are a safe addition to the water and can be found at your local backyard-bird shop. You can also clean baths with a weak bleach-and-water solution (one part bleach to ten parts water)—always rinse well when you are done cleaning. Vinegar and water are also a good bet. Two capfuls of vinegar to one cup water is recommended. Rinse well. A sturdy brush makes the job easier.

Nesting in August

COMMON BIRDS NESTING

goldfinches	cardinals	titmice
sparrows	chickadees	wrens
finches	thrashers	doves

By late August, most of your birds are done nesting, though some, like finches, doves, and sparrows, will often continue nesting into September—so don't clean out the nesting boxes quite yet.

From a safe distance, watch the young sparrows hopping around your yard with flapping wings and wide-open beaks, begging their parents for food. Their tails seem to be the slowest to develop fully. We often refer to these young sparrows as "no-tails." Look for lots of no-tails this month.

Continue providing nesting material like pet fur, wool, or short pieces of yarn.

Sisters' Tips for August

From Mary:

Listen for different sounds in your yard this month. Some birds are beginning to migrate south and you don't want to miss them making a stop in your yard. Often you will hear them before you see them.

From Anne:

Lots of goldfinches at your nyjer seed this month. It can be hot—provide only fresh nyjer for more goldfinch activity. Nyjer can spoil within two months—keep it cool and dry.

From Geni:

This is the most active month for hummingbirds. Provide fresh nectar and enjoy the show.

AUG

Some birds, like Barn Swallows, will help raise their younger siblings—parents are exhausted from a long nesting season and appreciate the assistance.

Backyard Habitat in August

COMMON BIRDS IN YOUR YARD

goldfinches warblers robins
cardinals grosbeaks hummingbirds
towhees gnatcatchers

By August, most of your bird-friendly plants have matured, providing the birds with the natural food they are looking for. Watch for beautiful yellow goldfinches picking the seeds from your coneflowers, sages, and sunflower plants. When Anne was living in Minnesota, she watched American Goldfinches from her kitchen window. They methodically ate row by row of seed from a giant sunflower. They would start at the top and work their way down, happily clinging to the flower head the whole time.

Don't overlook the towhees and cardinals scratching the ground beneath your cosmos and zinnias, looking for dropped seed.

Waves of hummingbirds are migrating south and need the high-energy nectar from your flowering honeysuckles, sages, and trumpet vines. Families of Bushtits, gnatcatchers, and warblers are busy eating insects from your bushes and trees. All evergreens are popular—their sappy bark traps the insects, making for an easy-to-catch meal.

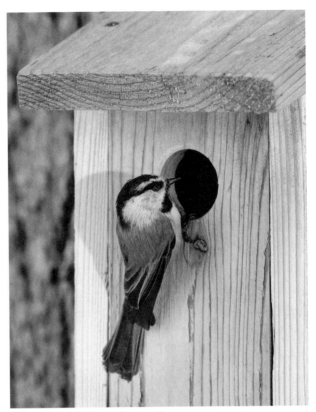

This chickadee is almost done nesting.

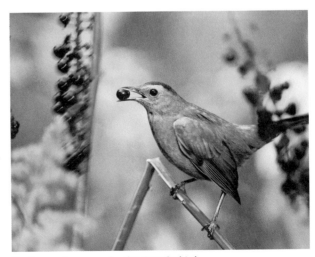

Berries go down easy for this Gray Catbird.

date	birds sighted	notes

AUG

date	birds sighted	notes

AUG

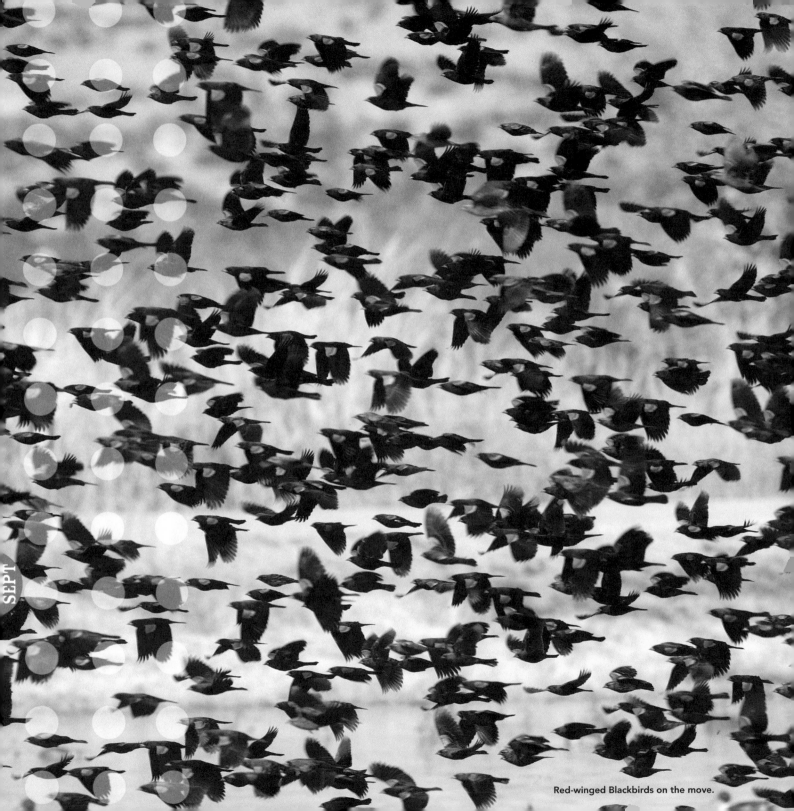

SEPT

Red-winged Blackbirds on the move.

SEPTEMBER

SEPTEMBER While kids are going back to school, your hummingbirds, buntings, orioles, and tanagers are flying south for the winter. Continue to feed hummingbirds this month. By September, most adults have moved south, but young ones are still on the move and need that boost of energy from your nectar.

Keep your eyes peeled this month while in your yard and out and about. When birds are on the move, you are likely to have some interesting sightings. We often see the unexpected warbler, tanager, or waxwing while on a walk in the neighborhood. Local parks often provide a resting spot for flocks of sparrow species as they swing through. Watch for birds that may move a little unusually or for a flash of color you don't normally see. House Sparrows don't usually flock in preparation to migrate because they are permanent residents, so if you see a flock of LBJs (little brown jobs), it's probably a different type of sparrow species moving through. Watch for White-throated, White-crowned, Song, and Chipping Sparrows this month. Check your field guide to identify the sparrow species you are most likely to see in your area.

Make your yard an inviting rest area for the birds because you never know who might fly in and stay for a meal or two and a bath. As always, a natural

Birds to Look For

(found in most regions unless otherwise noted)

Chipping Sparrow
Lark Sparrow (Western two-thirds of U.S.)
Lincoln's Sparrow
Black-headed Grosbeak (West)
Rose-breasted Grosbeak (Eastern half of North America)
Baltimore Oriole (Eastern half of U.S.)
Bullock's Oriole (West)
Calliope Hummingbird (West)
Rufous Hummingbird (West)
Broad-tailed Hummingbird (West)
Ruby-throated Hummingbird (Eastern half of U.S.)
Black-chinned Hummingbird (West)
Lazuli Bunting (West)
Indigo Bunting (Eastern half of U.S.)
American Robin
Black-capped Chickadee (Northern two-thirds of North America)
Carolina Chickadee (Southeast)
Mountain Chickadee (West)
American Goldfinch (Northern two-thirds of U.S.)
Lesser Goldfinch (Southwest)
Northern Cardinal (Midwestern and Eastern U.S.)
Ladder-backed Woodpecker (Southwest)
Downy Woodpecker
Hairy Woodpecker
House Finch
Common Grackle (East)
Great-tailed Grackle (West)
Blue Jay (Midwest and East)
Scrub Jay (West and Southwest)
Spotted Towhee (West)
Eastern Towhee (Southeast and lower Midwest)
House Wren

habitat with native flowers, shrubs, and trees will attract the widest variety of birds. Your cosmos, maximillians, and purple coneflowers are loaded with natural seeds that goldfinches, chickadees, and even crossbills will devour this month. A variety of feeders and baths also helps to make your yard an irresistible oasis.

Birdseed in September

COMMON BIRDS AT SEED

cardinals	grosbeaks	thrashers
titmice	nuthatches	Purple Finches
starlings	chickadees	sparrows
jays	towhees	
juncos	House Finches	

Best September Mix

50% black-oil sunflower, 40–45% white millet, 5–10% safflower

MORE TREES = MORE SUNFLOWER

If you live in a heavily wooded area, increase black-oil sunflower to 65–70%, decrease millet to 30%, and use 5% safflower.

The juncos are coming, the juncos are coming! Customers are often thrilled to see the first junco of the season. Increase the amount of white millet you feed in September to attract these cute little birds, plus a wide variety of sparrow species, to your yard. Watch

Quick Seed Tips

* Feed a mix with at least 40 percent white millet to accommodate more autumn ground-feeding birds.

* Watch for the arrival of the juncos. You will see them eating the white millet on the ground beneath your feeder.

* Watch as birds flock in preparation to migrate or for winter feeding.

closely—that small brown bird may not be just another common House Sparrow. White-crowned, Chipping, Lark, Lincoln's, Brewer's, and White-throated are just a few of the interesting sparrow species that you can attract to your yard with white millet in September.

Throw white millet directly on the ground or include it in a mix in your feeders, so it will end up on the ground where juncos, towhees, doves, and sparrow species prefer to eat it. Open ground tray feeders are a great addition to your yard this month. Juncos and sparrows love tray feeders.

As always, the majority of your seed-eating birds prefer black-oil sunflower, so this should be the main seed you provide, either by itself or as the primary ingredient in your mix. Birds like to eat sunflower from a tube-, tray-, or hopper-style feeder.

This month watch as nuthatches, woodpeckers, and jays grab a sunflower seed from your feeder and stash it away in unusual places as they prepare for the winter. We've seen jays store seeds in the molding around our car windows. If we hadn't been watching those busy birds, we would have been quite perplexed by the falling birdseed when we rolled down our car windows!

A Reminder: Millet Is Good—Milo Is Bad

White proso millet, the favorite of ground-feeding birds.

This cheap mix is loaded with milo (the round, reddish seed).

These two types of seeds are often confused and understandably so. The names are similar. Both are little, round seeds that get kicked to the ground. Millet

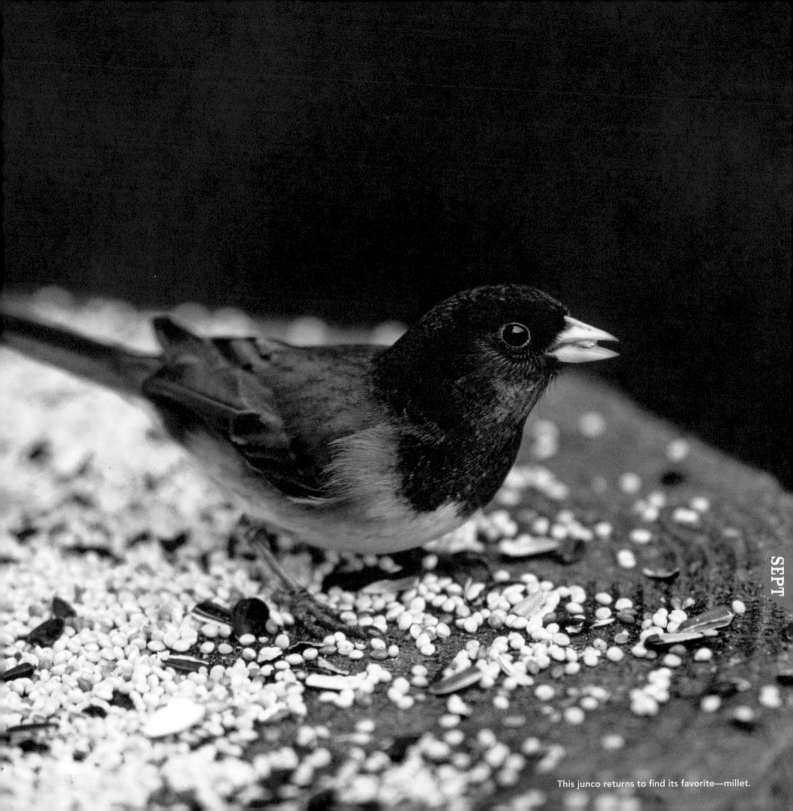

SEPT

This junco returns to find its favorite—millet.

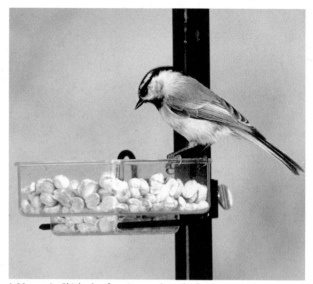

A Mountain Chickadee feasting on these high-energy nuts.

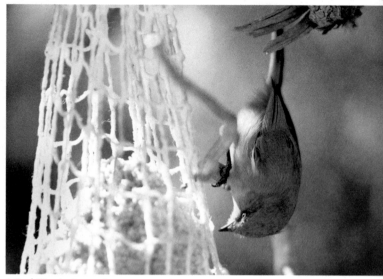

A Bushtit enjoying suet.

gets eaten (unless your mix is too heavy in millet), but milo is a filler—birds don't like it. Be careful about using most commercial mixes from the grocery or big-box stores. Often they contain a high percentage of milo and other fillers like wheat.

This month watch for your cardinals, titmice, and doves picking the safflower out of your mix. Its high oil content is just what these birds are craving. Safflower is a great problem solver if fed alone. Squirrels, grackles, and starlings don't much like safflower, and House Sparrows will often turn their beaks up at it, too.

Shelled peanuts are loaded with the fat that your woodpeckers, jays, chickadees, nuthatches, and kinglets can't get enough of as they prepare for the cold. September is the perfect time to add a shelled peanut feeder to your yard. Don't be surprised to see your woodpeckers hide nuts in the crevices of trees. This makes for a nice winter stash of food when natural food supplies are low.

Because they are often the only bird to go headfirst down a tree, nuthatches will stash their nuts, seeds, and bugs in the downward-facing crevices of the tree. This hidden food is not easily seen by most other birds that search for food by moving side to side or from bottom to top.

Continue feeding nyjer seed for your goldfinches and Pine Siskins. In September, goldfinches are still nesting, so you may notice more hungry youngsters at your finch feeder. Consider adding an extra feeder to accommodate this increased activity. We like the mesh-style finch feeders—either the nyjer sock or stainless-steel mesh feeder work well. Goldfinches and Pine Siskins can easily cling to them, but other birds usually cannot. If your House Finches have learned to cling to your mesh feeder, add an upside-down nyjer feeder. It forces birds to hang upside down to get the seed. House Finches can't do this, but goldfinches and Pine Siskins can dangle that way all day long.

Suet in September

woodpeckers	nuthatches	finches
titmice	thrashers	jays
creepers	chickadees	Bushtits
gnatcatchers	kinglets	flickers

If temperatures remain warm this month, use no-melt suet doughs. Switch to fatty suets as the weather cools. You can make the switch to the fatty suet sooner if your feeder is in the shade. We recommend feeding suets loaded with nuts this month. Nuts offer a needed high-energy treat for your birds.

Remember to position your suet close to a window so you can see up close who is there. Suet-eating birds will slowly come within a couple of feet of your house if they feel protected by the cover of shrubs and trees.

We like to securely mount suet cages against a tree. Log-style and tail-prop suet feeders can be free-hung in a tree. At first, smear your suet feeder with peanut butter and birdseed—this will jump-start activity.

Flickers start to show up in September. Like many woodpeckers, flickers usually announce their presence. Listen for their loud, piercing call. You'll find these large, dramatic woodpeckers eating suet or picking ants from the ground.

Mealworms in September

robins	wrens	warblers
bluebirds	waxwings	starlings

In September you may want to use dried/roasted mealworms. Live mealworms are most popular with nesting birds in the spring and early summer months. Place the mealworms near your birdbath to attract the widest variety of birds. Watch for robins, starlings, thrashers, and jays at your mealworm feeder. Your robins will especially enjoy raisins or dried cherries mixed in with the mealworms. Dried mealworms can be fed in an open tray—sprinkle them with birdseed to get things going.

Nectar in September

hummingbirds
orioles

Hummingbird Feeding

It is a common misconception that hummingbirds won't migrate south if we keep feeding them. Hummingbirds migrate by instinct. In fact, even in northern regions and the mountainous western region, keeping your feeder out until late October or early November may just give some young straggler hummingbirds the boost of energy they need to continue south. So September is still a prime time for attracting them.

Oriole Feeding

Many of your nesting orioles have headed south, but those migrating from farther north may stumble

Kids' Project

This is the month to contact Cornell Lab of Ornithology and become involved in Project FeederWatch. Kids love to identify and count the birds at the feeder. Cornell uses this information to help them study North American bird populations. Be a part of this exciting scientific project.

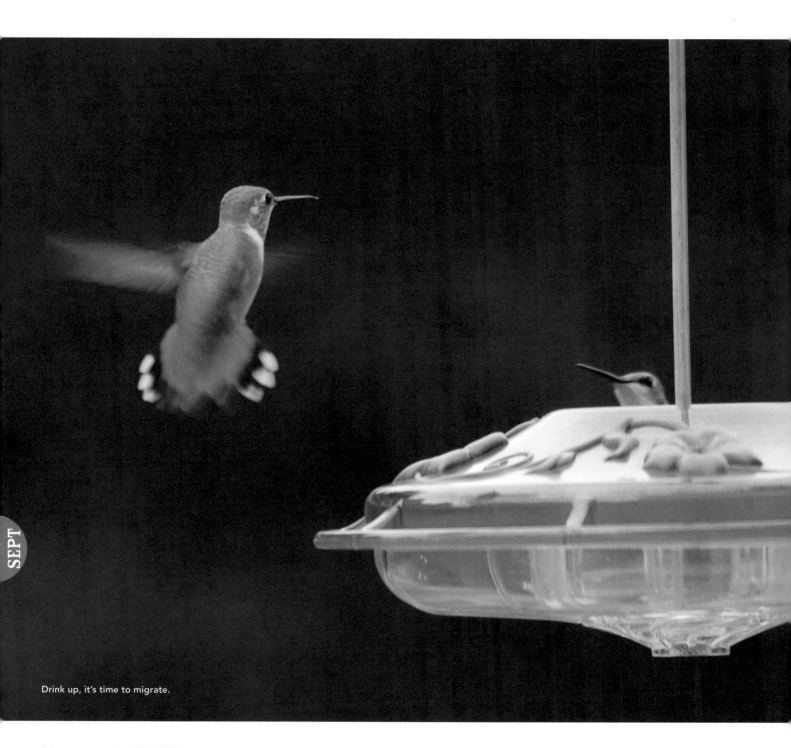

Drink up, it's time to migrate.

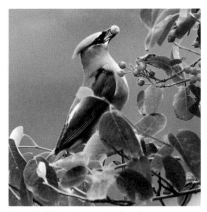

A Cedar Waxwing eating berries.

A cardinal relishing a good bath.

upon your feeder for a much-needed drink. One September, we made the mistake of taking down our oriole feeder early in the month, only to hear the familiar clacking call of the oriole several days later. After quickly rehanging our feeder, we enjoyed a late visit. Now we just keep it out with fresh nectar until the end of September. Hummingbirds will often visit an oriole feeder, too.

Fruit in September

COMMON BIRDS AT FRUIT

robins	grosbeaks	Cedar
finches	woodpeckers	Waxwings
starlings	mockingbirds	cardinals

One of the most awesome sights Mary ever saw in her backyard was a flock of fifteen to twenty Cedar Waxwings taking turns eating her dried fruit. After about ten minutes they were gone. You never know what you will see, so continue feeding dried raisins, cherries, or cranberries this month. Feed dried fruit in an open feeder near a birdbath. Sprinkle it with birdseed to lure birds to your fruit if you need to. You can even add dried mealworms to your dried fruit—robins and starlings will love it.

Fresh apple and orange halves can be skewered flesh side up on a prong-type feeder or tree branch. Fall-migrating orioles and tanagers will love the oranges, and your resident mockingbirds will eat apple halves year-round. Don't be surprised to see Red-bellied Woodpeckers in the East and Red-naped Woodpeckers in the West discovering this tasty treat.

Water in September

COMMON BIRDS AT THE BATH
Everybody! Including:

cardinals	starlings	sparrows
robins	grosbeaks	Cedar
finches	warblers	Waxwings

Every day in September we receive calls from excited customers asking us to help identify a new bird they spotted at their bath. That's because this month is the busiest part of the autumn southward migration for many birds. Sparrow species, like Song and White-throated, as well as warblers, robins, hummingbirds, and waxwings are just a few of the migrants that you can attract to your yard by providing water. Because many fall migrants are easily hidden by late-summer foliage in your yard, luring these birds out to an

SEPT

These Black-Capped Chickadees are drawn to moving water.

easy-to-see bath might be your only chance to see them as they swing through this month.

With winter fast approaching in the North, be sure to use a bath that will hold up to freezing and thawing. Birdbaths made of concrete or ceramic are risky,

even with the use of a deicer. Plastic or metal baths are best. Some heavy stone baths can be used in the winter, but they must be made of granite or some other "forever"-type material.

Place your bath where you can see it. You don't want to miss the action. You should also be able to fill it easily in cold weather—and be ready to add a deicer, especially in far northern regions. In Minnesota, Anne would sometimes need a deicer in her bath on chilly September nights so birds would not encounter ice in the morning.

Moving water will attract a wider variety of birds to your yard this month. Add a bubbler, mister, or dripper to entice elusive fall migrants like tanagers, buntings, and warblers. By late summer many of us are tired of cleaning and refilling our baths. Hang in there, though; the birds you see during migration will make the effort worthwhile.

Nesting in September

COMMON BIRDS NESTING

sparrows
goldfinches

Most birds are done nesting, but goldfinches and House Sparrows are the two exceptions. They will nest into fall if there is an abundance of food. We have seen baby goldfinches and sparrows flapping their wings with beaks wide open, begging for food in late September.

Continue putting out materials for your late nesters. Goldfinches prefer wool, but your pet's fur makes for a nice, insulated nest. Wait until later in the fall or early winter to clean old nests from nesting boxes; you don't want to risk disturbing late nesters in September.

In cold weather, your nest boxes will often be used by chickadees, nuthatches, woodpeckers, and others

Sisters' Tips for September

From Mary:

Listen closely. Migrating warblers can be hard to see, but their lovely chirping calls will alert you to their presence. Moving water can lure warblers into view.

From Anne:

Be lazy with your yard—overgrown is good. Nobody rakes or prunes the forest.

From Geni:

Continue feeding the hummingbirds. Feeding them won't stop them from migrating south.

looking for shelter at night. September is a great time to add a roosting box, a specially designed box that allows several birds at once to find protection from the elements. Make sure it is located where you can watch the birds coming and going and where it is safe from predators. Refer to the nesting section of Backyard Birding Basics (page 45) for detailed information on roosting boxes.

Backyard Habitat in September

COMMON BIRDS IN YOUR YARD

warblers	juncos	robins
cardinals	thrashers	grosbeaks
waxwings	towhees	finches
woodpeckers	chickadees	sparrows

This month look for migrating warblers stopping by to eat insects from your sunflowers and sages. Towhees and sparrow species often do what we call the "towhee shuffle." Watch as they scratch forward and backward on the ground in dried leaves and other plant material, looking for insects and dropped seeds. Watch for flickers rooting around on the ground for tasty ants and other bugs.

To attract the most activity to your yard, don't be too quick to cut back or clean out plants like sunflowers, hollyhocks, coneflowers, and sages that have gone to seed. Fall-migrating warblers, juncos, and sparrow species depend on these plants for food as late as January. Berry-producing shrubs and trees (like mountain ash) are a magnet to flocks of birds, including the stunning Cedar Waxwing. If you haven't already planted berry-producing, bird-friendly plants, don't worry. Fall is a good time for planting shrubs, trees, and many perennials. Sumac, pyracantha, mountain ash, juniper, hawthorn, and coneflowers are just some of the plants that can lure more birds to your backyard.

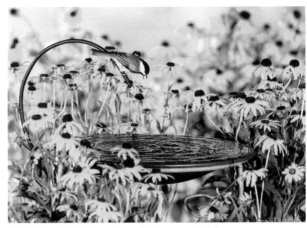

A Carolina Chickadee enjoys a late summer drink.

SEPT

Quick Habitat Tips

- Copy nature in your backyard.

- Don't rush to cut seedheads from plants. Your birds will eat from these through winter.

- Watch your sunflowers, coneflowers, and other seed-producing plants for warbler activity.

- Birds love an overgrown, dense yard.

- Leave plant material on the ground for towhees, juncos, and sparrow species.

SEPT

date	birds sighted	notes

date	birds sighted	notes

A Tree Sparrow revels in seed.

OCTOBER
Wow, October has it all—goblins, ghosts, and ghouls by night and migrating birds by day. Fall southward migration is at its peak. Stop, look, and listen. Watch for flocks of juncos and sparrow species like White-throated and White-crowned Sparrows at your ground feeder as they arrive for winter. Listen to migrating warblers chirp with excitement as they feast on insects at your native plants and shrubs.

Have several types of feeders out in your yard: a hopper-style feeder with a good mix, a ground-style feeder with millet, a suet or peanut feeder for insect-eaters like the Ladder-backed Woodpecker in the Southwest and the Downy and Hairy Woodpeckers found throughout North America, and a nyjer feeder for finches.

Have at least one bath, and for those of you in the North, now may be the time to add a deicer to ensure a steady supply of ice-free water.

Allow your native vegetation to become overgrown. Remember, nobody rakes, mows, or cleans up the forest, and the vast variety of birds you find there love it. Try to have everything your birds are looking for—the effort will pay off.

Birds to Look For

(found in most regions unless otherwise noted)

Cedar Waxwing

Song Sparrow

Chipping Sparrow

White-throated Sparrow (Eastern two-thirds of North America)

White-crowned Sparrow

Dark-eyed Junco

Brown Creeper

American Robin

Brown Thrasher (Eastern half of U.S.)

Black-capped Chickadee (Northern two-thirds of North America)

Carolina Chickadee (Southeast)

Mountain Chickadee (West)

White-breasted Nuthatch

American Goldfinch (Northern two-thirds of U.S.)

Lesser Goldfinch (Southwest)

Northern Cardinal (Midwestern and Eastern U.S.)

Ladder-backed Woodpecker (Southwest)

Downy Woodpecker

Hairy Woodpecker

House Finch

European Starling

Tufted Titmouse (Eastern half of U.S.)

Juniper Titmouse (Southwest)

House Sparrow

Common Grackle (East)

Great-tailed Grackle (West)

Blue Jay (Midwest and East)

Scrub Jay (West and Southwest)

Spotted Towhee (West)

Eastern Towhee (Southeast and lower Midwest)

OCT

Birdseed in October

COMMON BIRDS AT SEED

towhees	doves	jays
juncos	grosbeaks	nuthatches
cardinals	finches	titmice
thrashers	chickadees	sparrows

Best October Mix

50% black-oil sunflower seed, 40% white millet, 10% safflower or shelled peanuts or both

MORE TREES = MORE SUNFLOWER

If you live in a heavily wooded area, increase black-oil sunflower to 60–65%, decrease white millet to 30–35%, and add 5% safflower or nuts.

House Sparrows looking for an easy meal.

October is a good time to increase the amount of white millet in your mix. Juncos are arriving to spend the winter and they love it. These cute birds are often called "snow birds" because they arrive in the fall and will spend the winter months in your yard.

Look for flocks of sparrows and other birds such as doves and towhees at your seed feeders and in your yard in October, too. It is the prime flocking season. As cold weather approaches and food becomes depleted, birds join together to find what remains. If one bird finds a food source, others follow and benefit from it as well.

Quick Seed Tips

- Feed a mix with at least 40 percent white millet to attract ground feeders like juncos, towhees, and sparrow species.

- Add a peanut feeder as a high-fat food source for your birds.

- Feed daily to attract a wider variety of migrating birds to your yard.

This month, you may see the White-throated, Chipping, Song, White-crowned, or Lark Sparrow. White-crowned, who are found throughout most of North America, and White-throated, who are more common in the central and southern regions, are usually seen only in late fall and winter. They nest in northern Canada. White-throated Sparrows are similar in appearance to the White-crowned, but have a white throat and yellow lore (yellow spot on the nose).

Scatter white millet on the ground or in a ground tray near bushes or other cover to lure these birds into your yard. If you use a mix in your tube- or hopper-style feeder, make sure it contains at least 40 percent white millet, which will be knocked out by the sunflower-eating birds at your feeder and end up on the ground right where your sparrows, juncos, doves, and towhees want it! Use less millet in your mix if you live in a heavily wooded area.

Of course, black-oil sunflower seed is still the favorite of most of your birds, including House Finches, cardinals, chickadees, nuthatches, and grosbeaks. It is packed with fat and calories, just what birds need as temperatures begin to drop. Feed black-oil sunflower

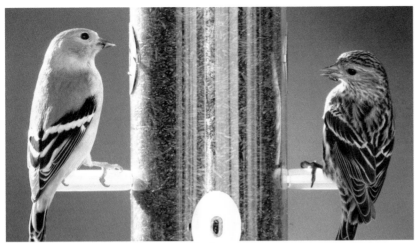

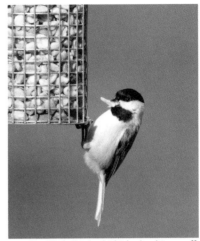

A goldfinch and a Pine Siskin share a nyjer feeder.

Has this Black-Capped Chickadee bitten off more than he can chew?

alone or in a mix in an elevated tube-, hopper-, or tray-style feeder for the best results. And don't forget safflower—a tray feeder filled only with safflower will be loved by your cardinals but left alone by squirrels and blackbirds like grackles and starlings.

Continue feeding nyjer seed in a specialized nyjer feeder for your goldfinches and Pine Siskins.

In many areas goldfinches stick around all winter, but their brilliant yellow summer plumage does not. Nesting season is over, so bright yellow feathers are no longer needed to attract a mate and would now only attract a predator. This month watch as your goldfinches turn to a less conspicuous olive-green. Look for Pine Siskins to arrive in large flocks at your nyjer feeders, too.

We prefer mesh-style finch feeders—either a nyjer sock or stainless-steel mesh. Goldfinches and Pine Siskins can easily cling to these feeders, but other birds cannot.

Migrating birds work up quite an appetite. Add a shelled-peanut feeder and watch as flocks of Bushtits, kinglets, warblers, and woodpeckers stop in your yard for this high-energy snack.

Permanent residents like White-breasted Nut-hatches, Downy and Hairy Woodpeckers, jays, and chickadees love shelled peanuts all year long. October is also a great time to attract south-bound migrants like Ruby or Golden-crowned Kinglets, who also like peanuts.

As winter approaches, birds need more calories. It's hard work staying warm through cold autumn nights. Peanuts are the perfect high-calorie, fatty treat for your residents and visitors.

Place shelled peanuts in a mesh-style feeder, which is easy for nut eaters to cling to. Most nut-eating birds

Kids' Project

It's pumpkin-carving time! Save the pumpkin seeds and the pumpkin meat and serve them on an open tray to the birds. Finches, sparrows, jays, and juncos should clean it up.

for the **BIRDS** **173**

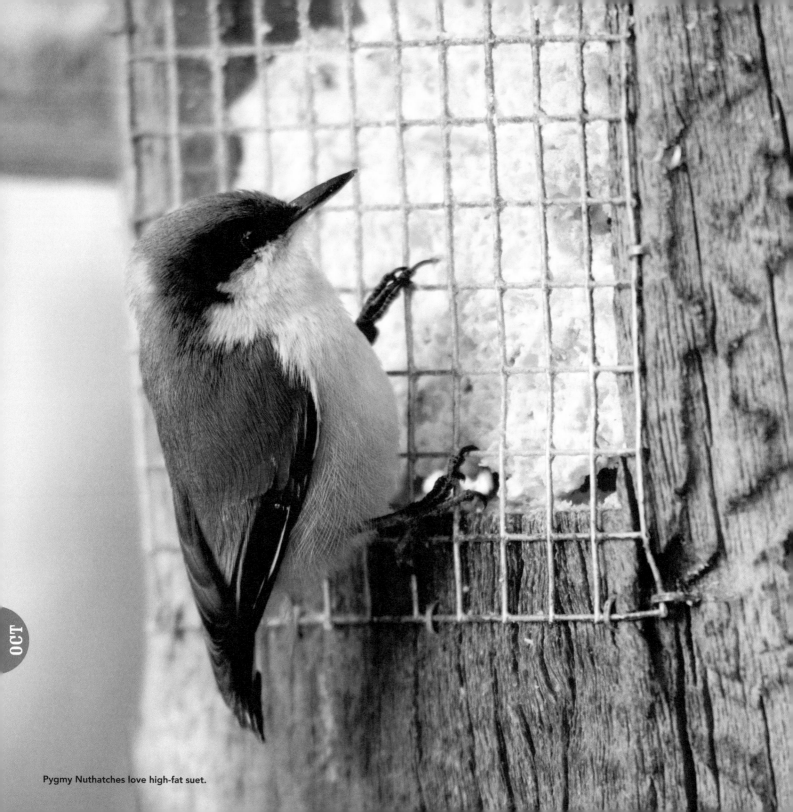

Pygmy Nuthatches love high-fat suet.

can easily cling. You can also put nuts in a hanging or ground tray, or on a stump.

Don't forget to add a seed block loaded with sunflower and peanuts—cardinals, chickadees, nuthatches, woodpeckers, Brown Creepers, and others will love this steady source of food. A good-quality seed block is more black than yellow—more sunflower than millet.

Suet in October

COMMON BIRDS AT SUET

warblers	Bushtits	finches
nuthatches	gnatcatchers	jays
woodpeckers	creepers	wrens
thrashers	kinglets	chickadees

We have seen more unusual birds at our suet in October than in any other month. Every year we look forward to seeing the Red-naped Sapsuckers stop at our suet feeder for a quick energy boost as they continue their southward migration. Brown Creepers, found throughout North America, are most likely to come to suet starting in October because their supply of insects is diminishing with the onset of colder weather. In the southern United States, look for Yellow-rumped Warblers at your suet. They nest in Canada but come south looking for food as winter approaches.

The suet feeder should be firmly mounted against the trunk of a tree or nestled in its branches, but the tree doesn't have to be big. The best luck Anne ever had with suet was when the feeder was nestled against the branches of a scrubby little patio tree. In one September and October she saw chickadees, nuthatches, woodpeckers, Bushtits, Black-headed Grosbeaks, kinglets, and Yellow-rumped Warblers. The feeder hung less than three feet from the kitchen window, so it was a great show.

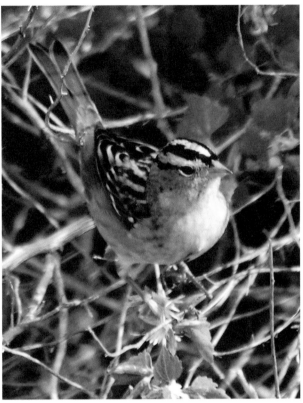

A White-Crowned Sparrow is protected by dense native cover.

Quick Suet Tips

- Use fatty suets in cooler fall temperatures; they give the birds more calories.

- Display suet in more than one location to attract a wider variety of birds to your yard.

- Mount your suet securely in a tree or bush—where the birds are.

- If using suet for the first time, smear the feeder with peanut butter and press birdseed onto the peanut butter. Birds recognize seed and are thus prompted to discover your suet

OCT

Mealworms in October

COMMON BIRDS AT MEALWORMS

COMMON BIRDS AT MEALWORMS

| robins | chickadees | warblers |
| bluebirds | wrens | starlings |

Your nesting birds couldn't seem to get enough live mealworms to feed their young all summer—but this month the birds may turn their beaks away from live mealworms. Feeding mealworms is not especially important in October. However, you may want to continue to offer dried/roasted mealworms. Southward-migrating warblers will enjoy this tasty treat while passing through your yard.

Nectar in October

POSSIBLE BIRDS AT NECTAR

hummingbirds

orioles

Hummingbird Feeding

Up North we often told folks to leave their hummingbird feeder out till it froze. Another good rule of thumb is to keep fresh nectar out at least two weeks after you've seen your last hummingbird.

By October you are seeing the last of the females and babies swinging through from northern nesting areas. Hummingbirds are tiny and migration can be difficult for them. They need to reach a certain body weight to complete their migration, and young ones are often the last to reach this weight. This month watch for these young hummingbirds stopping at your feeder for a much-needed boost of energy to help them on their way. Enjoy these sweet little birds as long as you can.

Refer to the nectar feeding section of Backyard Birding Basics (page 30) if you want more information on hummingbird feeders.

Oriole Feeding

Most of your orioles are long gone, but we still recommend keeping your oriole feeder out this month. You don't want to feel guilty when that late-migrating oriole shows up and finds nothing to eat. Migrating hummingbirds will also come to your oriole nectar feeder.

Fruit in October

COMMON BIRDS AT FRUIT

| robins | mockingbirds | finches |
| waxwings | woodpeckers | cardinals |

Not all fruit-eating birds migrate south for winter. Continue feeding dried raisins, cherries, or cranberries if you live in an area where robins or mockingbirds stay all year. In much of North America, watch for flocks of beautiful Cedar Waxwings at the dried fruit in your yard in October. The larger, almost identical Bohemian Waxwing is found in far northern regions. We like to mix seed with our dried fruit until birds discover it. Place a dish or tray of seed and dried fruit near your birdbath for more activity.

Cardinals, woodpeckers, and finches will continue to eat fresh apple halves all year long, unless your climate freezes the fresh fruit too quickly.

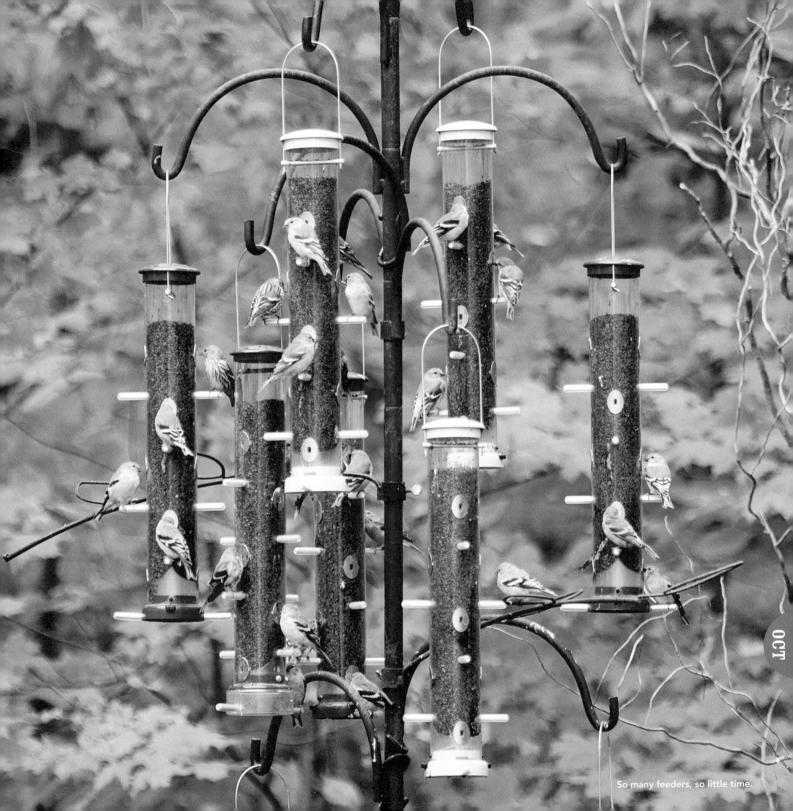

So many feeders, so little time.

Water in October

COMMON BIRDS AT THE BATH

Everybody! Including:

robins	goldfinches	nuthatches
starlings	sparrows	chickadees
waxwings	Pine Siskins	warblers
grosbeaks	juncos	titmice
finches	cardinals	

This month the birds' southward migration is at its peak. Attract cute little warblers and beautiful waxwings to your yard with water. Not all migrating birds eat seed, but they all need water.

Use a birdbath that can hold up in freezing temperatures. Add a deicer to keep your water ice-free: remember, a clean bird is a warm bird. Many deicers have a thermostat so are on only when they need to be. Consider a bath with a thermostatically controlled deicer built in—they work well even in below-zero temperatures.

Every October we see a variety of sparrows such as Lincoln's, Song, and White-crowned at our open water.

As always, use a shallow bath—no more than two inches deep—to encourage smaller birds like titmice, nuthatches, and wrens to bathe. We often hear customers say that their birds never bathe. Then we dis-

This Mourning Dove appreciates an ice-free bath.

cover that they are using a fairly deep dog's water dish and we know why.

More than one bath is great and will only increase your and the birds' enjoyment.

Nesting in October

COMMON BIRDS NESTING

By October your adult birds are exhausted from a busy spring and summer nesting season. In most areas of North America, the summer phoebes, kingbirds, flycatchers, buntings, tanagers, and swallows have flown the coop. These insect-eating birds will return in the spring.

Wait at least until November to clean out nesting boxes. Watch for birds roosting in your nesting and roosting boxes at night for shelter and warmth. Add a roosting box to your yard so cold birds have a sheltered spot to spend cold nights. More than one bird at a time may huddle together in your box to stay warm.

Quick Bath Tips

- Birds love to bathe in the cooler temperatures; provide water year-round.
- Use a bath that will hold up in freezing temperatures; no cement, ceramic, or terra cotta.
- Moving water is a bird magnet.
- Put your bath where you can see and fill it easily.

Backyard Habitat in October

COMMON BIRDS IN YOUR YARD

warblers	robins	jays
nuthatches	finches	woodpeckers
juncos	thrashers	chickadees
cardinals	grosbeaks	sparrows
towhees	waxwings	

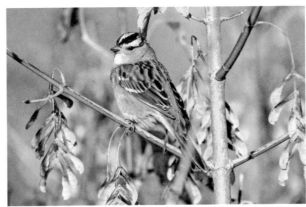

A White-Crowned Sparrow blends into native cover.

October is peak migration time for many birds, and this is also the best time to entice the widest variety of birds to your backyard. Does your yard have what these hungry birds are looking for? Flocks of Cedar Waxwings and robins are on the move this month, searching for berries from juniper, mountain ash, holly, Virginia creeper, and hawthorns.

Don't cut back your dried seedheads or rake up those leaves this month. Remember that the habitat matters more than manmade feeders or baths. Dense natural cover not only provides food for your birds but offers protection from the elements.

While walking in our city neighborhood one October, we noticed two immature Western Tanagers in a tree. We were walking quickly and had no binoculars, but we heard an unusual bird song and started looking in time to see a flash of dull yellow. So keep in mind that listening will help you spot birds, too.

In addition to tanagers, this month keep alert for warblers and kinglets picking insects from your native plants, bushes, and vines. These cute little birds often go unnoticed, so listen for their loud chirps; this usually gives them away.

Goldfinches and Pine Siskins will entertain you with their acrobatics as they hang every which way, grabbing the seeds from your sunflowers, cosmos, coneflowers, and sages.

Ground-feeding juncos, towhees, and sparrow species will shuffle back and forth doing the "towhee shuffle" in dried leaves and other plant material, searching for insects and dropped seeds. White-throated and White-crowned Sparrows also have a distinctive little scoot and hop.

Sisters' Tips for October

From Mary:

Add a seed block loaded with high-calorie sunflower and nuts. Large blocks are long-lasting and ensure your birds an early breakfast.

From Anne:

Feed more millet to lure in juncos. Open ground trays are most popular for these snow birds. These ground-feeding birds often feed near bushes or other cover, so put the seed where the birds are. Watch for the distinctive flash of white tail feathers as the juncos fly away.

From Geni:

Watch for migrating warblers at your birdbath this month.

NOTES

date	birds sighted	notes

OCT

date	birds sighted	notes

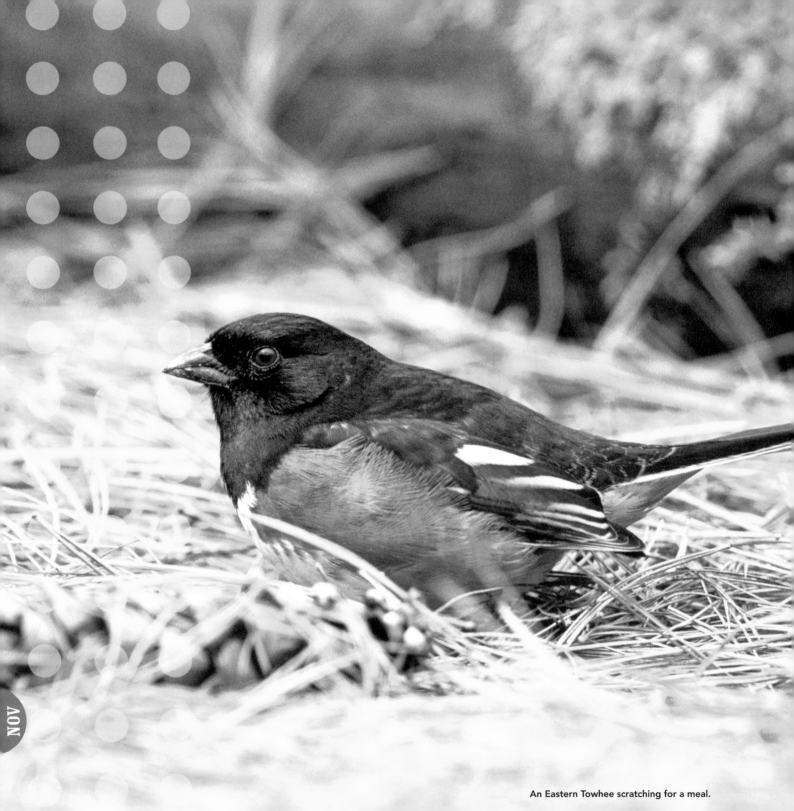

An Eastern Towhee scratching for a meal.

NOVEMBER

Winter is fast approaching, and in some areas it has arrived. As we are preparing our Thanksgiving feast, your birds are busy preparing for the cold weather ahead. Cardinals, juncos, finches, grosbeaks, and others are pooling their resources, forming flocks to better search for enough food to get them through a cold winter. Birds don't want to be alone searching for food in scarce times. They might not find any without the help of others; if one bird finds food, they all benefit.

An unusual bird you may see this month, one almost always seen in flocks, is the Red Crossbill. Found in the northern and western regions of North America, these birds wander erratically and so can be uncommon at times. They literally have a crossed bill, which allows them easier access to the conifer pinecone seeds they love.

November is a great time for high-fat food choices like suet and peanuts for chickadees, nuthatches, and woodpeckers. With freezing temperatures here for many of us, it's the time to put out the birdbath deicers. A clean bird stays warmer.

Prepare a feast for your birds this month, and you will be rewarded with their presence all winter long.

Birds to Look For

(found in most regions unless otherwise noted)

Yellow-rumped Warbler (South)
White-throated Sparrow (Eastern two-thirds of North America)
White-crowned Sparrow
Dark-eyed Junco
Pine Siskin
Purple Finch (Eastern half of U.S.)
Black-capped Chickadee (Northern two-thirds of North America)
Carolina Chickadee (Southeast)
Mountain Chickadee (West)
Red-breasted Nuthatch
White-breasted Nuthatch
American Goldfinch (Northern two-thirds of U.S.)
Lesser Goldfinch (Southwest)
Northern Cardinal (Midwestern and Eastern U.S.)
Ladder-backed Woodpecker (Southwest)
Downy Woodpecker
Hairy Woodpecker
Bushtit (West and Southwest)
House Finch
European Starling
Tufted Titmouse (Eastern half of U.S.)
Juniper Titmouse (Southwest)
House Sparrow
Common Grackle (East)
Great-tailed Grackle (West)
Blue Jay (Midwest and East)
Scrub Jay (West and Southwest)
Spotted Towhee (West)
Eastern Towhee (Southeast and lower Midwest)

Birdseed in November

cardinals	nuthatches	White-crowned
thrashers	jays	Sparrows
juncos	towhees	Chipping
titmice	White-throated	Sparrows
finches	Sparrows	Song Sparrows
chickadees		

Best November Mix

50% black-oil sunflower, 40%–45% white millet, 5%–10% safflower, striped sunflower, or shelled peanuts

MORE TREES = MORE SUNFLOWER

If you live in a heavily wooded area, increase black-oil sunflower to at least 65%, decrease white millet to 30%, and use 5% safflower, nuts, or striped sunflower.

A cardinal and a goldfinch share a meal.

Cold weather means birds need more calories to stay warm, and this means more activity at your feeder. All the birds that come up to your feeder want black-oil sunflower—birds like cardinals, chickadees, House Finches, and nuthatches. These birds kick the white millet to the ground, where birds like juncos, sparrow species, doves, and towhees prefer to eat it, and by November these birds are looking for a yard to call home. If you have lots of juncos look-ing for millet, consider adding a ground feeder to your yard. White-crowned Sparrows return in late fall to wherever they found food last winter. By feeding consistently, you can help to increase the number of birds in your yard every year.

Black-oil sunflower is like an electric blanket for your birds, and come November they need it. This month watch for nuthatches stashing sunflower seeds under the bark of trees.

Fill your feeders very early for more activity; as nights get colder, birds wake in need of quick nour-ishment, and the early bird gets the food. Watch for small flocks of millet-eating juncos scratching the ground just before dawn and returning at dusk for more. Cardinals, too, feed early and late but are after sunflower and safflower at the feeder.

Your cardinals, jays, and grosbeaks will finish up the small percentage of safflower, shelled peanuts, or striped sunflower seeds in your mix. Titmice (Juniper

Quick Seed Tips

- Feed the birds late in the day or first thing in the early morning, just before or after the cold night. Birds need food to stay warm.
- Watch for small flocks of juncos eating millet on the ground.
- Watch for nuthatches storing sunflower seeds and shelled nuts in the bark of trees for a late-winter snack.

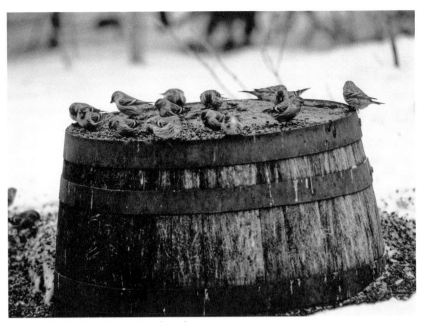

Common Redpolls eating scattered seed.

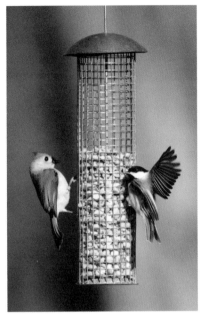

Peanuts—a perfect fall feast for this titmouse and chickadee.

in the West and Tufted in the East) love to pick safflower seeds out of your seed blend.

Feed your mix in tube-, hopper- or tray-style feeders. Tube- and hopper-style feeders work best when it's snowy because they don't catch as much snow. Many of us spend more time indoors in winter months. November is a good time to reposition your feeders so you can see them from your windows.

Continue feeding nyjer seed. In many areas, goldfinches overwinter, and nyjer seed is what they are looking for. Pine Siskins form large flocks to search en masse for food and love to stumble upon your finch feeder. Pine Siskins are common in North America all winter but are nomadic. This means you can't count on them showing up, but you can be ready for them if they do. Always feed nyjer in a specialized feeder separate from your other feeders. Also, hang your nyjer feeder near a birdbath where you can easily see it. Finches will come very close to a window. We like

mesh-style nyjer feeders (socks or stainless-steel), and so do your goldfinch and Pine Siskins. We've had to add extra socks to keep our flock of siskins happy.

Jeepers—creepers! Cute but often overlooked, Brown Creepers are just one type of non-seed-eating bird you can attract this month by feeding shelled nuts. These little brown birds actually start at the bottom of a tree and creep up the trunk, searching for food. Look closely, as they blend right in to your tree trunks. Hang your shelled-peanut feeder in a tree near the trunk where creepers, nuthatches, woodpeckers, kinglets, and Bushtits are more likely to find it. We like the sturdy stainless-steel peanut feeder—squirrels can't destroy it. If squirrels are dominating your peanut feeder, hang it from a disc-style baffle to discourage them.

Jays especially love in-shell peanuts! Feed them in a tray, on a stump, from your hand, or even from the top of your shoe, as one of our customers did.

If you feed only one thing to your birds this winter,

it has to be top-quality seed blocks packed with high-energy nuts and black-oil sunflower. Seed blocks attract both seed and nut eaters (imagine cardinals and woodpeckers at the same place). A great benefit is that you don't have to refill them daily. So sit back, stay warm, and enjoy your birds with your morning coffee!

Suet in November

COMMON BIRDS AT SUET

woodpeckers	warblers	jays
flickers	creepers	finches
chickadees	Bushtits	
nuthatches	thrashers	

Not feeding suet this month is like not serving pumpkin pie at Thanksgiving. Your backyard is not complete without the addition of suet to the feast. Nuthatches, creepers, woodpeckers, kinglets, Bushtits, and even wintering Yellow-rumped Warblers are attracted to it. In November, you'll find Yellow-rumped Warblers wintering in much of the East, South, and extreme West and Southwest. Watch woodpeckers grab a hunk of suet and stash it in the cranny of a tree. We often see these birds searching the tree trunk later in the winter, hoping that another bird did not discover their secret stash.

You may notice that suet-eating birds spend more time and energy than usual this month combing the trees for insects, larvae, and other food. Most parts of

Quick Suet Tips

- In cold weather feed suet in more than one location for more activity.
- Use fatty suets—they provide more calories to keep birds warm.
- Use suets with added nuts for a wider variety of birds.

the country are getting cold in November and birds need more food to survive. Some birds like Brown Creepers tend to spiral up a tree looking for food hidden under its bark, while the White-breasted Nuthatches come down the tree headfirst. By using a different approach, each of these tree-clinging birds can find food missed by the other. Take note of how your birds search for food in unique ways.

Remember, when you first put out your suet feeder, smear it with peanut butter and birdseed. Birds don't always recognize suet as food, but seed-eaters will notice the seed and this will help jump-start activity at the feeder. Suet sometimes becomes more popular with your birds in November as colder weather increases their caloric needs, so be ready to see more activity and to go through more suet this month.

Use a suet cage or a log-style or tail-prop suet feeder. Larger woodpeckers, like the Red-bellied in the East and the Northern Flicker, found throughout North America, prefer tail-prop feeders. Having a place to prop their tail gives them easier access to the suet. Mount or hang your suet feeder in a tree where you can easily see it. Birds will come very close to a window. As the weather cools even more, add one or a few extra suet feeders. Be patient: attracting a wide variety of birds to suet may take months.

Mealworms in November

COMMON BIRDS AT MEALWORMS

robins	waxwings	wrens
thrashers	starlings	

Mealworms can be an unexpected treat for your birds this month. Watch flocks of wintering robins, waxwings, and starlings discover this high-protein snack. By November, European Starlings are displaying their winter plumage. Gone are the yellow bill and shiny purple-

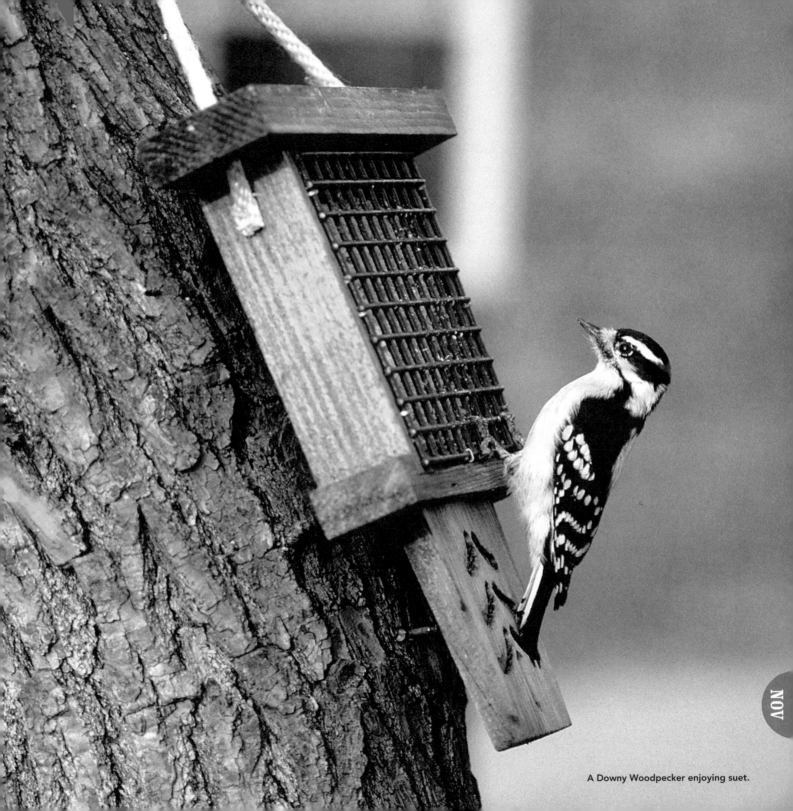

A Downy Woodpecker enjoying suet.

black feathers; they now sport dramatic gold and white spots and a plain black bill. November can also bring flocks of Cedar Waxwings to your mealworms. The movement of these vagrants is unpredictable, as they move in flocks to wherever they can find food.

Place your mealworm feeder near your birdbath and mix some seed or suet pellets with the worms to help attract attention. In colder months we use dried/roasted mealworms, because freezing temperatures can kill live mealworms. Any open tray works well as a mealworm feeder and can be hung or placed on a stump or the ground.

Nectar in November

POSSIBLE BIRDS AT NECTAR
hummingbirds
orioles

Hummingbird Feeding

By November your hummingbirds have probably migrated south for the winter. Only in some areas of the extreme South, Southwest, and West coast will some hummingbirds stay all year. Continue providing fresh nectar if you live in an area where hummingbirds overwinter. For the rest of us, it is time to clean our feeders and store them away until spring.

Oriole Feeding

By this month orioles have migrated south, where there are plenty of insects and nectar-producing plants. If you are in Florida, you *may* see an occasional Baltimore Oriole during the cooler months—like some people, these orioles may choose to spend winters in the Sunshine State. For those of you in this part of the country, continue to feed nectar. Otherwise, clean your feeder and store it inside until spring.

Fruit in November

POSSIBLE BIRDS AT FRUIT

| robins | finches | cardinals |
| starlings | mockingbirds | waxwings |

By November, your birds have lost some of their appetite for fruit, especially in colder regions where fresh fruit is tough to feed in freezing temperatures. However, you might be able to entice robins, starlings, and waxwings to dried raisins, cherries, or cranberries by mixing these fruits with dried/roasted mealworms. These high-protein worms can be a real eye-catcher for your birds. Continue feeding fresh apple halves for your finches, cardinals, and mockingbirds in southern regions where they won't freeze. Dried fruit can be fed from any type of tray feeder, and fresh fruit can be skewered, flesh side up, onto a spike or tree branch. Display fruit near your ice-free bath. Birds are more likely to discover it while using the bath.

Kids' Project

For many kids, filling birdfeeders can be an enjoyable and educational responsibility. This month have your kids fill the birdfeeders and provide fresh water for your backyard birds. Be sure to toss some white millet on the ground for wintering juncos. The birds will reward your family with their beautiful colors and chirps. If possible, hang a tube feeder right outside your child's bedroom window. Try a window feeder with suction cups that can easily attach to the window glass.

A heated birdbath makes drinking easy for this Blue Jay.

Water in November

COMMON BIRDS AT THE BATH

Everybody! Including:

cardinals	waxwings	chickadees
bluebirds	starlings	nuthatches
robins	doves	titmice
grosbeaks	sparrows	woodpeckers
finches	juncos	

November is the month we begin looking for ways to stay warm, and so do your birds. As we head indoors, the birds rely on their clean feathers to insulate them from the cold weather. Cardinals, jays, robins, finches, bluebirds, and waxwings are just some of the birds that will be splashing away at your water this month. Yes, robins will often stay, even in cold climates, if they can find open water and food, like leftover berries on native shrubs and trees. If you see robins in the late fall and winter, you usually see many at one time, as they flock to find open water and food. Birds pool their resources in cold weather.

Remember, a clean bird is a warm bird. Once the birds discover your ice-free bath, they will return again and again all winter long.

We have a few dedicated customers who fill their baths with warm water several times a day to prevent them from freezing. When Geni lived in northern Illinois, she did not own a deicer and filled her bath with a jug of water every morning. Some birds, like her flock of Northern Cardinals, waited patiently in a nearby tree until she was done pouring, while others, like her bold Black-capped Chickadees, landed in the bath before she was done. If you can use one, a deicer might be a bit easier.

Visit your backyard-bird store to find a birdbath that has a built-in, thermostatically controlled deicer. That way it's only on when it needs to be. The water doesn't get warm; it just stays above freezing. Place your bath where you can see the birds bathing, and near an outlet if you're using a deicer.

Use a bath that can withstand freezing temperatures—not ceramic or cement. Plastic or metal will hold up best. Provide fresh water daily.

More is better: Multiple baths provide your birds more options for drinking and bathing, which provides you with better bird-watching opportunities.

Nesting in November

COMMON BIRDS NESTING

By November your birds are done raising their families and are settling in for the winter. But clean out your boxes and leave them in place—you never know who will decide to move in, and you want to be ready.

Your nesting boxes can be as active in winter as they were during the spring and summer nesting season. They offer a safe, warm place for birds to roost. There can be quite a lot of competition for this prime winter roosting real estate. One November Mary saw flocks of finches, jays, and chickadees chirping loudly and dive-bombing the flicker box. She soon discovered this mobbing behavior was brought on because an owl had decided to roost there for the winter. She watched as the owl left the box at dusk and returned at dawn. The smaller birds carried on with their

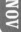

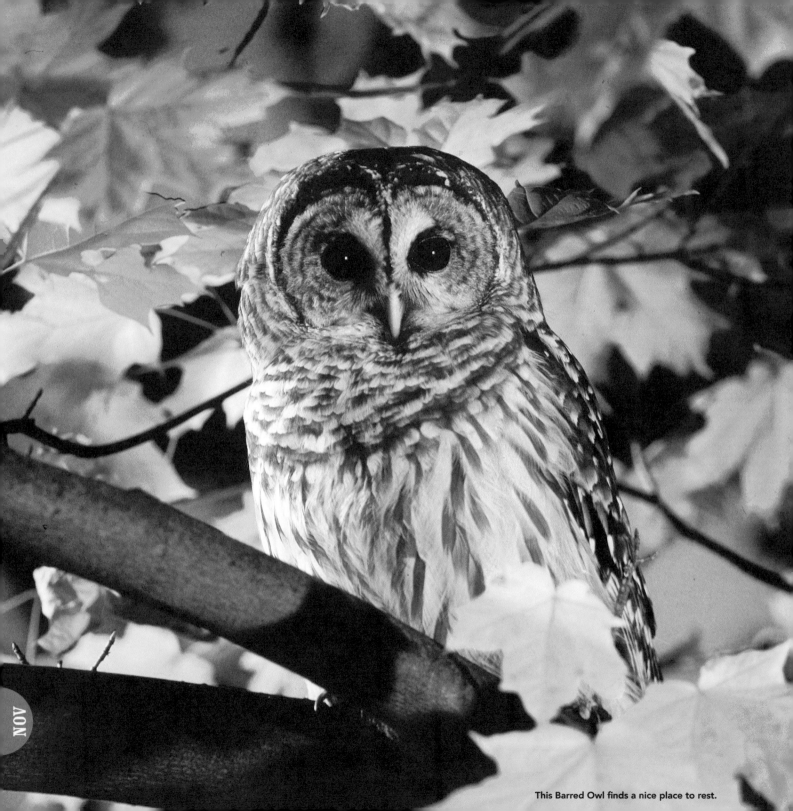

This Barred Owl finds a nice place to rest.

mobbing all winter, which probably made it difficult for the owl to get much rest.

You might want to add a roosting box to your backyard this month. Hang or mount it on a tree trunk or building to best provide your birds a place protected from the elements. Refer to the nesting section in Backyard Birding Basics (page 41) for more information on roosting boxes.

Backyard Habitat in November

COMMON BIRDS IN YOUR YARD

juncos	towhees	chickadees
grosbeaks	woodpeckers	nuthatches
cardinals	sparrows	hawks
titmice	thrashers	owls
robins	finches	
kinglets	jays	

November can bring a bountiful feast for our birds and for us. This month watch for juncos, robins, towhees, and sparrow species, like White-crowned, Song, and Chipping Sparrows, scratching through your fallen leaves and other plant material, as they look for insects and seeds beneath. Mockingbirds in the South and flickers, bluebirds, and robins throughout North America will be busy eating berries from pyracantha, Virginia creeper, sumac, and junipers. These are the natural foods your birds depend on for their survival. Remember, if you copy nature by having a dense, native, overgrown yard, you can attract the widest variety of birds to your yard all winter long.

When you do have to do a bit of lawn maintenance, be sure to create a brush pile for the birds to provide shelter from the cold and protection from predators. We have watched birds frantically fly into a brush pile as a hawk circled above looking for a meal.

Don't cut back your dried seedheads. Birds like Pine Siskins, finches, and cardinals will continue feeding on these plants well into January. Native flowers, shrubs, and trees are the best sources of food and cover for your birds and will help you attract more birds.

Quick Habitat Tips

- Don't cut back dried seedheads or other vegetation. Birds will use these plants as food and cover.

- Watch for robins and waxwings eating winter berries from your berry-producing bushes and trees.

- Watch for towhees, sparrow species, and juncos on the ground doing the "towhee shuffle" in dried leaves and other plant material, searching for food.

Sisters' Tips for November

From Mary:

A clean bird is a warm bird. Use a birdbath deicer to provide an ice-free water source for your wintering birds.

From Anne:

Don't forget the dessert! Offer suet in more than one location to attract non-seed-eating woodpeckers, kinglets, creepers, Bushtits, wintering warblers, and others.

From Geni:

Create a winter refuge for your birds. Brush piles and overgrown native vegetation provide food, shelter, and cover for all the birds. They will give thanks by returning to your yard all winter long.

NOV

date	birds sighted	notes

date	birds sighted	notes

NOV

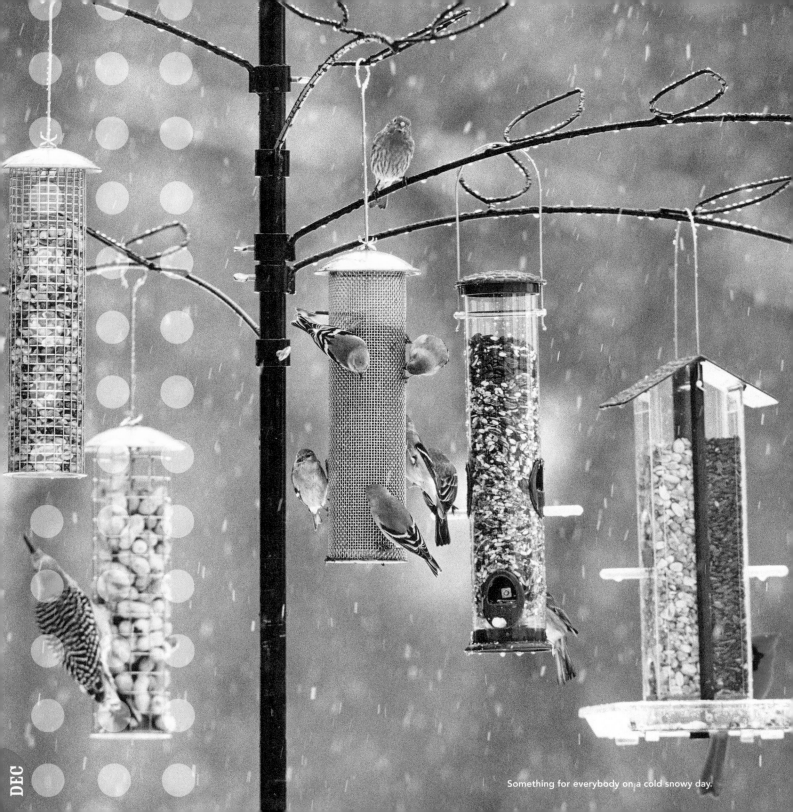

Something for everybody on a cold snowy day.

DECEMBER

The holiday season has arrived. As you hustle and bustle this month, don't forget to spend time enjoying the birds in your backyard. Remember, natural food is becoming more scarce, and days and nights are colder, so your birds are working harder than ever to find food and stay warm. Put some food out every day to make sure they find their way to your yard. Birds don't become dependent upon us, but in cold and snowy weather, what we provide helps more than usual. Suet and shelled nuts are the perfect high-energy food and will attract Pygmy Nuthatches in the West and Red-breasted and White-breasted Nuthatches throughout North America.

Make sure your bath has a deicer so birds can count on finding open water for drinking and bathing.

In the northern United States and Canada, watch for flocks of Common Redpolls. Although often confused with House and Purple Finches, whose males have a reddish chest and head, Common Redpolls (both male and female) have a distinct "thumbprint" of red on their heads. Redpolls are an irruptive species, meaning that their populations can change from year to year. Some years people see very few Redpolls, and other years the population explodes. This is due in part to weather patterns and availability of food. If the weather is particularly cold and snow and ice

Birds to Look For

(found in most regions unless otherwise noted)

Common Redpoll (Northern third of North America)

Evening Grosbeak (North and West)

Ruby-crowned Kinglet (South and West)

Yellow-rumped Warbler (South)

White-throated Sparrow (Eastern half of U.S. and West coast)

White-crowned Sparrow (Southern half of U.S.)

Dark-eyed Junco

Pine Siskin

Brown Creeper

Purple Finch (Eastern half of U.S.)

Black-capped Chickadee (Northern two-thirds of North America)

Carolina Chickadee (Southeast)

Mountain Chickadee (West)

Red-breasted Nuthatch

White-breasted Nuthatch

American Goldfinch (Northern two-thirds of U.S.)

Lesser Goldfinch (Southwest)

Northern Cardinal (Midwestern and Eastern U.S.)

Ladder-backed Woodpecker (Southwest)

Downy Woodpecker

Hairy Woodpecker

House Finch

European Starling

Tufted Titmouse (Eastern half of U.S.)

Juniper Titmouse (Southwest)

Common Grackle (East)

Great-tailed Grackle (West)

Blue Jay (Midwest and East)

Scrub Jay (West and Southwest)

Spotted Towhee (West)

Eastern Towhee (Southeast and lower Midwest)

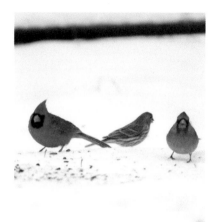

Cardinals and snow...a beautiful combination.

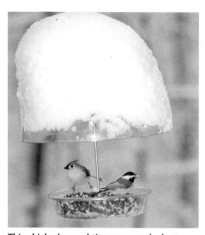

This chickadee and titmouse are lucky to find dry seed.

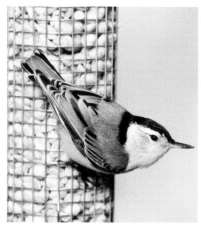

Peanuts warm this nuthatch right up.

have buried most available food, then the Redpolls may be forced to move en masse to warmer areas where more food can be found.

Daylight is fleeting in December, so much of your bird watching may have to be done in the early mornings and on weekends. If your time is short this month, consider putting out a large block of seed. We call these "vacation blocks," and they are perfect to guarantee a steady source of food when you're too busy to fill feeders.

Birds' days are shortened in December, too. They sleep when it's dark, so in order to survive the winter, they need to consume a lot of calories in a limited time each day. You can expect activity at your feeders throughout the daylight hours. Some birds like juncos and cardinals eat at daybreak and at dusk. Others will appear at your feeder or bath later in the morning—they may just be waiting for the temperature to warm up a little.

Take time for yourself and the birds this month.

Birdseed in December

COMMON BIRDS AT SEED

cardinals	juncos	titmice
jays	finches	thrashers
chickadees	towhees	sparrows
flickers	grosbeaks	
nuthatches	doves	

Best December Mix

50% black-oil sunflower, 40% white millet, 10% safflower and shelled peanuts

MORE TREES = MORE SUNFLOWER

If you live in a heavily wooded area, increase black-oil sunflower to at least 65%, decrease white millet to about 30%, and use 5% safflower or shelled peanuts.

While we are stoking the fire and pulling up the blanket, our birds are also looking for ways to stay warm. Black-oil sunflower, shelled peanuts, and safflower seeds' high oil content helps birds build up a winter coat. Cardinals, chickadees, House Finches, nuthatches, and others will visit your feeders daily, looking for these high-energy seeds. Don't be surprised to see juncos make a rare appearance at your above-the-

ground feeder this month, looking for a little high-calorie sunflower.

As always, toss white millet on the ground or feed it as part of a mix so it will get kicked to the ground. White millet is the favorite of your ground-feeding juncos, towhees, and sparrow species, who will scoot on top of the snow searching for it. Make sure to feed millet in an area where these ground-feeding birds can easily access it. Clear an area of snow so the birds will easily find the millet you toss out for them. You can also feed millet or a high-millet mix in a ground tray—be ready to brush snow off the feeders.

A tray of safflower (fed alone) is always a welcome sight for cardinals, titmice, House Finches, and chickadees. Hang it wherever you like—no need to worry about squirrels, who usually won't eat safflower.

Feed your mix in tube-, hopper-, or tray-style feeders. Consider adding larger-capacity or extra seed feeders this month so you don't have to go out in the cold and snow as often. Tube and hopper feeders best protect your seed from wet snows.

House Finch or Purple Finch?

Two birds commonly seen at seed feeders who are often mistaken for each other are the House Finch and the Purple Finch. Most of us have seen little brown finches with a reddish head and chest at our feeders. How do you tell which one you are seeing? If you live in the West, it's almost certainly a House Finch. In the East, Southeast, and eastern section of the Midwest, you may have Purple Finches, so take a closer look.

Both male Purple and House Finches have a reddish head and chest and can be tough to tell apart. The females, however, are easier. Look for a distinctive white stripe above the eye of the female Purple Finch. The female House Finch has no such eyebrow. Since males will stick with their own kind, if you see a female with a white eyebrow, you know the males nearby are also

Purple Finches. The alternate is true for House Finches. Both House and Purple Finches love sunflower seed, but will also eat nyjer and safflower.

Feeding shelled nuts, usually peanuts, is the perfect holiday gift for your woodpeckers, chickadees, kinglets, creepers, and Bushtits. We have even seen ground-feeding juncos fly up to our shelled-nut feeders, looking for that extra boost of energy shelled nuts have to offer in cold winter weather.

We use a stainless-steel peanut feeder without a tray. The lack of a tray to sit on sometimes discourages large birds like Blue Jays, who can easily scare away nut-eaters like nuthatches and chickadees. If you don't mind large birds, feed your shelled nuts in a tray feeder.

Jays love to eat nuts and are very bold. Feed in-shell peanuts almost anywhere—on a stump, a tray, or even a wire-mesh peanut wreath. Check with your local backyard-birding store for more ideas.

Nyjer is a tiny seed that packs a high-energy punch for your wintering goldfinches and Pine Siskins. Watch for huge wintering flocks of Pine Siskins stopping by to refuel at your nyjer feeders this month. Add an extra feeder if your existing ones are too crowded.

Quick Seed Tips

- Feed a mix with at least 50 percent black-oil sunflower and safflower seed. These seeds pack a high-calorie punch for your wintering birds.
- Use a mix with at least 40 percent white millet to attract more "snow birds"—juncos.
- Feed daily in colder weather: Your birdseed helps the birds stay warm.
- Offer millet in a ground tray or an area free of snow for easy access for your ground-feeding birds.
- Offer seed blocks for a steady supply of food.

Don't be afraid to hang those feeders near a window so you can see goldfinches and Pine Siskins up close. Placing your nyjer feeder near a birdbath may encourage more activity.

We like a mesh-style nyjer feeder—either a thistle sock or the longer-lasting stainless-steel mesh feeder. Goldfinches and Pine Siskins can easily cling to these feeders, so no tray is necessary. A tray will catch the messy nyjer shells, but it also gives sparrows an easy perch, and their presence can discourage the goldfinches and Pine Siskins you'd prefer to see.

Goldfinches and Pine Siskins are disloyal and nomadic in their feeding. They may come and go, so don't be surprised if you lose them for a while. Empty finch feeders of old nyjer and fill them with fresh seed every few weeks.

Suet in December

COMMON BIRDS AT SUET

woodpeckers	creepers	kinglets
jays	nuthatches	Bushtits
flickers	wrens	warblers
chickadees	finches	

'Tis the season for suet cakes. Suet is loaded with the fat and calories your woodpeckers, nuthatches, chickadees, kinglets, wintering Yellow-rumped Warblers,

Quick Suet Tips

- Feed fatty suets this month with lots of added nuts to provide your wintering birds with the fuel they need to stay warm.
- Feed suet in a tree or bush where suet-eating birds normally search for food.
- Feed suet in more than one location for increased activity.

creepers, and Bushtits need to stay warm on cold December nights. Golden-crowned and Ruby-crowned Kinglets live throughout North America and love suet. Watch these tiny birds constantly flit their wings while at your suet. In the winter, birds often join forces and look for food as a group. Don't be surprised to see all of these birds mixed together in flocks this month—except for Bushtits, who form their own flocks.

When first hanging your suet feeder, you may need to teach birds that suet is food because it doesn't look like anything they find in nature. Mount or hang the suet feeder on a tree, fill it with suet, and then smear the feeder with peanut butter and birdseed. The peanut butter is just the glue for the seed. Birds recognize seed as food, and this will get activity started. Place the feeder just outside a window where you can easily see it.

On bitter cold days in Minnesota, Anne would sometimes notice less activity at seed feeders, especially if they were out in the open away from the protection of shrubs and trees, and more activity at suet nestled snugly in dense cover. In really cold weather you may get more activity by moving all your feeders nearer to the birds as they huddle together in shrubs and trees. Make it easy for them.

If you have a lot of snow this month and food is buried and tough to find, you may catch carrion-eaters like crows and ravens eating your suet.

Refer to the suet section of Backyard Birding Basics (page 27) for more information on suet feeding.

Mealworms in December

COMMON BIRDS AT MEALWORMS

robins	starlings	thrashers
waxwings	sparrows	bluebirds

In many areas, even in the North, robins, bluebirds, and waxwings overwinter, forming large flocks so as to better search for food. These birds love mealworms.

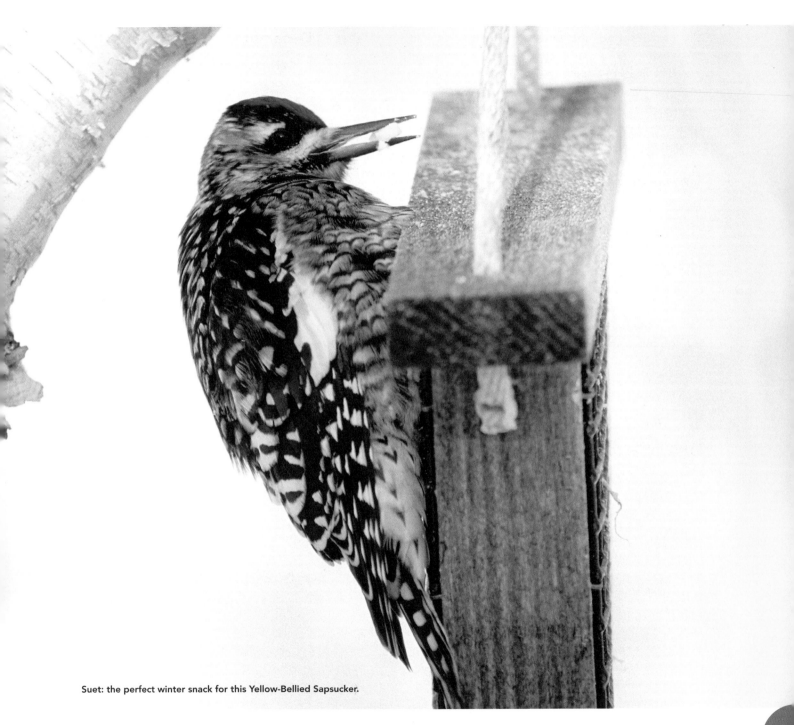

Suet: the perfect winter snack for this Yellow-Bellied Sapsucker.

Use dried/roasted mealworms this month, and place them near your ice-free water, where birds at the bath are more likely to discover them. You may want to mix your mealworms with dried fruit like raisins or dried cherries. Robins love dried fruit. If birds turn their beaks up at your roasted mealworms, mix a little birdseed in to jump-start activity.

Nectar in December

POSSIBLE BIRDS AT NECTAR

hummingbirds

orioles

Hummingbird Feeding

If you live in an area where hummingbirds overwinter, then continue feeding nectar. This is usually in the extreme southern, southwestern, and western coastal regions of the United States.

Oriole Feeding

A few Baltimore Orioles overwinter in Florida. Floridians should continue to offer these beautiful birds nectar.

Fruit in December

POSSIBLE BIRDS AT FRUIT

mockingbirds	robins	sparrows
finches	woodpeckers	waxwings

Offer dried raisins, cherries, or cranberries for wintering flocks of robins, bluebirds, and waxwings. Apple halves are a nice holiday treat for finches, mockingbirds (found mainly in southern regions), and sparrows. Mix seed with dried fruit to encourage bird activity and place it near your birdbath. A ground feeder or tray feeder works well for dried fruit. Grape jelly will be a hit with Baltimore Orioles, who are found overwintering in Florida, and with Northern Mockingbirds, found wintering mainly in southern regions.

Water in December

COMMON BIRDS AT THE BATH

Everybody! Including:

cardinals	chickadees	juncos
nuthatches	thrashers	titmice
robins	grosbeaks	sparrows
towhees	bluebirds	warblers
finches	waxwings	

Our customers are often surprised to see their birds bathing on cold winter days. We often hear "Won't the water freeze to their feathers?" or "Won't their feet stick to the bath?"

The answer is no. Their feet are like fingernails and don't feel cold or freeze to things. There are a *very few* documented cases of birds freezing when wet—usually starlings in extreme cold. This may be because European Starlings seem to be the most common bathers in bitter temperatures. The benefits of providing water for birds in the winter far outweigh the tiny risk of freezing, so the best gift you can give your birds this month is an ice-free water source.

Cardinals, finches, starlings, sparrows, and others will splash with joy, forcing you outside into the cold to refill the bath, but you know they appreciate it. Don't be surprised to see large flocks of robins swarm your birdbath this month. Robins winter in most of North America, but their "red breast" becomes much duller in color.

Add a deicer to keep your water ice-free. Consider a thermostatically controlled one, or a birdbath with a deicer built in. Anne owned one in Minnesota for years, and even at twenty degrees below, her birds had open water. The water doesn't ever get warm but rather stays just above freezing.

Make sure to use a bath that will not crack with freezing and thawing. Concrete and ceramic can crack even with a deicer and should be brought in during

freezing weather. Metal or plastic are good options in colder months and can easily accommodate a deicer.

Nesting in December

COMMON BIRDS NESTING

Birds are not nesting this month. Watch for owls roosting in your larger nest boxes during the day. The Western Screech-Owl in the West and the Eastern Screech-Owl in the East are small owls that are most likely to roost in nesting boxes. Owls are solitary, but watch for more than one flicker at a time using the box in winter. Flickers often use nest boxes to roost in at night. Watch for birds entering the box at dusk and leaving at dawn.

Refer to the nesting section of Backyard Birding Basics (page 41) for more information on roosting boxes. Most birds will use roosting boxes for protection from the cold.

Backyard Habitat in December

COMMON BIRDS IN YOUR YARD

cardinals	finches	towhees
chickadees	juncos	titmice
grosbeaks	robins	sparrows
nuthatches	goldfinches	warblers
jays	Pine Siskins	

Dense, overgrown shrubs and trees are birds' best protection against the cold and snow. Vegetation also acts as a gas station to them, inviting them to park and refuel. The cocooned insects, seeds, and berries your birds find there are what your birds need to stay warm and survive through the winter months.

Birds rely on our feeders for only a small fraction of their diet, even in cold weather. They really do depend on nature for their survival, so make sure your

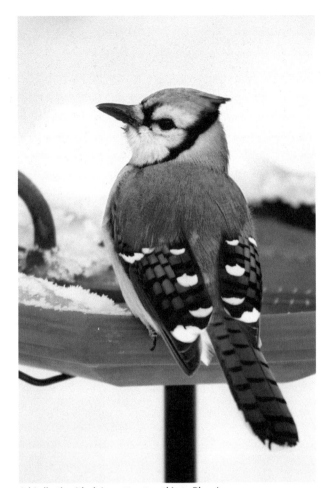

A birdbath with deicer attracts a thirsty Blue Jay.

Kids' Project

Create a holiday tree for the birds. String popcorn, cranberries, orange and apple slices, and in-shell peanuts together. Drape around a tree or bush in your yard. All your birds will enjoy this holiday meal.

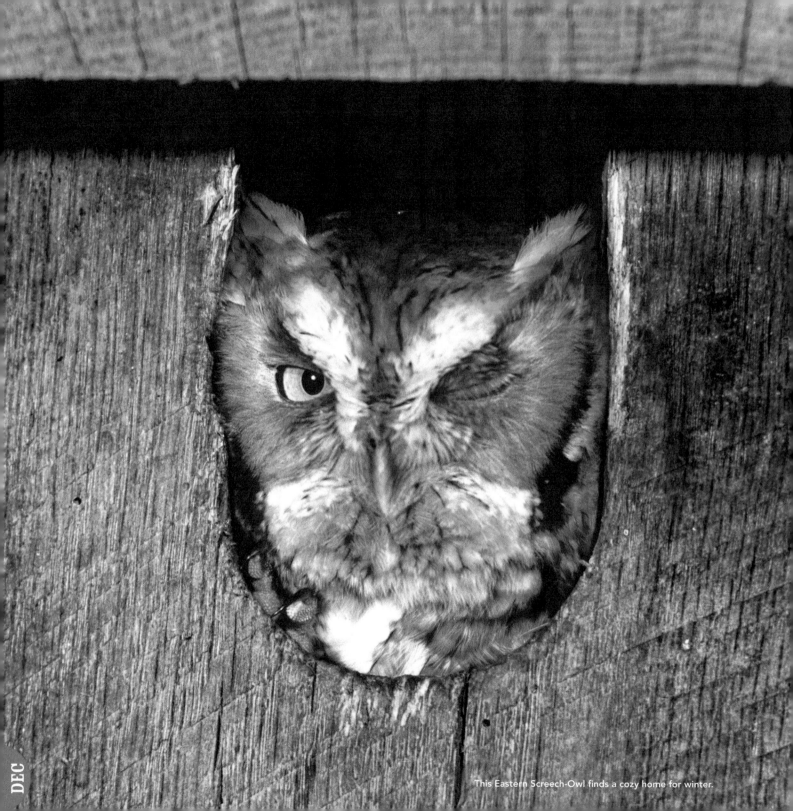

This Eastern Screech-Owl finds a cozy home for winter.

backyard copies nature. Heavy snows and ice can be deadly for your birds, covering the natural foods they depend upon. Knock the snow and ice from your native seed- and berry-producing plants and shrubs. Cardinals, chickadees, nuthatches, titmice, and others will appreciate your effort.

Creating a brush pile for your birds can also provide needed cover from the elements. An old Christmas tree added to a pile of branches and yard waste can be a welcome refuge for your birds.

This month look for flocks of robins, mockingbirds, and waxwings stealing the berries from your holly, pyracantha and mountain ash. Many of our customers have also noticed that cardinals love the dense, year-round cover that the evergreen tree arborvitae provides. Cardinals and others love the fruit of the Russian olive as well.

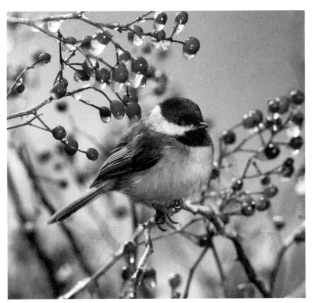

A chilly chickadee feasts on berries.

Quick Habitat Tips

• Don't cut back natural vegetation. Birds use it as protection from the cold.

• Don't rake up leaves. Towhees and other birds depend on these and other plant debris for winter food.

• Watch as your Pine Siskins, finches, and grosbeaks pick the seeds from pinecones and other native trees and plants.

Sisters' Tips for December

From Mary:

Brush heavy snow and ice from your native seed- and berry-producing plants to make it easier for your birds to find natural foods.

From Anne:

Put out a good-quality, thermostatically controlled, heated bath. Birds need water every day and have trouble finding it when it's frozen!

From Geni:

Feed fatty suet in more than one location to give your woodpeckers, creepers, kinglets, and wintering warblers the extra fuel they need this month.

date	birds sighted	notes

date	birds sighted	notes

TROUBLESHOOTING
Some of the problems that come with feeding the birds and how to solve them

In the years we have owned and operated Wild Birds Unlimited stores, we have talked with tens of thousands of customers about what is going on in their backyards. We have heard fabulous stories of watching birds and the enjoyment it brings. We have also heard about the challenges that can come with the hobby. Feeding birds can sometimes encourage unwanted guests or create quite a mess.

We have heard it all. . . .

"I love feeding my birds, but I wish I could get rid of the pigeons. They are taking over my feeders and scaring all my other birds away."

"How do I keep the squirrels off my feeders? They are driving me nuts!"

"I only see sparrows and blackbirds at my feeders."

"My neighbor's cat is killing my birds—what do I do?"

"I have mice in my yard, and I know it's because I feed the birds."

"I enjoy feeding the birds, but my husband is complaining about the mess."

Don't worry. We have solutions for these and other common problems that have worked for many of our customers. Finding the right solution for you may require a bit of time, money, and compromise, but we are confident that following our recommendations will help you to enjoy your birds for years to come.

UNWANTED GUESTS
Squirrels

Okay, we know what you're going to say: "It's impossible to keep squirrels out of my feeder." Well, we disagree. We have heard stories about your attempts—greasing the pole, putting nails on your feeder to poke the squirrels when they jump down for a snack, etc., etc., etc. It's simple, really. Stop all the futile attempts and follow a few simple rules.

Step 1: Safflower.

Put only safflower in your seed feeders. Don't mix it in with other seed, as squirrels will just eat around it like a kid eats around green beans in a casserole. If safflower is fed alone, squirrels rarely eat it. You might not see as wide a variety of birds as you would with a good mix, but cardinals, House Finches, titmice, chickadees, and doves love safflower.

Step 2: Keep Them Out!

If you want to keep feeding your seed mix or you want to protect other feeders, such as your peanut feeder, there are several ways to keep squirrels out.

Poles and Squirrels. Hang or mount feeders from a pole. The bottom of the feeder must be high enough to keep squirrels from jumping up to it (usually five feet high is adequate).

The pole must stand at least eight feet away from anything that can serve as a launching pad for the squirrel.

Squirrels can climb poles, so add a squirrel baffle to your pole. We like the stovepipe style, which is usually about six inches across and fourteen inches long. Make sure the top of the baffle is five feet off the ground (remember, the ground is higher in winter, so in snowy climates you may need to have the bottom of the feeders and the top of the baffles at least six feet up from the ground.

If your squirrel is still getting to your feeder, watch to see how he's doing it and move your pole, baffle, or feeder accordingly. Maybe he's launching from an unexpected place, like the side of your stucco house.

Decks, Squirrels, and Squirrel-Proof Feeders. Hanging a feeder from a deck rail is an invitation to a squirrel, and a feeder in that position is very difficult to protect.

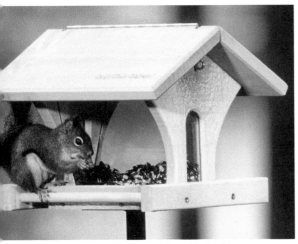

A squirrel squeezes into this feeder.

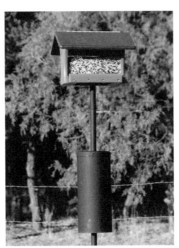

Keep squirrels off your feeder with a stove-pipe-style baffle.

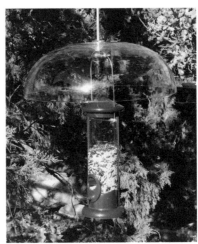

Protect your small, hanging feeders with a dome-style baffle.

If your deck rail is the perfect spot for your viewing, then use straight safflower or a squirrel-proof feeder. We like the type that closes under the squirrel's weight or the type that flips squirrels off. Even cages around a tube feeder can be effective if there's enough space between the cage and the tube to keep the squirrels from reaching in for the seed. Birds fly through the cage openings to the feeder inside.

Tree Hanging and Squirrels. Protecting a feeder hung in a tree from squirrels is a challenge, but it can be done. The trick is to hang the feeder way out on a branch so the squirrel can only get to the feeder from above. It must be eight feet from the trunk or other branches from which the squirrel might launch.

Hang a large disk-style baffle above the feeder to cut off the squirrel's last route, and this should do it. We find a tube feeder without a tray is best in this situation. Any small feeder, including a mesh peanut feeder or suet feeder, is easily baffled from above. When squirrels try to flip around your baffle or leap from far away, you want them to have as little as possible to hang on to. That's why small, skinny feeders are best in this circumstance.

Squirrels and Nyjer. In our experience, squirrels don't much like nyjer. Don't use a finch mix, as squirrels will go after the other parts of the mix. Feeding nyjer alone is often a squirrel-free and a great way to attract goldfinches.

Suet and Squirrels. Squirrels don't usually like plain suet. They like the nuts and seeds mixed *with* the suet. Either baffle suet as we've described, or feed plain suet.

Step 3: Be Smarter Than the Average Squirrel

Whether you are trying to keep squirrels off your seed, peanuts, or suet, it can be a challenge. When using the techniques we've described, if those rascals keep winning, watch to see how they are defeating your efforts. Make adjustments. Keep in mind, squirrels have all day to figure out how to get your bird food. It's their job.

They can be fun to watch. I know that's hard to hear for some of you serious squirrel warriors, but if you do as we suggest you may find a bit of peace from the battle and be able to enjoy watching their futile attempts.

Raccoons

Raccoons usually steal seed and suet at night. Discourage these night-time bandits by bringing in your feeders at night or by using the squirrel deterrents reviewed above.

Raccoons can climb poles, too, and with their long reach can also climb past most squirrel baffles. Use a longer stove-pipe-style baffle, twenty-three inches or so, to keep out both squirrels and raccoons.

Raccoons wander into yards at night.

Large Birds

Large birds dominating feeders can be a real problem. Whether the troublemakers are pigeons, jays, or blackbirds like grackles or starlings, we have a variety of ways to keep them at bay.

Specialized Dome Feeders

We have sold hundreds of specialized dome seed feeders called the "Dinner Bell." These have an adjustable dome that can be lowered to allow only smaller birds to feed. You can adjust the dome to allow larger cardinals, jays, grosbeaks, and thrashers to feed and still keep pigeons and doves out. If you want to exclude jays, grackles, or starlings with this feeder, however, you will also exclude cardinals, grosbeaks, and other similar-sized birds. The feeding tray has

sides that are high enough to discourage the birds from knocking much seed out to the ground where pigeons and doves can easily get to it.

If you want to exclude pigeons, we recommend using black-oil sunflower seed all by itself in this dome-style feeder. If you're feeding a mix, some millet always gets kicked to the ground, where pigeons and doves will eat it. So feeding only sunflower in an adjustable dome feeder keeps pigeons out of the feeder and off the ground.

Open Trays with Cages

Keep Out Pigeons and Doves. Use an open-tray feeder on the ground or mounted on a pole with a specialized cage on top of the tray. These cages, designed to keep pigeons and doves out, usually have two-inch openings to allow larger cardinals, jays, thrashers, and grosbeaks as well as all of your smaller birds to easily enter and feed from the tray. The trays have sides that help prevent seeds from being knocked out of the feeder. To attract the widest variety of birds, we recommend using a mix with at least 50 percent black-oil sunflower and the rest mostly white millet.

Ground-feeding juncos, sparrow species, and towhees will often feed from open-tray feeders on or above the ground, and these birds love white millet. If millet is going to the ground and pigeons find it there, switch to only black-oil sunflower in the tray.

Tube-Style Feeders with Cages

Discourage Large Birds like Pigeons and Black Birds. If you are using a tube-style feeder, you may be able to buy a cage designed to fit over the tube. Check with your local wild bird specialty store.

Cages vary greatly in design. Most have small openings to allow only small birds to feed. You can also buy a tube feeder with a cage already attached. These work well to discourage large birds only if the cage is far enough from the tube to keep large birds from sticking their head through to the seed.

Seed is easily knocked out of tube-style feeders. Pigeons and doves often feed on the ground below the tube feeders. If this is problematic, we recommend feeding only black-oil sunflower in your caged tube feeder. It is less likely to be knocked out of your tube by the other birds.

Safflower

Not only do squirrels not like safflower, but grackles and starlings tend to stay away, too. It must be fed alone in a feeder to be effective.

House Sparrows

For many of you, the non-native House Sparrow is an unwanted visitor at your feeders. House Sparrows are most common in city backyards.

Tips to discourage House Sparrows:

• Use a mix high in black-oil sunflower with little or no white millet. Lots of ground-feeding birds love the millet, but it's also the favorite of the House Sparrow. Most birds love black-oil sunflower—cardinals, grosbeaks, chickadees, and nuthatches, in particular.

• Use only safflower in your tube, tray, and hopper feeders if feeding less millet isn't effective. Cardinals, House Finches, doves, chickadees, and titmice will gladly eat safflower, but it's not appealing to the House Sparrow.

• Use a mesh-style (nyjer sock or stainless-steel mesh) nyjer feeder to discourage House Sparrows from eating your nyjer. Sparrows can't cling easily to mesh feeders. Goldfinches and Pine Siskins love nyjer in a mesh feeder.

• Hang a mesh-style peanut feeder to attract chickadees, nuthatches, and woodpeckers. Sparrows sometimes don't cling as well.

• Add a suet feeder or two. Free-hang a log or tail-prop suet feeder from a tree and mount a suet cage securely on a tree to best attract Bushtits, woodpeckers, nuthatches, and chickadees. House Sparrows are less attracted to plain suet or suet mixed with nuts. They will eat suet mixed with grain, though, so avoid this type and check your labels carefully.

Generally, avoiding high-millet mixes and going to straight seeds like black-oil sunflower or safflower is your first step toward lowering your House Sparrow population. Then, by adding a few different types of feeders which House Sparrows have trouble using, you can attract a wider variety of birds. If you want even more detailed information about discouraging House Sparrows, your local backyard-bird-feeding shop is a good resource.

Rodents

Rodents should not be able to depend on any steady source of food. If rodents are visiting your feeding area, you can discourage them by not overfeeding. Putting out more seed than your birds will clean up in one

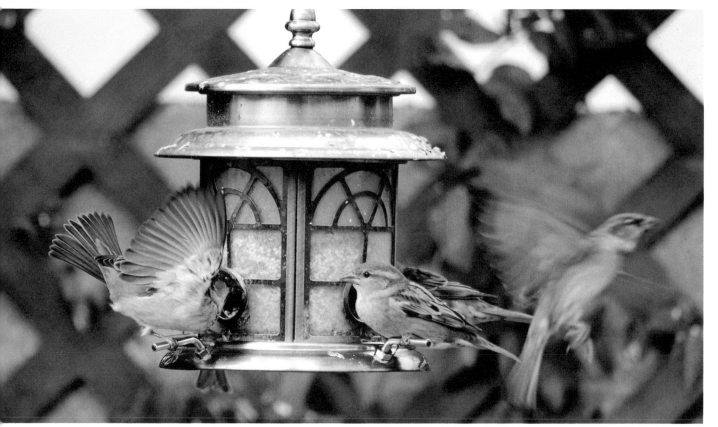

House Sparrows mob this seed feeder.

day can attract rodents looking for an easy meal. Also stay away from birdseed mixes that contain milo, wheat, flax seed, and other filler grains. Birds don't like these seeds and will kick them to the ground. This un-eaten seed buildup is a rodent attractor.

OH! WHAT A MESS!

You love your birds but don't like the mess. We have simple solutions that have worked for many of our customers that will keep your bird-feeding area clean for you and your birds.

No-Mess Birdseed Mix

One of the most popular birdseed mixes in our store is called No-Mess. It contains only hulled (shell-less) seeds. That's right—no shells, no sprouting.

"No-mess" birdseed—no shells, no sprouting.

Our customers often refer to it as the "no muss, no fuss birdseed."

Its ingredients are mainly sunflower chips, hull-less white millet, and cracked corn or peanuts. All the birds love it.

If you want no mess but don't want the cracked corn and hull-less white millet, which will be knocked out for ground-feeding birds, then feed only sunflower chips. These are hulled sunflower seeds that have no shell and will not sprout, so they make no mess under your feeders.

Top-Quality Birdseed Mixes

Low-quality mixes are guaranteed to make a mess. Remember, stay away from birdseed mixes that contain milo, wheat, flax seed, and other filler grains. Most commercial mixes are loaded with these. Most backyard birds kick these seeds out of the feeder to the ground because they don't like them, but neither do the ground-feeding birds. These uneaten seeds build up, create a mess, and can sprout in your yard.

Backyard-bird-feeding stores offer high-quality birdseeds and birdseed mixes. If your area does not have a backyard specialty store, don't settle for a low-quality, messy mix. You will get more bang for your buck purchasing only black-oil sunflower seed, which can usually be found in grocery, hardware, or feed stores.

Nectar feeding can also be messy. Some types of hummingbird and oriole feeders can drip, causing a sticky buildup below the feeder. That is one reason we prefer the no-drip saucer-style feeders. The feeding holes are on the top, so dripping is almost impossible. Another problem with nectar feeding is ants. Once they discover your feeder, they can crawl into it, contaminate the nectar, and be a real mess to clean up. Check with your local bird store to find an ant trap. We recommend the moat-type trap that you fill with water and hang above your feeder. Ants can't swim and won't cross your moat, even to get to your sugar water. Some of our customers put oil in the moat to slow evaporation, but since hummingbirds sometimes drink this water, we think that's a bad idea.

IT'S WET OUT THERE!

Birds don't usually like wet seed. If you live in a wet climate, follow these simple steps to keep your birdseed fresh and dry for your birds:

- Use feeders that protect seed from the elements. Tube-style feeders work well. If seed is getting wet in your tube, hang it under a dome baffle or a specially made weather guard that you can find at your local bird store.
- Dome-style feeders work well, too. Most are fitted with an adjustable roof that can be lowered to keep out the elements.
- Hopper feeders with a wide overhang usually offer your seed adequate protection. We like hopper feeders made out of recycled milk jugs—they last forever, even in wet climates.
- Open-tray feeding is a great way to welcome and see a variety of birds. If you live in a wet area, it may be harder to manage . . . but it can be done. Put only small amounts of seed in your feeder so if it rains you don't have a large pile of wet, moldy seed to dispose of. Brush snow off trays quickly and refill them with fresh, dry birdseed. Check your local backyard-bird store for a tray feeder with a cover.
- If, during or after a wet spell, you notice birdseed in your feeder going uneaten for a long time, empty the feeder and refill it with fresh, dry birdseed.

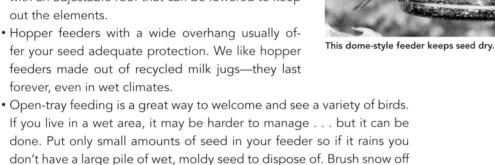

This dome-style feeder keeps seed dry.

LIONS, TIGERS, AND BEARS

Thankfully, most of us don't have lions and tigers visiting our backyards, but many of us have cats killing our birds, and a few of you may have bears dining at your feeders.

Cats

House cats kill over one million songbirds every year. Cats are pets, not natural predators.

Your best defense against your own cats killing birds is to keep them indoors. Your sweet little kitty turns into a killing machine when allowed to roam. Once when we were outdoors at a friend's house, our friend was

explaining that her cat never killed birds—just as her cat came around the corner with a dead bird in its mouth. Just because you don't see your cat kill a bird doesn't mean it isn't happening.

If neighbor cats are a problem in your yard, ask your neighbors to keep their kitty inside. If that doesn't work, minimize the risk of attack for your birds.

- Always place your birdfeeders in an open area away from bushes or other cover where cats can hide.
- Minimize ground feeding. Cats are more likely to catch a bird on the ground. So, don't use a mix: feed black-oil sunflower by itself in above-the-ground feeders. With no millet or other ground-feeding seed, you will discourage ground feeding—thus keeping your birds safer.
- Birds are most vulnerable when wet. Provide a birdbath (pedestal or hanging style) in an area away from bushes or other cover where cats can hide. Birds are vulnerable at ground baths.

Bears

Bears love birdseed, suet, and hummingbird nectar. They can easily demolish a birdfeeder with one bite or swipe.

Believe it or not, there are bear-proof seed feeders available. These heavy-duty feeders won't keep bears away but may keep your feeder out of the garbage can. Our stores carry tube feeders that have a lifetime warranty, which includes a one-time replacement for bear damage.

In some cases, the best solution to bear problems may be to temporarily remove your feeders until the bear moves on to greener pastures. You can also bring your feeders in at night, when they are most vulnerable to bears.

TROUBLESHOOTING DISCLAIMER

Whether we are talking about bears, squirrels, or pigeons, we are dealing with wild animals. We have helped thousands of people solve their birdfeeding challenges, but every now and then, we run into a creature that somehow defeats our attempts to keep it out of our feeders. It just doesn't follow the rules. We've seen "supersquirrels" defeat baffles by jumping higher and farther than should be possible. We've heard about grackles eating safflower, which they are supposed to dislike. Sometimes it may be wise to just give in and enjoy the show.

REFERENCES

Ehrlich, Paul R. *The Birdwatcher's Handbook*. Oxford University Press, 1994.

Kaufman, Kenn. *Birds of North America* (Kaufman Focus Guides). Houghton Mifflin, 2000.

Morrow, Baker H. *Best Plants for New Mexico Gardens and Landscapes*. University of New Mexico Press, 1995.

North American Bluebird Society Website, www.nabluebirdsociety.org

Sibley, David Allen. *The Sibley Guide to Bird Life and Behavior* (National Audubon Society). Alfred A. Knopf, 2001.

Sibley, David Allen. *The Sibley Field Guide to Birds of Western North America* (National Audubon Society). Alfred A. Knopf, 2003.

Sibley, David Allen. *The Sibley Guide to Birds* (National Audubon Society). Alfred A. Knopf, 2000.

Stokes, Donald and Lillian. *Stokes Field Guide to Birds, Eastern Region*. Little, Brown and Company, 1996.

Stokes, Donald and Lillian. *Stokes Field Guide to Birds, Western Region*. Little, Brown and Company, 1996.

INDEX

Page numbers in *italics* refer to illustrations

A

April, 85–97
 birds, 85
 birdseed, 86–87
 fruit, 91
 habitat, 95
 kids' project, 87
 mealworms, 88
 nectar, 90–91
 nesting, 92, 94–95
 sisters' tips, 95
 suet, 88
 water, 92
August, 145–57
 birds, 145
 birdseed, 146, 148–49
 fruit, 152
 habitat, 155
 kids' project, 146
 mealworms, 149, 151
 nectar, 151–52
 nesting, 154–55
 sisters' tips, 154

 suet, 149
 water, 152, 154

B

basic tips, 18
bears, 216
birdbaths, *35*, *36*, *37*
 in April, 92
 in August, 152, 154
 in December, 200–201
 with deicers, 40–41, *41*, 66,
 178, 200
 with drippers, *37*, *38*, 39, *93*,
 106, *139*, 146
 in February, 66–67
 in January, 55
 in July, 139
 in June, 124–25
 in March, 78
 in May, 107–8
 in November, 189
 in October, 178
 quick tips, 92, 107, 178

 in September, 165–66
 with solar pumps, 39, *39*
 tips, 37–38
 types, 37, 166
 in winter months, 166
birdseed, 18–24
 in April, 86–87
 in August, 146, 148–49
 conserving, 24
 in December, 196–98
 in February, 62, 64
 feeders, 25–27
 "fillers," 19, 160
 in January, 50–53
 in July, 132–33, 135
 in June, 116–18
 in March, 74–75
 in May, 100–101
 mixes, 18–19
 no-mess blends, 20, 213–14,
 214
 in November, 184–86
 in October, 172–73, 175

perishable, 19
prices of, 24
quick tips, 18, 51, 64, 74, 86, 101, 117, 132, 148, 160, 172, 184, 197
seed blocks, 20–21, *20*, 52–53, 75, 87, 175, 186, 196
in September, 160, 162
top quality, 214
wet, 215
blackbirds, *158*
black-oil sunflower, 19, 20, 21, *23*, 51, 62, 146, 160, 212
bluebirds, *12*, *34*, 42, *44*, 45–46, 62, *67*, 77, 80, 94, 108–9, *116*, *120*, *124*, *125*, 126, 149, *150*, 151, 191, 198, 200
buntings, 21, *84*, 85–86, *100*, 101
Bushtits, 24, 53, 64, 65, 77, 102, 117, 135, 141, *162*, 173, 185, 186, 197, 198

C

cardinals, 20, 21, 22, 33, *48*, 51, 52, 53, *62*, 64, *67*, *74*, *75*, *117*, 132, *133*, 155, *165*, 175, *184*, 188, 191, *196*, 197, 203
catbirds, 126, *155*
cats, 215–16
chickadees, 20, 21, 22, 24, *25*, *41*, 42, 51, 52, 53, 64, 65, 69, 74, 75, *76*, 77, *78*, 80, 87, 88, 94, 102, *103*, 108, 110, *117*, 124, 132, 133, 148, *155*, *162*, 166, *167*, *173*, 175, *185*, *196*, 197, 198, *203*
corn, cracked, 21–22, *23*
corncobs, 22

creepers, 24, 53, 64, 77, 87, 88, 175, 185, 186, 197, 198
crossbills, 183

D

December, 195–205
birds, 195
birdseed, 196–98
fruit, 200
habitat, 201, 203
kids' project, 201
mealworms, 198, 200
nectar, 200
nesting, 201
sisters' tips, 203
suet, 198
water, 200
doves, 21, 51, 52, 74, 101, 115, 132, 133, 146, 148, 160, *178*

F

February, 61–71
birds, 61
birdseed, 62, 64
fruit, 66
habitat, 69
kids' project, 62
mealworms, 66
nectar, 66
nesting, 67–68
sisters' tips, 69
suet, 65
water, 66–67
feeders, 25–27
dome, 210–11, *215*
fly-through, *101*
ground, *25*
hopper, 25, *25*, *101*

mesh, 212
nectar, 30, *31*, 32
nyjer (thistle), 27, 64, 75, 87, 101, 117, 133, 198, 212
and squirrels, 208–9, *209*
suet, 29, *29*, 68, *72*, 77, 88, *102*, *187*, 212
tail-prop, *88*, 186, *187*
tray, 25–26, *25*
tube, 26–27, *26*, 211
finches, 20, 22, 33, 41, 51, 52, 53, *60*, 62, 64, 74, 94, 110, 125, 126, 132, *146*, 148, 162, 167, 185, 188, 191, 197, 201
flickers, 22, *28*, 42, 45, 52, 56, 65, 69, 88, *102*, 118, 167, 186, 191, 201
flycatchers, 88, 103, 126
fruit, 33
in April, 91
in August, 152
in December, 200
in February, 66
in January, 54
in July, 137, 139
in June, 123
in March, 78
in November, 188
in October, 176
quick tips, 33
in September, 165

G

gnatcatchers, 102, 141
goldfinches, 22, *26*, *51*, 64, 75, *87*, 101, *106*, 108, *117*, *118*, 127, *133*, *139*, 141, *147*, 148, 155, 162, 166, *173*, 179, *184*, 185, 197–98

INDEX

grains, 19

grape jelly, 33, 87, 91, 123, 137, 152

grosbeaks, *11, 15,* 20, 21, 22, *25,* 33, 51, 53, *62, 64,* 67, 81, 86, 92, 100, *101,* 110, 123, 127, 133, *153*

H

habitat, 46–47
 in April, 95
 in August, 155
 in December, 201, 203
 in February, 69
 in January, 56
 in July, 140
 in June, 126–27
 in March, 81
 in May, 110
 in November, 191
 in October, 179
 quick tips, 47, 95, 127, 141, 167, 191, 203
 in September, 167

hawks, 92

hummingbirds, 30, *31,* 32, *32,* 66, 78, 90, *90,* 92, 102, 104, *104,* 107, 110, 120–21, *121,* 124–25, 126–27, 136–37, *136,* 139, *144,* 145, 151–52, *151,* 155, 163, *164,* 176, 188, 200

J

January, 49–59
 birds, 49
 birdseed, 50–53
 fruit, 54
 habitat, 56
 kids' project, 52
 mealworms, 54
 nectar, 54
 nesting, 56
 sisters' tips, 56
 suet, 53–54
 water, 55

jays, 21, 22, 24, 52, 64, 74, 87, 117, *132,* 148, 160, 162, 173, 184, 185, *189,* 197, *201*

July, 131–43
 birds, 131
 birdseed, 132–33, 135
 fruit, 137, 139
 habitat, 141
 kids' project, 136
 mealworms, 135–36
 nectar, 136–37
 nesting, 140
 sisters' tips, 140
 suet, 135
 water, 139

juncos, 21, *50,* 51–52, 53, 64, 74, 160, *161,* 179, 191, 196, 197

June, 115–29
 birds, 115
 birdseed, 116–18
 fruit, 123
 habitat, 126–27
 kids' project, 118
 mealworms, 120
 nectar, 120–21
 nesting, 125–26
 sisters' tips, 127
 suet, 118
 water, 124–25

K

kestrels, 42, 45

kids' projects:
 April, 87
 August, 146
 December, 201
 February, 62
 January, 52
 July, 136
 June, 118
 March, 75
 May, 102
 November, 188
 October, 173
 September, 163

kinglets, *29,* 53, 65, 77, 87, 102, 118, 162, 173, 179, 197, 198

M

March, 73–83
 birds, 73
 birdseed, 74–75
 fruit, 78
 habitat, 81
 kids' project, 75
 mealworms, 77
 nectar, 78
 nesting, 80
 sisters' tips, 80
 suet, 77
 water, 78

May, 99–113
 birds, 99
 birdseed, 100–101
 fruit, 105, 107
 habitat, 110
 kids' project, 102
 mealworms, 103–4

nectar, 104–5
nesting, 108–10
sisters' tips, 110
suet, 102–3
water, 107–8
meadowlarks, 21
mealworms, 34, *89*, *103*
 in April, 88
 in August, 149, 151
 in December, 198, 200
 in February, 66
 in January, 54
 in July, 135–36
 in June, 120
 in March, 77
 in May, 103–4
 in November, 186, 188
 in October, 176
 quick tips, 34
 in September, 163
millet, 21, 22, *23*, 62, 74, 87, 100–
 101, 116, 160, *160*, 197
milo, 19, 160, *160*
mockingbirds, 34, 55, 88, *89*, 126,
 135, 141, 188, 191, 200, 203

N

nectar, 30, 32
 in April, 90–91
 in August, 151–52
 in December, 200
 in February, 66
 in January, 54
 in July, 136–37
 in June, 120–21
 in March, 78
 in May, 104–5
 in November, 188

 in October, 176
 quick tips, 30, 90, 104, 151
 in September, 163, 165
nest boxes, 42, *43*, 44–45, *44*, 56,
 75, *79*, 80, *109*, *125*, 189
nesting, 41–47
 in April, 92, 94–95
 in August, 154–55
 in December, 201
 in February, 67–68
 in January, 56
 in July, 140
 in June, 125–26
 in March, 80
 in May, 108–10
 no-nos, 42
 in November, 189, 191
 in October, 178
 quick tips, 42, 67, 94, 126
 in September, 166–67
November, 183–93
 birds, 183
 birdseed, 184–86
 fruit, 188
 habitat, 191
 kids' project, 188
 mealworms, 186, 188
 nectar, 188
 nesting, 189, 191
 sisters' tips, 191
 suet, 186
 water, 189
nuthatches, 20, 21, 22, 24, 42,
 51, 52, 53, 64, *65*, 69, 75,
 77, 87, 88, 94, 100, 117, 1
 33, 148, 160, 162, 173, *174*,
 175, 184, 185, 186, *196*,
 197, 198

nyjer seed (thistle), 22, *23*, 116,
 148, 185, 209

O

October, 171–81
 birds, 171
 birdseed, 172–73, 175
 fruit, 176
 habitat, 179
 kids' project, 173
 mealworms, 176
 nectar, 176
 nesting, 178
 sisters' tips, 179
 suet, 175
 water, 178
orioles, 30, 32, *32*, *33*, 75,
 88, 90–91, *90*, 103, *104*,
 105, *105*, 110, 121, *122*,
 123, *123*, 126, 127, 137,
 137, 152, 163, 165, 176,
 188, 200
owls, 42, 45, 67, 189, *190*, 191,
 201, *202*

P

peanut butter, 52, 62, 102
peanuts, 22, *23*, 52, 64, 74,
 117, 133, 148, 162, 185,
 197
pheasant, 21
phoebes, 88, 92, 120, 125
pigeons, 210–11
Pine Siskins, 22, 52, 64, 75, 87,
 117, 133, 148, 162, *173*, 179,
 185, 191, 197–98
Project FeederWatch, 163
Purple Martins, 42

INDEX

Q
quail, 21

R
raccoons, 210, *210*
redpolls, *185*, 195–96
robins, 20, 33, 34, *55*, 56, 62, 67,
 73, 75, 77, 80, 87, 88, 103,
 114, 120, *130*, 135, 139, 189,
 191, 198, 200, 203
rodents, 212–13
roosting boxes, 45, 56, 191

S
safflower, 21, *23*, 52, 64, 132–33,
 197, 208, 211–12
sapsuckers, 175, *199*
September, 159–69
 birds, 159
 birdseed, 160, 162
 fruit, 165
 habitat, 167
 kids' project, 163
 mealworms, 163
 nectar, 163, 165
 nesting, 166–67
 sisters' tips, 166
 suet, 163
 water, 165–66
sparrows, 19, 21, 51, 78, 79, 86,
 100, 126, 132, *146*, *154*, 159,
 166, 167, *170*, *172*, 175, *179*,
 184, 191, 197, 200, 212, *213*
squirrels, 21, 22, 208–10
starlings, 78, 186
suet, 27–29
 in April, 88
 in August, 149
 in December, 198
 in February, 65
 in January, 53–54
 in July, 135
 in June, 118
 in March, 77
 in May, 102–3
 in November, 186
 in October, 175
 quick tips, 27, 53, 175, 186, 198
 in September, 163
 and squirrels, 210
sunflower chips, 22, *23*, 101, 133
sunflower seeds, 22, *23*, 148
swallows, 45, 92, 109, 155

T
tanagers, 33, 73, 87, *100*, 105,
 110, 123, 124, *138*, 165, 179
thistle, *see* nyjer seed
thrashers, 21, 22, 52, 94, 126,
 184, 191
titmice, 21, 22, 24, 42, *50*, 51, 52,
 63, 74, *117*, 133, 148, *185*,
 196, 197
towhees, 21, 51, 74, *98*, 100, 110,
 132, 155, 179, *182*, 196, 197
troubleshooting, 207–16

W
warblers, 52, 55, 77, 87, 88, 92,
 100, 108, 173, 179, 186, 198
water, 35–41
 in April, 92
 in August, 152, 154
 in December, 200
 in February, 66–67
 in January, 55
 in July, 139
 in June, 124–25
 in March, 78
 in May, 107–8
 moving, 38–40
 in November, 189
 in October, 178
 ponds, 39–40
 quick tips, 35
 recirculating pump, 39, 55
 in September, 165–66
 in winter, 40–41
 see also birdbaths
waxwings, *8*, 33, 34, 56, *57*, 62,
 66, 69, 78, 92, 123, *165*, 167,
 176, 198, 200, 203
woodpeckers, *20*, 22, 24, *28*, *29*,
 33, 52, *53*, *62*, 64, 65, *68*, *72*,
 74, 75, *77*, 87, *88*, *91*, 94, *102*,
 105, 107, 117, 118, *119*, 123,
 127, 133, *134*, 135, *148*, *149*,
 160, 162, 165, 173, 175, 185,
 186, *187*, 197, 198
wrens, 42, 44, 66, *79*, 80, 94, 102,
 103, 178

PHOTO CREDITS

© Jess Alford: Pages 19, left & right; 31; 35; 38, right; 39; 43; 75, right; 98; 209, center & right; 214.

© Aspects, Inc.: Pages 26, left & center left; 118.

© Rees Bevan: Pages 7, left; 26, center right; 28 right; 138; 153.

© Birds Choice: Pages 33, top & bottom; 34; 74; 88; 90, right; 101, right; 104, right; 105, left; 120; 166.

© Peter J. Daniello: Pages 7, center; 19, center; 29, right; 32, right & left; 40; 90, left; 121, left; 122; 136; 137; 160, right; 164; 175; 213.

© Looker Products Inc.: Page 37, right.

© Maslowski Wildlife: Front cover; pages 6, left & center; 7, right; 8; 11; 12; 15; 28, left; 32, center; 36; 48; 51; 55; 57; 60; 63; 64, right & left; 65, right; 67, right & left; 68; 72; 75, left; 76; 77; 78; 79; 84; 89; 91; 93; 94, right & left; 102; 103, right; 104, left; 105, right; 106; 111; 114; 117, right & left; 119; 121, right; 123; 124; 125; 130; 133, right; 134; 139; 140; 144; 147; 148; 150; 155, top & bottom; 158; 161; 162, right & left; 165, right; 167; 170; 174; 177; 178; 179; 182; 185, left; 187; 190; 194; 196, right; 199; 201; 202; 210; 215.

© Wild Birds Unlimited, Inc.: Pages 6, right; 23 all; 25 top & center; 26, right; 29 left; 37, left; 38, left; 41, left; 44, right and left; 47; 62; 65, left; 86; 87; 100, left & right; 101, left; 103, left; 109, right & left; 116; 127; 132; 141; 160, left; 184; 203; 209, left.

© Wild Birds Unlimited, Inc. / Jim Carpenter: Pages 25, bottom; 41 right; 50, left & right; 53; 81; 100, center; 133, left; 146; 165, left; 172; 173, left & right; 185, right; 189; 196, left & center.

© Gail Yovanovich Creations: Pages 20; 149; 151; 154.

Bird illustrations
© istockphoto.com / John Woodcock

date	birds sighted	notes